WHY THE PAIN, WHAT'S THE GAIN?

WHY THE PAIN, WHAT'S THE GAIN?

The quest for extreme fitness

DANIEL KUNITZ

Aurum
Press

Quarto is the authority on a wide range of topics.

Quarto educates, entertains and enriches the lives of our readers—enthusiasts and lovers of hands-on living.

www.QuartoKnows.com

First published in Great Britain in 2016
by Aurum Press Ltd, 74-77 White Lion Street, London N1 9PF
www.aurumpress.co.uk

First published in 2016 in the United States by Harper Wave,
An imprint of HarperCollins Publishers
www.harperwave.com

A catalogue record for this book is available from the British Library.

ISBN 978 1 78131 292 6
ebook ISBN 978 1 78131 610 8

10 9 8 7 6 5 4 3 2 1
2020 2019 2018 2017 2016

Typeset by William Ruoto
Printed and bound by CPI Group (UK) Ltd, Croydon, CR0 4YY

FOR JENN

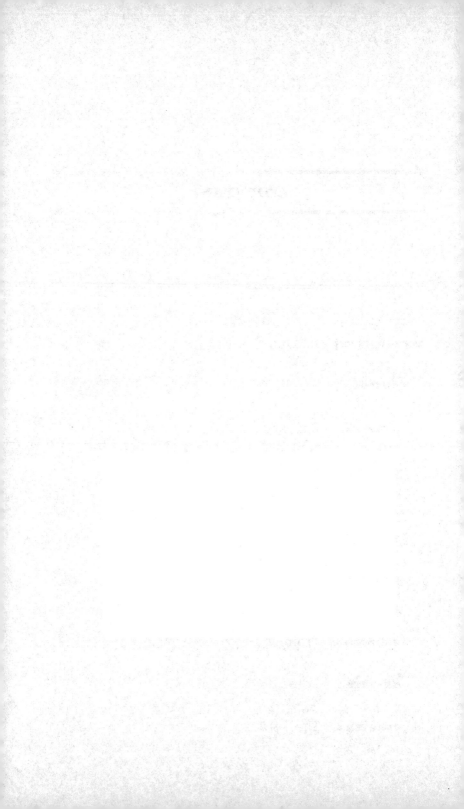

CONTENTS

Whoever goes in search of humans will find acrobats.
PETER SLOTERDIJK

WHY THE PAIN, WHAT'S THE GAIN?

I t is the young who most reliably bring news of the future. To-day's flash comes from my cousin Juliet, who has just entered the eighth grade. I don't know her well, or any other girls her age, but to my untutored eye she seems a bit taller than average, thin though not skinny, with shoulder-length brown hair. She is girlish, even ladylike, and not particularly known in our family as big on sports. This makes it all the more astonishing when, while sitting around a pool with some other cousins of a similar age, Juliet announces that she has joined the women's weightlifting team at her school.

That *is* news—not so much of Juliet but of all womankind. When else in human history but now could her casual statement be possible, or even imaginable? Since when have women been encouraged to lift heavy weights, to form a team of weightlifters?

Her announcement does not, however, faze the boys she's speaking with. All within a few years of her, not one finds it odd or surprising when Juliet nonchalantly explains that she and a friend joined the team "because we wanted to start a new sport that would make us stronger."

A generation earlier, when I was her age—and, what's more, for every generation preceding hers down to the beginning

of time—a girl wanting to get stronger would have provoked snorts of disapproval, mockery, often disgust. Young women were not supposed to want muscles; were not to bother with being strong: such desires were deemed unfeminine. And for a girl entering her self-conscious teens, like Juliet, it would have been especially unlikely. There might have been some boys in my junior high school who wished to pump themselves up into musclemen like Arnold Schwarzenegger and Sylvester Stallone's Rambo, but as far as I recall we had no weight room. And while the majority of girls at my school may have hoped to get as skinny as Jane Fonda in one of her workout videos, they were far more likely to do it with cigarettes, Diet Coke, and fasting than with aerobics. Besides, lifting was considered dangerous for kids that age—just one of the many things that could supposedly "stunt your growth."

But in the autumn of 2013, the male cousins around the pool—reedy, pale, and more taken with coding than athletics—find it perfectly normal for a girl to do strength sports, as does the girl herself. Without realizing it, these kids are denizens of a world that has begun reconceiving the very idea of fitness; they inhabit a New Frontier that a handful of adventurers began exploring about fifteen years ago, just before the turn of the millennium. And two of the key features of this territory that these adventurers have inadvertently pointed out are the prominence of women and the acceptance of strength training.

G irls hoisting heavy weights above their heads; women with muscles; girls who are stronger than many boys: these are some of the last remaining female cultural taboos. They persist in the East as well as in the West. Yet these taboos are being rapidly broken down.

Nowhere is this more apparent than in the sport Juliet adopted, though it is still largely unknown by the American public. In Europe

and Asia, where it is a hugely popular, teenage boys and girls will know exactly what is meant by the word *weightlifting*. It is emphatically *not* bodybuilding, which is what comes to most of our minds when we hear the clank of iron; it does not entail the most common lift seen in gyms, the bench press; nor does it have anything to do with hoisting enormous stones or pulling airliners with your teeth. Weightlifting consists of the two barbell events included in the Olympic Games (and because of this it is also known as Olympic lifting): the snatch and the clean-and-jerk.

The clean-and-jerk combines two basic and entirely common human movements: the clean, in which you pull a weighted bar from the floor to your shoulders; and the jerk, which powers the bar from the shoulders to a locked-arm position over your head. The snatch is more complex: with a very wide grip on the weighted bar, you heave it in one swift motion from the ground to overhead. While the Oly lifts, as they are known, might sound brutish and scary to the uninitiated, they are in fact as graceful as dance, demanding agility, flexibility, and speed as much as strength. They are also highly technical, requiring years of practice even to approach competence. Their subtlety adds to the obsessional nature of the lifts. I envied Juliet for getting such an early start, and after I told them about her, so did the women with whom I train.

I didn't try the Olympic lifts until my thirties, and like many people in recent years, my introduction came through CrossFit. During high school and college I did no systematic exercise, and in fact I don't recall anyone ever suggesting that doing so might be beneficial. I participated in no team sports in school, either. I was an avid skier, over the fifteen-odd days a year that skiing was possible for a kid growing up in suburban Maryland. And on occasion I'd play tennis,

go hiking, or ride my bicycle—all of which I continued to do after college, when I moved to New York and began working as an editor at *The Paris Review*, a literary magazine that George Plimpton had founded with several others in 1953.

It was at *The Paris Review* that I became alienated from my physical existence, and where we became reacquainted. At our worst, my cohorts and I at the magazine emulated the wasted waif aesthetic of the time, the nineties, and gave no thought to improving or maintaining ourselves physically. We thought of ourselves as living the life of the mind. At our best, we emulated George, who, I now see, was an exemplar of a mid-twentieth-century ideal of vigorous masculinity. He was athletic enough for journalistic stunts like playing quarterback for the Detroit Lions, boxing against Archie Moore, standing in as goalie in a hockey game, and taking a few turns on a circus trapeze, all of which he recounted in brilliantly hilarious books. His was an ethos of play—of recreation rather than training. And so he maintained a strong tennis game well into his sixties; he liked bird watching; he never took a taxi or the subway (let alone drove a car) when he could bike instead. But running or lifting weights, anything that might unduly spike the heart rate or tax the muscles, was out of the question: they would have interfered with the nightly revelry. The most charming of men, George was world-famous as a host. Planeloads of people flew in from every part of the globe for the parties he threw several times a week. And when George wasn't hosting, we—the handful of us, all in our twenties, who worked at *The Paris Review*—followed him like a column of ducklings out into the Manhattan night, to book parties, benefit galas, random birthday parties, intimate soirees, movie premieres, or just to a bar to get sloshed. To a kid from the suburbs, and even to the metropolitan sophisticates among us, who had gone from Park Avenue to Harvard before re-

turning to the city, our life was impossibly glamorous and exciting. We spent our nights seeded among the beau monde of famous writers, actors, TV personalities, politicians, and socialites. And with them we poured gallons of scotch down our gullets; we snorted drugs; we smoked cigarettes and pot. George, however, was not just some empty bon vivant. In fact, he had an ingrained Protestant work ethic: no matter how deep into the night he dove, he always surfaced on cue, waking each morning to put in a full day of writing and editing.

I was less resilient.

For a period, George hosted weekly Friday night tennis matches at one of the clubs he belonged to. Then pushing seventy, he bounced through games with vim, while I, then in my late twenties, was dismayed at how easily winded I became, playing *doubles* no less, a game I'd always thought of as being for the geriatric set. By then a flight of stairs would leave me bent over with a tubercular wheeze; I felt incapable of carrying around much more than a gin and tonic. The reason for my physical degeneration was that for the previous decade I'd lived almost entirely in my head: writing, reading, editing, looking at art, thinking. But also smoking a pack or more a day, drinking every night, and consuming way too many powdered drugs. My body had become a trash depot. Healthy eating meant a burger from the deli rather than McDonald's, or perhaps some green peppers on my pizza. Like many people at that invulnerable age, I gave almost no thought to my body. Or worse, I had a romantic view of my sorry physical state: I was an artist, a bohemian; dissipation came with the role.

For someone so enthralled with thought, I am in retrospect puzzled by my failure to reflect on the basic assumption on which my existence was based—that the mind and body sleep in separate bedrooms, leading their own lives. I might have considered that the

brain is part of the body, that the two are in fact one: if you're treating yourself like a sewer, you're bathing your brain in shit. I've since come to understand that the old canard about choosing between the life of the body and the life of the mind (a bastardized version of the ancient and more valid distinction between the *via activa* and the *via contemplativa*, the active, political life versus the contemplative way) sets up a false distinction. It's a bias based on the assumption that energy expended physically must be deducted from our mental account. Contrary to what I believed in high school, jocks need not be stupid, while eggheads, to the extent that they deny their physical lives, are fools.

In the New York literary world of the nineties, almost everyone—though not George—remained still gleefully stuck in that high school mentality. We thought *physical culture* was an oxymoron (with the emphasis on *moron*—we preferred our *oxy* with *contin*). That's not to say we were inactive: we had endlessly rechargeable batteries when it came to carousing. George had an extraordinary constitution—up to a point. When his lifestyle finally exacted a toll on his health, it was steep: he died at the comparatively young age of seventy-six. But it certainly wasn't only George or my own slide into dissipation that prompted me to consider a change. When the anchorman Peter Jennings, who was a close friend of George and someone in whose excellent company I spent a fair amount of time, was diagnosed with cancer, I had before me the example of an athletic guy felled by cigarettes. And Jennings represented not only New York to me, but also mountain life: he was a strong skier. Several times each year I flew out to Utah and tried to keep up with a posse of hard-core snow addicts, but now a day on the slopes crippled me, battering my legs into useless appendages and burning through what lung tissue I had left.

Eventually my wider circle of friends, people who had taken

heroin chic all too literally, began to succumb to their bad habits. Several close friends died of overdoses; others were carted off to rehab. Each departure left a ghostly residue of questions and bewilderment. Perhaps, rather than living the life of the mind as I had believed, I was in actuality living a mindlessly self-destructive physical existence.

One morning, while trying to manage the trick of power vomiting into a toilet without moving so much as a millimeter, because every twitch was like a hammer striking the gong of my migraine, sending ripples of pain through my limbs and eyeballs, it dawned on me that the state of your body isn't something you either choose to care about or leave be, for your body never just is—it is always either decaying or getting stronger. Not choosing is still a choice.

At the time, you were expected to hit forty like a car in neutral at the top of a long hill with a progressively steeper grade: at first the decline is a gentle roll, but it quickly picks up speed as it seeks its nadir. This was the assumption about aging that obtained in my youth and into my adulthood; it is an assumption that still exists for many of us today. You will drive up mountains instead of hiking them; doubles will replace singles tennis; you will walk instead of run; you will gain fat around your middle; you will take up golf. Or bridge.

Soon after turning thirty, when the deaths of my peers and others in my circle had accumulated like the smoker's phlegm in my lungs, I decided I needed to reverse course, to start running up the down escalator. It occurred to me that I'd never heard of anyone battling the progressive decay of the flesh with a progressive pushback, gradually doing *more* exercise each year, dialing in nutrition a little more precisely. The idea was that drastic life changes, like crash diets, rarely stick—I already knew that from my negative experience with habits. I

knew how easy it was to fall into bad ones, I knew that trying to break them too swiftly was a recipe for failure, and I knew that good ones needed to be knit slowly into the fabric of my life.

What happened to me over the next decade has numerous parallels, albeit on a different time scale, with how the wider culture came to understand fitness. In the 1970s, for instance, people began to shake off the smoking-drinking-drugging hangover of the previous era in unprecedented numbers by joining in the new fad for jogging. Twenty years later, I did the same.

Of course, by that time some things had changed. The terminology, for one: what was once a mellow jog became *running*. Forty years ago, you jogged at talking pace because it was feared that your heart might explode if you got out of breath. If you went too fast, you might destroy your knees or do some other insidious damage to yourself. This argument over intensity could still be heard when, in 1984, Jim Fixx, author of the extraordinarily popular and influential 1977 book *The Complete Book of Running*, suffered a massive heart attack—while running. His death reignited a long-standing debate over whether exercise is actually dangerous to your health rather than beneficial. It turned out that congenital heart disease, not working out, killed Fixx. But he might have unknowingly contributed to the problem. So new was running that many people believed it to be a panacea that inured you to the ill effects of smoking, drinking, and a poor diet—much as people today make wild claims for juice cleanses and yoga. Diet guru Nathan Pritikin reported that Fixx believed he didn't need to concern himself with his diet overly much because running would keep him healthy.

By the time I took up running, however, I was under no such illusions. And yet, like William Hurt in the 1981 film *Body Heat*, I would light up a cigarette to celebrate finishing my morning three

miles. It's not that I imagined exercise would save me from cancer or emphysema; rather, I hoped that it might help me quit smoking. I figured that if I got into a running groove, it would make breaking the habit much easier, since each day without a cigarette would begin with a slightly better, less lung-knifing run.

Not shockingly, it worked. Running and not smoking reinforced each other. What did come as a surprise was the utter transformation that occurred after only a few months of nicotine abstinence—I felt like I'd taken a shower after a long sleep, cleansed and awake. My desire for red meat evaporated, and in its place a craving for vegetables was precipitated; and where once I'd forced myself to run, now I couldn't go two days without it.

Perhaps this sounds merely like trading one addiction for another. And if by *addiction* we mean its colloquial but vague sense of any habit-forming activity, then there is some truth to it. However, one of my aims in this book is to show that there is a far more nuanced, and ultimately more profound, way to understand the widespread phenomenon of the exercise habit. To put it briefly: by swapping cigarettes for running, I had taken a few stutter steps in the direction of what I will call, after the philosopher Peter Sloterdijk, the practicing life. Addiction is just the repetition of a habit; it's the sameness of the repeated act that mollifies us. The practicing life demands one continually reform and reevaluate one's habits as part of a process of deliberately shaping one's existence.

One day you can't understand why anyone would choose to sweat and pant at a way-too-early hour wearing barely any clothing; the next you can't understand how anyone cannot do it. Still, the appeal of running is easy to understand. It's primal: the rush of increased oxygen intake, the satisfaction of pushing yourself, the simple pleasure of

moving through the landscape; it's an expression of something basic in us, the ability to hunt and to flee. I loved running and have never since lost the passion for it. But, as for so many others, it was also the gateway drug to a more holistic training practice.

Running is monostructural: it improves your endurance but not your strength, balance, explosiveness, or flexibility. It might make you skinny, but it won't produce muscles. To be well rounded in your conditioning, it helps to have a gym. But in the eighties, when gyms first began to undergo rapid subdivision to meet rising demand, a global picture of the body's capacities wasn't available. People went, for the most part, to look better, and muscle tone became an increasingly desirable aesthetic trait. If Madonna's sculpted shoulders and triceps in her 1990 video for "Vogue" and Mark Wahlberg's abs in his 1992 ad for Calvin Klein underwear were shocking at the time, a decade later, when I found my way into the gym, such enhancements had become commonplace. Popular culture was beginning to validate a more developed physique than had been acceptable for most of the twentieth century.

I found my way into the gym by way of the swimming pool. A buddy and I had traveled together to a wedding in India. My friend swam laps whenever he found a pool, and because it can be difficult to run in India, I followed suit. At first, fifteen minutes of laps left me sputtering and gasping for air, but as my technique improved and I got stronger, I began to enjoy it. More significantly, blood flowed into and filled the tissues of my upper back, arms, and shoulders as I climbed out of the pool, bearing with it news of muscles I hadn't heard from in many years. Who knew that a little activity could provide so much intimate information? That there are whole parts of you that you've been unaware of, even while carrying them around all your life?

Just feeling my own musculature changed my perception of mus-

cles. Before swimming, my ideal of a male body was super-thin: I can't recall giving any thought to muscles, and if I did, it wasn't positive. Muscles were for lunkheads. Yet after only a few months of lap swimming, of paying attention to other bodies as well as my own, I came to think it might be okay to have some definition in my biceps and abs, though not too much. I'd had an inkling of what strength might feel like and decided to investigate. I also wanted to get better at skiing and backcountry ski touring, the one sport I'd kept up all my life—not that I had any concrete sense of how strength training might help. In the end, I think it was the song of iron itself that lured me into the weight room. I could hear the mechanical clatter from the pool where I swam at my local YMCA and, since I hadn't had any negative exercise experiences to deter me, I ventured in.

I fell for the scene immediately. There was a camaraderie there of people from all walks of life: gay actors; Latino IT guys; accountants; buff men from the projects; the gangsters who joked with the judge; the old men who kept gin and Cinzano in their lockers, which they drank from little paper cups after their soak or sauna, wrapped only in a towel around the waist. And there was the purposeful strain, the rhythm of effort. Since I didn't have money for a trainer and had little idea what to do with the weights and machines, I did what most people do: I imitated those around me. I mimicked the men sidling up to the weight racks, checking themselves out in the mirror as they selected a pair of dumbbells, sat heavily with them, heaved their burdens to their chests, fell back, and began bench-pressing. I trailed them as they continued on to other ways of working their pectoral muscles—bench-pressing with a barbell, inclining or reclining the bench so as to work the upper pecs or the lower part of the pecs. And I proceeded, as they did, from the pecs to the biceps, doing hammer curls and preacher curls and reverse curls. Each muscle or

muscle group had its own exercise and most were on machines. There were ten or twelve such basic movements that people cycled through over the course of two or three days per week; any variation on them was rare enough to be noticeable.

As a novice, I fell eagerly into this routine. At the same time I wondered at what seemed like the halfhearted attitudes of so many of those in the weight room. Almost everyone appeared to rush through their sets, the barbells jumping up a couple of inches from their chests in tentative little hiccups, only to be yanked back again well before the presser's arm was fully extended. Apparently no movement was enjoyable enough to be completed, no range of motion interesting enough to be explored entirely. Just hurry through the row of insectile machines for a brief coupling with each, and get out of there. Or rather than hurry, plod along on the treadmill or Stairmaster or elliptical at a pace too slow to raise a sweat but perfect for flipping through *Us Weekly*. Over time, as I noticed that even those who showed up each day to the gym didn't make any visible improvements, I had to wonder if this was due to their perfunctory attitudes or the cause of them. There were legions of guys who, after twenty halting, grimacing crunches, which seemed mainly about pulling the chin abruptly forward to the chest, perhaps in an effort to strengthen the neck, nonchalantly flipped their T-shirts up in front of the mirror only to find that the layer of fat that had been hiding their abs a minute before their exertions was still hanging around. What brought these people back every day? And was I, who craved the workout more and more each week, one of them?

These observations only generated more questions, in fact a torrent of them. When bench-pressing, should I put my feet up, as though I were afraid a mouse might race across them? When pressing dumbbells overhead is it better to sit or stand? Should I press both dumb-

bells at once or one at a time, as I'd seen some people do? Press quickly or as slowly as possible? All the way up or halfway? Why on upper-body days did everyone start out with bench presses and then move on to bicep curls, lat raises, and seated dumbbell presses? Why did they use the Smith machine when they squatted on their lower-body days? Why are there upper-body days and lower-body days? Why was everything done in three sets for eight to ten repetitions? Who was right, the guys doing cardio before lifting weights or the guys doing cardio afterward? Was the StairMaster or elliptical machine better? Guys in the gym—I asked men because men are more commonly brought up in the world of weights—were really nice about answering my questions, even those who cursed and shouted to themselves while lifting. Sometimes I bothered the trainers, querying why, for instance, one had a client bring the bar only to the top of the neck rather than all the way to the shoulders in lateral cable pull-downs, and he'd respond that this technique would define the upper or lower part of the deltoid muscle more effectively. If I pointed out that logic suggested pulling the bar down all the way to the shoulder, using the full range of motion, wouldn't define the muscle any less but in fact work more of the muscle area, it would be pointed out to me that I am not a trainer.

I also began to question the exercises themselves. How would bicep curls, bench presses, or lat flies help me get better at ski mountaineering? What in the world would they help you do better? I'd never seen anybody make a bicep-curling motion outside of a gym.

It turned out I was far from unique in raising such questions. Others had asked them, too, and some had arrived at concrete answers in the form of what seemed to me entirely original approaches to fitness that were, I was convinced, far more effective than anything I'd heard of. But were they as new as I assumed them to be? Had we been working out the wrong way for thousands of years and only just,

in my lifetime, stumbled onto a better path? These two questions rubbed up against each other in my mind, heating the inquiries that resulted in this book. What I discovered were whole new regions of athletic endeavor.

My purpose here is both to sketch out the topography of these unexplored regions and to trace the cultural processes that have led us to them. Along the way, I'll address a number of themes that recur, for I have found that the history of fitness entails periods of forgetfulness and rediscovery, which gradually move our understanding forward. Those cycles reflect changing bodily ideals that are themselves the products of what we believe the good life to be at any given moment. Through these pages I will track the fortunes of exercise intensity and the discussions about whether or not exercise is healthful; I'll consider why conceptions of fitness have political implications, and I'll examine specific instances of fitness practices in the political arena, primary among them the role of women and how feminism, specifically, has led to a democratization of fitness practices that is still occurring; I'll delve into why people began training for aesthetics rather than for performance; I will register the impact of technological progress on how we perceive the body and how we attempt to improve it; and I will return throughout to the falsehoods and misconceptions of muscle that have characterized the history of fitness. I will also look at how various types of representation, from sculpture to video, give shape to our physical ideals, and I will attempt to paint a picture of the romance of training that has accrued through the centuries. In short, my method will be to scour old maps and documents to locate the new places to which our bodies are taking us.

INTRODUCTION

INTO THE NEW FRONTIER

Some fifteen years ago, around the turn of the millennium, the mirror in which we viewed our bodies was jostled, as if by an earthquake. A questioning of gym routines gathered steam, and we began to see our corporeal selves differently. The upheaval revealed an unexplored region where numerous aspects of physical culture converge: it is, as I named it above, a New Frontier.

We didn't all rush into this virgin territory at once; the voyages began among a tiny circle at the quake's epicenter and radiated out in ever-widening circles across the globe that continue to expand today. Arguably the most influential of that original cluster was Greg Glassman, the founder of CrossFit. Among his enormous contributions to the opening of this New Frontier was the first encompassing and operative definition of fitness, one that allows it to be tracked and measured. But the inspiration for that definition came, in a sense, from outside the gym itself. Then a personal trainer, Glassman was working with people whose lives depended on the shape they were in—police and firefighters and people in the military—and through that experience he came to value functional movements, exercises that mimic things we might do in our daily lives, like lifting something heavy or sprinting away from danger.

The shift to functional exercises consisted of two motions—the first going back to the basics, often historical ones, and the second opening fitness beyond the gym to everyday life. These two motions form the two crucial vectors of fitness in the New Frontier.

When your gaze slips off the mirror and onto how well you function in the world instead, you inevitably shift emphasis away from working out to change how you look and toward physical performance. You don't take up Parkour in order to get ripped, nor does the runway model who starts boxing do so primarily in order to slim down: we engage in such activities in order to become more agile, to get stronger, and to sharpen our mental focus. None of that precludes the desire to have an attractive body—it's just that a particular look no longer motivates the workout. And through this emphasis on performance, New Frontier Fitness is changing our notions of what constitutes an attractive physique, favoring muscle and athleticism in both sexes: it is slowly, though perceptibly, altering the very culture of the body.

Indeed, reshuffling of the circles on the target so that performance occupies the center leads to a number of sequelae. For instance, while you can lose weight (and thus change your appearance) doing exercise with low or medium effort, performance is improved only through adaptations at the cellular level that are brought about through high-intensity workouts. This has led experts who in the past might have advocated against heavy weights to embrace them, as well as the use of competition in workouts.

And although this shift to performance represents a major transformation of ethos in the culture of exercise from the past hundred years or so, it remains debatable whether the turn toward functional fitness was in actuality the catalyzing agent, or vice versa. At issue is the fact that to measure progress in performance, you need to quan-

tify the amount of work you do in a given amount of time—in other words, your power output. As Glassman notes, functional movements "are categorically unique in their ability to express power." And one might plausibly argue that the turn to exercises that are measurable in ergs was an outgrowth of the generalized cultural interest in the data-driven life. But whichever came first, there can be no question that quantifying one's existence—be it through measurable workouts, weighing and measuring food, tracking blood markers, steps taken, or metabolic processes, as well the evidentiary power these provide—is another characteristic of New Frontier Fitness. One might also argue that people just got tired of plodding through the old ground of physique-sculpting workouts and began to seek alternatives.

I n his 1960 speech to the Democratic National Convention, then-senator John F. Kennedy evoked a new frontier "of unknown opportunities and perils," which demanded extending the "Rights of Man" to African-Americans and others who had been denied them. Like Kennedy's political borderlands, New Frontier Fitness represents a democratization of the field, a radical expansion beyond the leisured class of men who have historically had the time and money to afford exercise.

Just as firefighters, police, and military personnel inspired the shift to functional movements, the adoption of them has swept working people of all types into this new arena. And the expansion has been more than just economic: many older people and children have begun training, often in ways and to degrees of strain once thought dangerous. Similarly, there has been an explosion of interest in strength training among women, where previously there had been very little—and this in turn is reorienting standards of beauty, changing society-wide perceptions of what types of bodies are attractive.

And yet this opening up of the borders occurs even as ever-more-visible disparities in fitness make starkly apparent the health consequences of economic inequality: the tiny international tribe of those with the resources to be hyperfit is growing but remains minuscule by comparison with the swelling masses of the chronically unwell.

My cousin Juliet, the weightlifter, would not recognize cultural critic Mark Greif's assertion that "[d]espite the new emphasis on female athleticism, the task of the woman exerciser remains one of emaciation." Greif made this claim in a provocative and widely noted 2004 essay, "Against Exercise," which, ironically, appeared just in time to become instantly outdated. He primarily inveighs against working out solely for aesthetic ends, also taking issue with the resistance contraptions designed to achieve them. The latter is pertinent because people at the cutting edge of fitness had just begun turning away from exercise machines, viewing them as nonfunctional, limiting to one's range of motion, and, by eliminating the use of stabilizing muscles, liable to make one weaker rather than stronger.

More troubling is Greif's assertion, "Modern exercise makes you acknowledge the machine operating inside yourself." His is a powerful, enduring, and yet, I think, lazy metaphor—which still pervades many discussions of fitness today. As Greif himself points out, people have been likening our bodies to machines since at least Descartes. But doing so in the context of exercise goes back a little more than a century, to the beginnings of working out for purely aesthetic ends; to the origin, in other words, of bodybuilding. What the metaphor gets wrong is that no matter how many operations a machine may be able to perform, structurally it remains the same, whereas a physical regime is about change: altering the structure of our bodies as well as our ability to deal with changes, both internal and external. Machines

remain static as they process or produce; fitness is adaptation, change in response to stressors.

The expansions of the New Frontier are not limited to the sorts of people who engage in fitness; they also include a widening of the types of activities, of stressors, those people expose themselves to. If in the past one was a runner or lifted some weights or perhaps did aerobics one day and yoga the next, today's somatic explorers combine an extraordinary range of activities: gymnastics, Parkour, weightlifting, power lifting, sprints, plyometrics, calisthenics, kettlebell sport, swimming, rowing, rope jumping, yoga, and martial arts, among others. Again the exemplar is CrossFit, which combines all of these, and often several at once. Yet New Frontier Fitness (NFF) also addresses nutrition, community, neuromuscular integration, brain health, meditation, visualization, ethics, and emotional well-being. Its manifestations tend, in short, to be holistic.

This is to say that fitness in the New Frontier is not a narrow affair, not something you do for an hour three days a week but rather something that structures your life. It recognizes implicitly that bodies are not like machines, which exist only to accomplish specific tasks, but are complex entities. Another way of thinking about this dispensational swing is that recreational workouts like tennis or aerobics have given way to an all-encompassing athletic mode for many people. Yet by *athletic*, I mean something much older than its ordinary connotation, something that reaches back to the very old frontier of ancient Greek training practices. You don't train aerobics or SoulCycle—these are essentially leisure activities, albeit beneficial, like a weekend soccer league. Of course people have always trained, but only recently—in the last fifteen years—have large numbers of ordinary people all over

the world, with jobs and lives and potbellies, begun training with something approaching the fervor of professional athletes. Their zeal has been similar to pro athletes', but with distinctly different goals: whereas the pro trains for a specific sport, the New Frontier athlete trains for life—to improve how she meets it and to deal productively with its pathos. Like the Greeks, she trains agonistically, competing primarily with herself, sometimes with others—not for a ribbon or cash reward but to be better, to surpass herself. The aim is not just sculpting a prettier body but honing our performance in the world, how we think, how well we interact, how we feel, as well as how we move and how much weight we can lift.

This agon, this competition with ourselves, is not always enjoyable or successful; we will confront failure and losses, and must live with these constantly. Not everyone is willing to venture into the hard life of the frontier.

Just as a soldier or firefighter will drill endlessly to master urban assault, say, or how to save someone cut off in a fire, so we practice the posture with which we face the world, how to sit, how to think calmly and clearly under duress, how to move purposefully in order to move quickly, how to treat those competing against us in any aspect of life, how to be aware of everything going on around us no matter our state of mind. Such a training regimen is best understood as *practicing for life*.

"What happened to you?" asks my friend Alex, whom I haven't seen in a number of years. "You're skinny . . . but bigger. How long has it been?"

"Oh, well . . ."

"You're kind of buff. And I think you look younger than the last time I saw you," she adds.

"Yeah," I reply. "It's the painting hidden in my closet that gets more decrepit with age. I stay the same."

But of course I'm not the same, as Alex has noted. She had known me as a professional egghead and cocktail-party attendee, someone for whom the body was little more than a substrate for the brain and a convenient aperture for introducing mind-altering substances.

"And you're drinking tequila," she points out, as if this might offer a clue to what I've been up to. Which it does. And since I have no self-control when it comes to gushing about my passions, I erupt with a bubbling monologue about how I've stopped eating grains and gluten altogether (hence the tequila), not because I'm intolerant but because I've been training really hard, getting up every morning at five o'clock, biking through dark streets to a CrossFit gym, banging out sets of handstand push-ups, Bulgarian split squats, Saxon side bends, pistols . . .

Alex gives me a stumped look. "Okay, but what are you training for?" she asks.

That is the crux question. If it were as simple as wanting to lose weight or pack meat onto my pectoral muscles or just look good naked, I'd have an easy answer. My reasons, however, are not easily stated: I could say I want to be stronger, faster, more agile, more flexible; that I want to move better and to think more keenly; that I want to counteract aging, to be more at ease in my skin, to have better sex, to function optimally as an organism. I could say that I want to surpass in every way possible the man that I am today and the one I'll be tomorrow, and that my athletic practice is at once a means to these ends and a model for achieving them. But voicing such thoughts is, frankly, kind of obnoxious.

Training for self-improvement or, better, for surpassing yourself

implies the uneasy notion of a hierarchy of achievement. Such ladders are something we in the West are taught to distrust if not disdain. Besting yourself suggests, at least analogically, besting others. And if those folks are getting better, doesn't it mean that others (perhaps you) are stuck in a rut or getting worse?

Or is it that we devotees of self-enhancement are actually just deceiving ourselves? Maybe we're just exercise addicts with a fancy story. Without a doubt some of us are. You can become dependent on the euphoria of exercise, and on the sense of control over your body (a phenomenon comparable to anorexia). Spend some time in a gym and you will meet people who obviously rely on their workouts in unhealthy ways: they don't take rest days; they spread their energy across multiple workouts instead of giving everything they have to one; they train through injuries; they spend so much time in the gym they forget what mountains, forests, beaches, or the sun looks like. Yet those people represent a minority even among exercise fanatics: they occupy the extreme blue pole of the fitness spectrum.

On the brighter end of that spectrum are those who—whether they realize it or not—are committed to fitness as an ascetic art. In ancient Greek, the word *askesis* means training or exercise. Our derivation from it, *ascetic*, denotes austerity or self-denial as a measure of discipline, and it tends to entail a withdrawal, often temporary, from the normal run of affairs. The more committed somatic explorers of the New Frontier embrace an asceticism that harks back to the old Greek forms, a secular stepping aside from the rush of life to train, focus, meditate, learn, and recharge. The underlying philosophical basis for this temporary withdrawal stems from a recognition that, strive as we might for balance, no final equilibrium can exist. Homeostasis is fleeting. We are always either getting stronger or weaker; improving or decaying; learning or forgetting—and the athlete tries to right the

ship daily, keeping it on course through training exercises that allow us to adapt to constantly changing conditions.

It is this marshaling of habits that I call the practicing life, of which athletic training is only one form. Practice regimes have evolved in many forms, from the ascetic life of religion to that of the military to artistic practice, acting, medicine, philosophy, and scholarship—all aim at some type of self-enhancement through training. But athletic practice holds special interest for us because it forms the basis for all the other types that followed—it is the one originally designated by the word *askesis*. While artistic, military, religious, or musical practice regimes are all voluntary, we are born into the regime of the body: we can ramp up our training or let it lapse, but we are always practicing some sort of fitness regime, be it sitting or gymnastics. Thus athletic practice serves as a pattern for the shaping of our lives, continually. For once we progress beyond the limited goal of merely shaping our bodies, we stop acting as if we were machines with a single purpose and instead begin aspiring to expansive ideals. We begin practicing an artistry of the self.

1

THE INNER STATUE

Popular or stereotypical images of gym rats are not hard to conjure: the meathead, bulky in his sleeveless T-shirt; the lithe lady in Lululemon who alternates yoga with running days; the chiseled Greek god. Few, I think, would imagine this other, arguably more common type: the fiend (muscles optional) hunkered at his computer gorging himself for hours at a stretch on "workout porn." No, our little beast is not putting himself through any single-hand exercises, he's just watching workout videos with the same obsessive attention usually reserved for porn. His or her (and there are many women) interest is not especially prurient, although the videos do pack a certain erotic charge. Rather, devotees compulsively click through these videos in search of inspiration and the beauty of the accomplishments of the athletes in them.

Today's online workout porn videos are direct descendants of the VHS aerobics tapes made by women in the 1980s—most famously Jane Fonda—who were the first to employ the new technology to disseminate the gospel of exercise. Back then entrepreneurs like Judi Sheppard Missett began making tapes as training tools for aerobics instructors, though it was Fonda, marketing the tapes to average women so they could follow along at home, who caused the

phenomenon to blow up. In the years since the turn of the century, the ease of producing and accessing videos has allowed fitness practices in the New Frontier to spread faster, more extensively, and in many more different forms than their predecessors did. And though many of these videos are instructive, most workout porn depicts training or competition at a level the average viewer couldn't hope to achieve. They are friezes in motion, picturing an ideal. Yet the models they present for us, the models we strive for, are only at times and incidentally perfect physical specimens—sometimes they are and sometimes not, and often they're too covered for us to know. We watch these videos for the beauty of the athletes' performance, not necessarily for their bodies (although that undoubtedly happens, too).

For example, one evening as I wallowed in the video stream, I came across a short film with a sequence of CrossFit athlete Ben Smith practicing snatches in his parents' garage, which he and his brothers had transformed into a gym. A boyish young man of about twenty, Smith crouches down, grasps the barbell at each end with as wide a grip as possible, and explosively stands, heaving the barbell up; then, at full extension, he drops his torso down again to catch the weight in a full, deep squat before standing with it to a fully locked out position overhead. Although Smith performs his lifts with the easy grace of an elite competitor, one who, several months after emailing with me, won the CrossFit Games, there's nothing dramatic or titillating about this sequence, nothing to immediately explain why it's been viewed more than 350,000 times, including several by me. Smith, a recent college grad with a degree in chemical engineering, is quiet and unassuming on camera. He does not display his muscles; instead, he wears a black Rogue Fitness T-shirt and red shorts; and the space he's in is undistinguished—a white refrigerator, a pull-up bar,

some weights and racks—except perhaps for the word *areté* spelled out vertically in large black-tape letters on the wall behind him.

When I first noticed it, the word made me straighten up a bit in my chair: classical Greek ideals aren't usually the preferred inspirational slogans for twenty-first-century kids. But it makes some sense for an exemplar of New Frontier Fitness like Smith. Although in ancient Greece the meaning of *areté* changed over time, at the high point of Athenian democracy it signified an excellence combining nobility of action and intellect—with *noble* in both cases carrying distinctly moral overtones. *Areté*, writes the great German classicist Werner Jaeger, "was the central ideal of all Greek culture." And that ideal, Aristotle tells us, could only be expressed through a unity of body, mind, and soul. It might be proven on the battlefield or, more commonly, in athletics.

Areté, in a contemporary setting as well as in the ancient context, is very different than trimming down or looking good naked or even just getting healthier—the predominant goals of exercise since well before Jane Fonda began putting out her videos. Smith put the ancient Greek word on his wall as a reminder, he tells me, to strive "for excellence in whatever you do in your life, whether it be sports, training, work, personal relationships, etc." His use of *areté* makes explicit a critique of earlier training methods, one that is implicit in all New Frontier Fitness practices: working out ought not to be merely about sculpting the body and making it conform to the dominant aesthetic, but rather it should be about enhancing the mind, soul, and body. This becomes clear in the video, where Smith isn't trying to pump up his biceps or etch his abs into a six-pack (the snatch being about speed, flexibility, and most important, neuromuscular integration—building the brain and muscles simultaneously); he's exploring what he is capable of physically, how well he can perform.

Ironically, though we might look to ancient Greece as a deep

source of this recent, New Frontier notion of holistic fitness, it is also the source of our standards of physical beauty (or, rather, male beauty; the female side is more complicated) that many hit the gym in hopes of achieving or approximating.

A muscled warrior-athlete in midstride, the *Doryphoros*, a sculpture by the ancient Greek artist Polykleitos, exemplifies an abiding Western physical ideal of masculinity—which is to say, pecs and abs worthy of an armored breastplate and a deep inguinal crease. He wears nothing but a smirk of lofty disdain. The work is a model of *contraposto*, or counterbalanced poise, his hip cocked and weight shifted to the right leg, while his left hand is raised to hold a spear or javelin. We don't know exactly what he held because the only extant versions of the statue are marble Roman copies of the original Greek bronze, the best one found in a *palaistra* (gymnasium) in Pompeii. *Doryphoros* means spear-bearer, but that name was given to the work by the Romans. Greek warriors didn't fight naked, but athletes were portrayed in the nude by ancient sculptors. Polykleitos's equally famous *Diadumenos*, known to show a young athlete tying a fillet around his head, was similarly unclad. Athletes were represented in the nude in ancient Greece because male citizens trained completely naked in a *gymnasion* (*gymnos* in Greek means nude, and from it our word *gymnasium* is derived).

The treatment of the musculature—the way the skin sags slightly onto the right kneecap under the weight of the quadriceps, the relatively demure biceps, the thick, doughy spinal erectors on his lower back—in short, the naturalism of the *Doryphoros*, and of the *Diadumenos*, too, strongly suggests that Polykleitos used actual men as models. You don't imagine a physique like the *Doryphoros*'s; you encounter a hundred versions in the *gymnasion* while watching men wrestle,

sprint, lift heavy stones, jump, and do other basic functional movements that build such a lean and well-cut body. What is fascinating is that, though the sculpture is likely based on observation, we know too that its proportions conform to a purely abstract, mathematical ideal, which Polykleitos enumerated in a text called *Canon*. Because the text itself remains lost, known to us only through citations by later writers, we don't know the exact proportions stipulated by the *Canon*. Scholars do agree, however, that the *Doryphoros* was the companion to

A Roman copy of the statue known as Doryphoros *by Polykleitos.*
(Courtesy of Jerry/Flickr)

the work—the teaching model, as it were—from which other artists could learn the principles of sculpting an ideal figure. The *Doryphoros* was the "epitome of Measure," the archaeologist Andrew Stewart writes. "Its body was perfectly proportioned according to a formula that related all its parts mathematically to one another and to the whole."

That the finest body might have been hewn according to mathematics marks the first known instance in the long history of fitness of the fixation on measure, or data. "Perfection," writes Polykleitos in the *Canon*, "comes about little by little through many numbers." And numbers rule us still, perhaps more than ever. Measurements and data have directed our aspirations through the centuries, from the weight-lifter's tallies of kilos, sets, and reps, to the 1970s jogger's concern for how far she can run in twelve minutes in the Cooper test, and on to today's biohacker's fussing over his blood markers.

I f for Polykleitos the *Doryphoros* represented a mystical set of pro-portions, the average Greek citizen saw in him something else entirely. The work belongs to a long statuary tradition in which victorious athletes were viewed not only as heroes but also venerated as gods or demigods, with Herakles being the exemplar of this shift to divine status. Thus, to our Greek viewer, the *Doryphoros* was at once an image and symbol of greatness, embodying the qualities to which citizens were urged to aspire: self-mastery, discipline, and strength, all manifested in a proportionate and exquisite physique. He is, in short, beautiful—to contemporary as well as ancient eyes. Yet for the Greeks, beauty had more expansive connotations than it does for us—it entailed goodness. And, as was the case with any statue of a hero-athlete, the *Doryphoros* would have manifested an exemplary form of beauty, *kalokagathia* (which combines the words in Greek for

beauty and *goodness*), which Jaeger defines as the "highest unity of all excellences," the peak form of *areté*.

This is rather different than the way we see great athletes now: though we often worship them, we generally don't credit them with the highest ethical standards.

We also have a much broader—looser, we might say—conception of physical splendor than the Greeks, for whom the body, and the trained body in particular, was central. As Aristotle makes clear, beauty for the Greeks always "implies a well-developed body: i.e. small people can be neat and well-proportioned, but not beautiful." In ancient Greece, hero-athletes became divine, while the gods themselves were always athletes, too, the reason being that the Greeks so revered the perfected human form that they felt it provided access to the divine, that it partook of divinity. Thus to a Greek citizen encountering the *Doryphoros*, the statue would have spoken to him with the authority of a god, urging him to emulate its perfection. And many did. Among the numerous contests held in Greek city-states was the *euexia*, a test of "bodily condition" with criteria such as symmetry and muscular definition—and these were not unlike our physique contests (as opposed to bodybuilding pageants, since the steroidal physiques presented there are well outside the mainstream).

The physique of Polykleitos's statue remains very much within the mainstream. For the last five hundred years or so, at least since the Renaissance, the West has set its standard of male beauty in the mold of such Greek statuary as the *Doryphoros* and the *Diadumenos*. Still, during the entirety of those five centuries, that standard remained largely an unattainable ideal. Even as recently as 1997, Stewart could claim that the *Doryphoros* reduces us, the audience, to the role of masochistic voyeurs, "who can look and envy, but little more." What a difference two decades makes. Today, explorers of the New Frontier

see the statue with something like Greek eyes, as an attainable ideal. So rather than merely gawking in wonder at the statue's physique, as people have done for centuries, a viewer today may very well see it as a Greek citizen did, as an advertisement for collectively held values, one admonishing: *Get yourself into the gym.*

What changed in the decades since Stewart's remark is that people—both men and women—completely reoriented their approach to fitness, aligning it far more closely with that of the ancient Greeks. The most obvious of those changes is that average people, the viewers of exercise videos like Ben Smith's and of statues like the *Doryphoros*, are training like athletes, many days per week and at high intensity (by which I mean both the fervor with which one exercises as well as the use of heavy weights). But what occasions the rise in frequency and intensity is an embrace of training as the basis of the practicing life, of seeing life itself as a challenge for which one must train, mentally and emotionally as well as physically—and this is a shift I will trace throughout this book.

Although the Greeks honored the gods, they worshipped only two things: the Logos (reason) and the human form. Like the poles of an electrical circuit, these were inextricably connected, the one ineffective without the other, a fact that was reflected in the key institution of classical Greek society, the *gymnasion*. So central was it, in fact, that any Greek settlement that lacked a *gymnasion* was not considered a city. This was a place both similar and significantly different to our gyms: the Greek version functioned as a place to train the mind in the techniques of reason as well as the body. In Athens, the three great *gymnasia*—Plato's Akademy, Aristotle's Lykeion, and the Cynosarges— were also the sites of the era's three major philosophical traditions, directed by philosopher-athletes. These institutions produced important

thinkers, politicians, poets, and playwrights, as well as great athletes. The intellectual work took place in the exedra.

For the moment, however, we'll restrict our view to the center of the *gymnasion*, the central, open-roofed, square courtyard where people worked out (many *gymnasia* had a second building, the *palaistra*, or wrestling gym, but over time the two words came to mean the same thing—and I use them here interchangeably—the way for us *gym* and *health club* tend to refer to the same thing). It had a dirt or sand floor, which was surrounded by changing rooms where an athlete stripped down and, depending on the day's activity, often tied off the foreskin of his penis before anointing his entire body with olive oil. We don't know exactly why either was done. Tying the foreskin might have prevented erections in the decidedly homoerotic atmosphere of the *palaistra*, prevented injury, or possibly improved performance (although I have no idea how, and I myself am unable to conduct such experiments). The oil would have burnished one's physique and may have protected the nude athletes from the elements, such as the cold or the sun; it may also have had religious significance, as anointing with oil is a common rite in many religious traditions. It is a testament to the importance of the gymnasium that among the very few personal items archeologists find in Greek grave sites are the *aryballos* (one's personal oil flask) and strigil (a slightly curved length of bronze used to scrape oil and dust off the athlete after he was finished working out).

In his dialogue *Anacharsis*, the Greek writer Lucian describes a fictional foreigner's visit to a *palaistra*, where he encounters men "grappling and tripping each other, some throttling, struggling, intertwining in the clay like so many pigs wallowing." These, naturally, are wrestlers, and in addition to them, a visitor would have found boxers facing off with their fists wrapped in leather strips; men practicing

at *pankration*, a combination of boxing and wrestling, not unlike to-day's mixed martial arts; men tossing javelins, while others crouched, whirled, and sent a discus spinning through the air; he would have found naked youths lining up to sprint the stade, which was one stadium length (about 200 meters); and others trotting out multiple stades, for something very close to a 5K run. This was the only distance event in ancient Greece or Rome; there was nothing remotely as long as a marathon at the Olympic Games or any such competitions. In fact, the original run from Marathon never occurred—it was a story concocted hundreds of years after the battle of the same name. The first Olympic distance marathon of twenty-six miles took place at the 1908 games in London, and its length was determined by the distance from Windsor Castle to London's Olympic Stadium.

In addition to the runners, wrestlers, and boxers, our visitor would have encountered men grasping in each hand bronze or stone weights shaped like a U or a dumbbell, known as *halteres*. The men would have taken several steps and, throwing their weighted hands forward, would have leapt into a long jump. The *haltere* helped the athlete fly farther. They were not used for resistance training, as dumbbells are today, though the Greeks did build strength with weights. Generally they lifted or threw large stones. Two were discovered not far from Olympia: a rectangular stone weighing about 100 pounds (45 kg) with the inscription, "I am the throwing stone of Xenareus," and another, a large block of red sandstone weighing some 315 pounds (143 kg), which bears a spiral inscription, "Bybon threw me over his head with one hand." Both are credible implements. In the World's Strongest Man contest, competitors lift a series of spherical concrete Atlas stones weighing between 220 pounds (100 kg) and 352 pounds (160 kg), while fitness athletes routinely loft 100-pound medicine balls over their shoulders. Less credible is a huge stone found on the

island of Thera, weighing 966 pounds (438 kg), with the inscription, "Eumastas, son of Kritobulos, lifted me from the ground."

Milo of Kroton, winner of six Olympiads in wrestling and the greatest strongman of antiquity, preferred animals to stones: supposedly he once heaved a four-year-old bull on his shoulders, carried it around the stadium, then butchered it and ate the entire carcass by himself. Legend has it Milo trained for such feats by lifting the animal each day from the time it was a calf, getting progressively stronger as it got larger.

G reek athletes strove not only to be strong or jump far, but to be the strongest, jump the farthest. Competition permeated their society; it structured every aspect of the *gymnasion*. The word *athlete* itself means "one who competes for the prize." Not for *a* prize, because there was only one. At the games, and there were others besides those at Olympia—at Delphi, Nemea, and Isthmia, for example, there were no team competitions, and there was no award for second place. You were either the victor or an ignominious loser, as the poet Pindar indicates in one ode dedicated to a victorious athlete: For those you defeated:

> there was at Delphi no decision
> for a happy homecoming like yours,
> nor did happy laughter awaken pleasure in them
> as they ran home to their mothers.
> They slunk through back alleys, separately and furtively,
> painfully stung by their loss.

Honor, the prize of *areté*, accrues only to winners.

By contrast, the modern Western legacy of competition is far more

ambivalent: the free enterprise system and the American and British legal systems are all driven by competition, and sports fandom is still a prime leisure pursuit, yet we hedge our adversarial zeal with the reassurance that what really matters is "how you play the game." And although our reluctance to divide the world so neatly into winners and losers surely represents an ethical improvement, it bespeaks a further case of mixed feelings, over how much pain is worth enduring and how much fervor is prudent, or seemly, to bring to exercise. In the West we pay lip service to suffering—"no pain, no gain"—and extoll the value of hard work, while at the same time we reach for any laborsaving technology available, especially exercise machines and pills that promise pain-free gains; we pop painkillers by the handful; we'll endure surgery rather than modify our eating habits to lose weight—in short, we'll expend enormous amounts of effort in order to avoid effort.

Surely there have always been people who courted difficulty, who embrace struggle as a point of honor—and they are always in the minority. One intriguing aspect of New Frontier Fitness, however, is the widespread embrace of suffering for something other than religious reasons.

Among the Greeks, valorizing struggle and pain was closely related to *areté* and their need to be first among men. "No toil, no honor," writes Lucian. "He who covets that must start with enduring hardship." What our typical Greek citizen saw when he came across a statue like the *Doryphoros* was evidence of that struggle; beauty and goodness are identical in him because he has toiled to look the way he does. Even his muscles—especially his muscles—signal this effort; they are, according to Stewart, "achieved. They bespeak the *pónos* or labor of long training and conditioning, suggesting that a man can improve what heaven has given him. They proclaim their bearer's self-

discipline and potential to achieve more, and implicitly put down the less strongly muscled: other men, and women. They signal success in the battle of life." Life is a competition, and they who succeed are made beautiful by the hard work of doing so.

E very couple of months I find myself in a place few go to willingly: facedown in a spreading delta of sweat after a workout, in so much pain that for a few seconds I actually cannot speak; I twitch and writhe and pound the floor waiting for the endorphins to kick in and the pain to ebb. This type of suffering can be emotional, it can make you want to weep; some people vomit or piss themselves as the waves of ache slap them down.

After the slobbering stops and I'm able to raise myself at least to my knees, I often reflect (thinking at this point being more feasible than moving) on how rare it is for any of us who live comfortable lives to experience such acute agony. Admittedly, this extreme of suffering is not at all a daily experience for me and my tribe. Yet how strange that there are tens of thousands of us in the New Frontier who repeatedly chase this terrible sensation.

We don't do it because it's fun or in any sense pleasant; rather we do it because it's instructive. Not only does this apex level of hurt produce physical changes that make you fitter, it produces mental adaptations that are ultimately more important: you learn that your perceived pain threshold is an illusion, that you're stronger, mentally and physically, than you had believed, and that the normal discomforts of exercise, not to mention of quotidian existence, are laughable by comparison. But there seems to be in most cultures a deeply rooted aversion to these sorts of experiences: they're seen as dangerous, extreme, and the desire for them weird. Even reaching the routine breathlessness and muscular distress of a CrossFitter completing sets of heavy

deadlifts and twenty-four-inch box jumps for time, a free runner's course of cat leaps and backflips off walls, or a playground gymnast's execution of a flag (holding your entire torso and legs horizontally off a pole) is uncommon today for all but a small, though growing percentage of the exercising population.

Suffering, be it just uncomfortable or to a tongue-biting degree, is the result of working the body at high intensity, a notion that, even before the Greeks adopted it, was largely disreputable and since then has been at best controversial. But for the Greeks pain from effort was in itself a beauteous thing: the process by which the *Doryphoros*'s muscles were achieved was as valued as the results. "By means of beauty all beautiful things become beautiful," says Socrates. The beautiful means is training, and the painful labor entailed by it makes training a romantic endeavor, a heroic endeavor. Indeed, one of the prizes an athlete could win at the games was for *philoponia*, or "love of training." The very existence of such a word speaks to how common that love was, while the numerous scenes of training depicted on vases and drinking cups attest to how highly Greek society esteemed the work of the *gymnasion*. It wasn't something only for youths. Plato in the *Republic* asserts that athletic training should begin at a young age, and that "it should be careful and should continue through life." And he goes on, here in a more romantic vein, to say it's not that the body improves the soul, but rather through training "the soul, through her own excellence, improves the body as far as this may be possible."

This notion that the pain and labor of training enhance the soul, and thus the whole person, never really disappears from Western culture, yet we'll see as we go on that *how* people train changes over the centuries, from monkish austerity in early Christianity to artistic asceticism in the early nineteenth century. The romance of physical training remained alive in certain traditions, like the military, for in-

stance, or among traveling acrobats and strongmen, but mass culture didn't rediscover it until the 1970s. At that point the allure and fascination with training begins to ripple out in shock waves as the notion that everyone ought to exercise takes hold in mass consciousness. We see the value and aura ascribed to training in the success of books like *The Joy of Running* and in numerous cinematic vignettes, from Rocky Balboa running through the streets of Philadelphia to inspirational music and later, in *Rocky IV*, carrying logs through deep snow, to Yoda putting Luke Skywalker through rigorous mental and physical exercises in *The Empire Strikes Back*. By the 1990s, women get into the action, with the bald Demi Moore doing single-arm push-ups in *G.I. Jane*, and a few years on with Uma Thurman as Beatrix Kiddo lugging buckets of water up a long, steep stairway under the tutelage of Pai Mei in *Kill Bill*. Today, tens of thousands of videos, not to mention numerous podcasts, online shows, and even Web channels have sprung up, all devoted to *philoponia*. The romance of training has blossomed into a spreading love affair with the life of physical practice.

But what's the point? To what end do we train and eat right and get enough sleep and learn new physical techniques and then relax by watching other people doing these things? One answer is, as for Ben Smith, to recover a kind of *arête*, an intellectual-ethical-physical excellence, perhaps as a sort of rebellion against the dominant forms of striving—for money or fleeting celebrity. But precisely what this higher striving means can only be elucidated by returning again to the source.

One of (if not *the* only) surviving portrait busts of Plato comes from a herm, or square pillar, from his *gymnasion* and presents him adorned with an athletic victor's ribbons—as an athlete, not as a

philosopher. Then again, the latter would have been a novel, even unheard-of designation at the time, for it was Plato himself who invented the word *philosophy*. According to Peter Sloterdijk, "The word 'philosophy' undoubtedly contains a hidden allusion to the two most important athletic virtues, which enjoyed almost universal popularity at the time of Plato's intervention. It refers firstly to the aristocratic attitude of 'philotimy,' the love of *timè*, that glorious prestige promised to victors in contests, and secondly to 'philopony,' the love of *pónos*, namely effort, burden and strain."

Why *philosophy* might contain within it references to athletic virtues is suggested by Plato's teacher and main protagonist, Socrates, who is fond of repeating the Delphic maxim "Know thyself" in his effort to teach the importance of the examined life. In the *gymnasion* one comes to know oneself through oneself. What is training in the gym, if not a daily inquiry into what and who we are? It is there that we learn how much pain we can endure, what our weaknesses are, what our strengths are, where our fears lie, and how we might face them; we learn the meaning of discipline, of measure, of perseverance, of change, of balance. This is the romance of a life of athletic practice: that the body becomes a medium of knowledge through which we might understand ourselves and the world. This too is another way that in ancient Greece beauty is invested with moral goodness, for in perfecting his appearance through training the athlete is also studying himself, examining his life.

To our ears, conditioned by some two millennia of Christian theology, discussions of self-regard and self-enhancement sound like pride, narcissism, and vanity. Whether we are believers or not, we can't escape the palpable sense of discomfort that attends such talk. As Jaeger puts it, "Christian sentiment will regard any claim

to honour, any self-advancement, as an expression of sinful vanity. The Greeks, however, believed such ambition to be the aspiration of the individual towards that ideal and supra-personal sphere in which alone he can have real value." By bettering himself, Aristotle tells us, the truly good man, the man of highest *areté*, is thus better able to serve others: his self-love is noble because it is motivated by the highest part of him, which is reason (as opposed to sensuality, greed, and the like). "And just as in the case of the state," Aristotle writes, "the most authoritative part is considered to be most truly the state or body." In other words, the body is an analogue of the state, in that both function best when ruled by reason; but also the trained citizen, driven by self-love to be strong, fit, and mentally keen, will serve the state better than the untrained citizen. Because of this, the Greeks considered regular attendance at the *gymnasion* to be a civic duty, not merely a personal benefit. It was a duty, too, because every Greek citizen was also a soldier in the military.

There was in fact an even more profound sense in which the body was considered an analogue of the state. To return to our example of the *Doryphoros*, its physique manifested what the Greeks called *isonomia*, perfect balance and symmetry. The first known use of the word has been attributed to Alkmaion of Kroton, who said that the human body maintains its health through *isonomia*, by which he meant an equal balance between the powers of moisture, dryness, heat, and cold. It is no accident that the city-state of Kroton was both a great athletic center (Milo, one of the greatest competitors, hailed from there) as well as one of the earliest democracies, for the underlying basis of that form of government was—and is today—*isonomia*, here meaning equality before the law. Thus the perfectly trained body was an image of the perfect state. Says Stewart: "the *Doryphoros*'s close-knit, apparently impenetrable muscles symbolize the robustness and

physical inviolability of the citizen body and therefore of the *polis* as well." It is no wonder, then, that the popularity of athletics in Greek society corresponds to the historical rise of Athenian democracy, and declines with it.

As Lucian says, with slightly satirical hyperbole, you suffer in the gym in order to win at the game of life, the rewards of which are not only honor but also freedom: "There is another contest in which all good citizens get prizes, and its wreathes are not of pine or wild olive or parsley, but of complete human happiness, including individual freedom and political independence, wealth and repute, enjoyment of our ancient ritual, security of our dear ones, and all the choicest boons a man might ask of Heaven. . . . They are provided by that contest for which this training and these toils are the preparation." Attendance in the *gymnasion* improves our society by bettering us.

It is important at this point to note that a Greek citizen was always a freeborn male and nothing but. Neither slaves nor women were citizens; they could not vote, were not educated, and could not attend the *gymnasion*. Women couldn't even peek in, and attending the games was strictly forbidden, as the ancient travel writer Pausanias explains: "As one goes from Skillos down the road to Olympia . . . there is a mountain with high, very steep cliffs. The name of the mountain is Typaion. The Eleans have a law requiring them to throw off these cliffs any women discovered at the Olympic festival." It was because men trained and competed in the nude that women, even aristocratic women, were barred from the festivals and from the *gymnasion*.

Nevertheless, we know that women did train and compete—and because of their importance to the state, it's not difficult to understand why. In the exceptional case of Sparta, women worked out (in the nude, as long as they were virgins), competed, and were educated

just as men were. According to Xenophon, the Spartan lawgiver Lykourgos, "thinking that the first and foremost function of the freeborn woman was to bear children, ordered that the female should do no less bodybuilding than the male. He thus established contests for the women in footraces and in strength just like those for the men, believing that stronger children come from parents who are both strong." Or, as Plutarch reports Gorgo, the wife of King Leonidas, saying, "Only Spartan women rule men. Only Spartan women bear men."

Beyond Sparta, in Athens and other city-states, women certainly swam recreationally, and we know they trained to some degree and had their own competitions, in running particularly, though we have only fragmentary evidence of the exact nature of these contests. Still, Greece was a strongly patriarchal society, and women's roles were always constrained. Their *areté* consisted of their beauty, and the Greeks held beauty contests at various games, as they did for men. So in this sense, too, Greek athletics was a mirror of their democracy, since theirs was a narrow and highly exclusionary democratic as well as physical practice.

Like so many aspects of Greek culture, the importance of athletic training to the health of the body politic is a notion that recurs intermittently in other societies throughout history. But there's an illuminating paradox to how training is woven into civic life: it is at once an outward and a profoundly inward pursuit, critical to the health of the body politic and yet a withdrawal from the affairs of men. Like the Cynosarges, the Lykeion stood as an enclosed grove just outside the Athens city wall, apart from the rush of commerce and politics. Although a place for hewing citizen-soldiers, the *gymnasion* was also a place to look inward, to commune with oneself, body and soul; it was a womb of sorts, where the public man could gestate. And

as we'll see later, that dialectic of worldliness and interiority becomes even more explicit in New Frontier Fitness, where the retreat of athletic training becomes practicing *at* life.

For the moment, however, it's worth noting that, even for those not taking part in them, athletics provides a haven from quotidian cares. The various contests and games served as a primary source of entertainment for the Greeks, as did the activities of the *gymnasion* itself, with its host of nude, muscled young men. Like today, homosexuality was a part of gym life, although in Greece explicit affection between men in that context was accepted to a far greater degree than it is now, and we can assume a certain amount of open gawking occurred even in the *palaistra*. As a place set aside from daily cares, and for aristocrats who had time, the *gymnasion* was associated with leisure, the word for which in ancient Greek is *schole*. What we call *scholarship* was just one of the ways one could use one's leisure time. Meeting and looking at young men was another. If you were to loiter about the *gymnasion*, there would be plenty of delights to behold—which is to say, the Greeks had their own version of workout porn.

All these sights, be they the *pankration* or pentathlon at the Olympic Games, the oiled youths at your local *gymnasion*, or one of the multitude of exquisite statues of athletic heroes one might encounter, served (in one respect) a similar purpose, which was to stimulate aspiration. Of the crowds of men attending the Games, the guide in *Anacharsis* explains, "we think it will increase their keenness for exercise." And, he continues, the spectators "depart with a passion thus engendered for toilsome excellence." A sculpture like the *Doryphoros* played much the same role: it too ad-

monished the viewer to better himself, to struggle on that ladder of self-ascension, or what Nietzsche would later call self-overcoming. Greek images of ideal male forms were not simply artworks to behold or worship, they were the outward embodiments of something each citizen carried within himself—an ideal inner statue that we must work hard to reveal.

2

BUT IS IT GOOD FOR YOU?

In 2007, the American College of Sports Medicine inaugurated the global initiative Exercise is Medicine, touting the preventative and curative benefits of working out to doctors and other health-care professionals. What is astonishing about this effort is not that doctors came together in such an endeavor, but that it took hundreds if not thousands of years to agree on its basic premise. Large enough numbers of doctors have been wary of, if not hostile to, exercise for centuries; the few who have embraced it stand out. As early as 1769, the Scottish physician William Buchan wrote, "exercise alone would prevent many of those diseases which cannot be cured, and would remove others where medicine proves ineffectual." And yet a full two hundred years later it seems doctors had failed to get off the couch and actually do something. "There is growing evidence on the preventive value of exercise," notes Dr. Peter Karpovich in 1968, adding, "It is possible that, in the not too distant future, physical education will become a part of medicine."

One reason for the blindness of the medical community to exercise is that it is, like many cures, simultaneously a poison and a remedy. In fact, it is the destructive aspect of exercise that causes us to get fitter, a process known as hormesis, which is a desirable

biological adaptation after exposure to nonlethal (and not overly destructive) levels of a stressor.

Still, this is no excuse, for we have had ample time—not two hundred years but well over two thousand years—to determine that working out is, by and large, beneficial to one's health. The notion was first propounded around 600 BCE by Susruta, a physician of the Indus River civilization, who wrote, "diseases fly from the presence of a person habituated to regular physical exercise." He advocated such activities as walking, jumping, swimming, riding, and perhaps wrestling—and that *perhaps* is key, since it is Susruta, too, who, at least in the written record, inaugurates the skepticism toward especially vigorous exercises, like wrestling, that will predominate in the cultural consciousness of both the East and West for the next 2,500 years and continues to do so, challenged but enduring, today. Although he recommends that exercise "should be taken every day," Susruta warns that one's effort should only be at half capacity, because strenuous or heavy workouts "may prove fatal."

Bear in mind that Susruta originates the idea of exercise as medicine more than a century and a half before Hippocrates, the exceptionally influential ancient Greek physician who also advocated it. Moreover, Susruta was already heir to a long tradition of athletics, for while they stand out for their devotion to the *gymnasion* and their veneration of the developed human form, the Greeks were not the first ancient people to take up exercise. In fact, from the diversity of the phenomenon, we can assume that as long as there have been bodies, people have found ways of exerting them for strength, for endurance, and in entertaining spectacles.

More than a thousand years before the high point of Greek culture, warriors and wrestlers in ancient India wielded heavy maces and

stones in order to build strength. We know, too, that in China, during the Western Zhou Dynasty (1066–771 BCE), archery was practiced and heavy tripods and cauldrons lifted; in Egypt, tomb paintings indicate that, at least among the elites, swimming, running, wrestling, boxing, and the hoisting of heavy objects were commonplace. Medieval sources date the Irish Tailteann Games back to 1829 BCE. The participants in this annual festival, originally begun as a funerary celebration (and thus comparable to Greek funerary games, like those held by Achilles for Patroclus in the *Iliad*), competed at open-air fairgrounds in such events as stone throwing, high and long jumping, spear or javelin throwing, wrestling, archery, and the wheel feat (or *roth-cleas*): spinning with and then throwing, for distance, an axle with an attached wheel.

Beyond these typically vigorous activities, some ancient cultures employed breathing exercises to promote health and fitness. In China, for instance, breath control was practiced as early as 2600 BCE. Interestingly enough, among the Egyptian tomb paintings are images of men in a lotus or Padma asana (cross-legged) pose, which today we would associate with yogic breathing practices. Yet while cultural intercourse between India and Egypt was likely in the ancient world, the very scant textual references—only a few lines—in the Indian yoga literature that refer to breathing exercises are from much later, the third and fourth centuries CE. And, as I'll discuss in chapter 7, what the Western world understands as yoga, with its fitness-oriented series of poses, is a very late development, one that doesn't really gel until the mid-twentieth century. But Daoyin (or Tao yin), a series of postures and breathing practices developed in China, dates at least back to the first part of the early Han Dynasty. The *Daoyin tu* painting, a sort of ancient exercise chart from 168 BCE, depicts forty-four exercise postures, each meant to cure a specific illness.

ontinuing in Susruta's footsteps, Hua Tuo (circa 140–208 CE), a Chinese physician, accepted the notion that the "body needs exercise. By moving about briskly, digestion is improved, the blood vessels are opened, and illnesses are prevented." Yet he too remained apprehensive about how much anyone might be able to take, warning, "it must not be to the point of exhaustion." Hua's prescription consisted of movements adopted from Daoyin and formalized into routines he called the Frolics of the Five Animals, in which one walks like a bear, stretches the neck like a bird, and also imitates tigers, deer, and apes. Nonstrenuous combinations of breathing, bending, stretching, and various postures, the Frolics are considered precursors to the dancelike, or soft, martial art of tai chi.

Also active in the second century CE, the Roman physician Celsus recommended an equally low-stress approach to what he would have called *curatio corporis* (treatment of the body). For him, walking, running, military drills, and even reading aloud counted as exercise, but he counseled never to go hard enough to cause sweating.

So by contrast with the earlier Greek veneration of struggle and thus intensity, these physicians represent a tendency toward what Michel Foucault identified in the classical world as "an increase of apprehension" about the body, especially regulating and caring for it. People are seen as physically vulnerable: gymnastics are not recommended for older adults, and even for younger people and healthy adults there is an anxiety that takes the form of, in Foucault's words, "fear of excess, economy of regimen, being on alert for disturbances, detailed attention given to dysfunction, the taking into account of all the factors (season, climate, diet, mode of living) that can disturb the body and, through it, the soul." The doctors emphasize the need for moderate efforts and warn that pushing too hard, lifting heavy weights, or sweating too much can have a deleterious, even fatal, ef-

fect. But you have to wonder why they were so twitchy. Did Susruta or Celsus really believe a person was likely to keel over after a set of hill sprints?

Again, their apprehensions, I suspect, stem from the creative-destructive aspect of workouts. Fretting over how much strain the body can take or that exercise might do us harm makes a certain amount of sense in an ancient context, when kings actually fought in battles and aristocrats often walked or rode long distances; when, in other words, everyone, even the upper classes, experienced serious physical challenges, and when medical knowledge was scant, if it was available at all. If sweating will make you dangerously cold, and you have no Gore-Tex or effective indoor heating to prevent it, you might want to avoid sprints. If a strained back could result in death on the field of battle or the inability to contribute to your community, you can justifiably avoid pressing huge logs overhead. However, in the leisured, sedentary world of the twenty-first century, such persistent fears are counterproductive.

This amplification of concern about the body, and the concomitant insistence on low-intensity efforts, is roughly contemporaneous with the decline of the Hellenic civilizations and the rise of Rome. And it is during this period that a class of professional athletes began to form in Greece; yet while the Romans—who were leery, if not downright prudish, about public nudity—initially enjoyed athletic competitions as a new form of entertainment (during the Republic they imported Greek athletes to compete in front of spectators), they never thrilled to these entertainments with anything like their passion for gladiatorial contests and other spectacles. There is scant evidence that watching athletic competitions spurred the average Roman himself to work out. In fact, the Romans largely denigrated athleticism—here meaning competition and focused training—as something only

for professionals, who were looked down upon, whereas general exercise for health was for the average citizen—as long as he (or she) had the leisure time to pursue it.

G alen of Pergamon (circa 129–200 CE) was the preeminent medical thinker of the Roman era (a time when medicine and philosophy were the same field), and his ideas about the body and fitness became dogma for centuries, until the end of the Renaissance. For a period in his late twenties he served as physician to the gladiators of the high priest of Asia, and this allowed him to experiment with training methods. His experience did not lead him to a positive opinion of the overall state of athletes, who, Galen says, represent the "extremes of good condition," which, paradoxically, makes their example dangerous. Though granting that athletes are strong, he complains that theirs is a useless sort of strength, for they can't "do agricultural work such as digging or harvesting or plowing," nor are their muscles helpful in battle, for, he asks, quoting Euripides, "Do men fight battles with *diskoi* in their hands?"

This just seems peevish, if not perverse. Isn't it obvious that an athlete ought to be able to plow or dig or engage in other types of manual labor? Indeed, in his seminal work on the subject, *De Sanitate Tuenda*, Galen himself suggests digging as an effective exercise for health, yet the Roman doctor ignores the possibility that an athlete might practice both his sport *and* other skills, such as military drills or the techniques of harvesting, that one does not preclude the other. Galen, however, could well have been affected by the pervasive Roman sense that athletes, at least in the Greek mold, are strange: how could these foreign, and thus alien-seeming, muscle-bound men who play in the nude do anything so normal as plow a field or fight in the army?

Still, there are veins of minable truth in Galen's perversity: he seems to recognize that in order to do anything well—be it fight battles or plow fields—one needs to train for them. This is one of the principal insights of the New Frontier Fitness embrace of the practicing life, which looks to athletics as the model for all training regimens. What NFF adds to this recuperated ideal is the notion of skill transfer: that training with a discus, for instance, will make you a better soldier; or, to give a more contemporary example, it has been found that practicing the snatch, a classic overhead movement, makes pro skiers better at what they do.

Practicing multiple skills that are only vaguely related will improve them all. The reason is that training occurs at every scale and in each domain, from the microscopic to the corporal, from the muscular to the mental. When I practice the clean-and-jerk, for example—which entails lifting a weight from the ground to my shoulders (the clean) and then from the shoulders to a locked-out position overhead (the jerk)—I put strain on my body that results in numerous adaptations: assuming I do enough repetitions to begin panting, I will spur my cells to begin creating more mitochondria, and that will eventually allow me to produce more energy; through repeated efforts of the movement I will learn to recruit more fibers in the muscles I'm using (untrained people are only able to use as few as 30 percent of their muscle fibers), and this will make me stronger; as will recovering from the micro-tears in the muscles caused by lifting the weight. But at the same time, I'm producing neuromuscular interactions that improve my mastery of the decidedly technical skills of cleaning and jerking, while also generating new connections between neurons, forging fresh pathways for thought and action. In other words, repeating these movements well produces a cascade of adaptations that are not at all specific, or restricted, to the lift itself.

I n addition to being good only at what they train for, athletes, Galen worries, "overexert every day at their exercises," which forces them to sleep too much; moreover athletes don't "derive any pleasure from their bodies," since "they are in constant pain and suffering." Some of their discomfort stems from eating too much, and he criticizes the health of athletes as being far from "highly desirable" because they aim for "physical mass—which cannot take place without an ill-balanced type of filling. And thus the state is rendered both dangerous and, from the point of view of public service, valueless."

So here is Galen holding a warped mirror to the athlete, reflecting the image of a narcissist. Bloated by food, in pain from overworking his body in pursuit of glory, the competitor is too self-absorbed to serve country or king. This marks a 180-degree reversal of the earlier Greek notion that the athlete, as someone constantly training for any eventuality, be it war or an emergency, represents an ideal type of citizen. As Socrates says in contrast, "Many with no other support than this [physical fitness] have come to the rescue of friends, or stood forth as benefactors of their fatherland; whereby they were thought worthy of gratitude, and obtained a great renown and received as a recompense the highest honors of the State; to whom is also reserved a happier and brighter passage through what is left to them of life, and at their death they leave to their children the legacy of a fairer starting-point in the race of life."

I don't take Galen's censure too personally, because I'm not an athlete: I'm merely a conspicuously diligent exerciser. Yet because one of the changes wrought by NFF is that ordinary people like me began working out in a manner similar to professional athletes—*like* them in determinedness and intensity, and with coaching, but not at the same training volume and certainly not with the same goals—Galen's

jabs raise an important question: how should we non-athletes train?

Because I do CrossFit, which entails daily competitions—against the clock, against yourself, but also against everyone else in the gym— it's all too easy to confuse general physical preparedness, which is my ostensible goal (and CrossFit's), with the professional sport of fitness. Yet as Galen implies, what professional athletes do to optimize their performance is not necessarily what is best for your overall health. In order to achieve the "extremes of good condition" of which he speaks, pros need to work out more and harder than the average exerciser, punishing their bodies in ways that will not increase longevity and may well lead to injury. However, is it detrimental to follow the pros by implementing strength programs to augment my normal routines; to practice skill work (Olympic lifting, handstand walking, etc.) and implement precise nutritional protocols; to schedule rest days, and employ body-maintenance tools like massages, saunas, and physical therapists? Of course not: on the contrary, these things will help make me fitter. Then again, I certainly do things that target pure athletic performance, the health benefits of which are dubious at best: I take creatine, beta-alanine, and other workout supplements, and these help me (a tiny bit, and in all likelihood that advantageous crumb lodges exclusively in my head) push my workouts harder than is necessary to keep my motor running smoothly.

The problem of striking the right balance between performance protocols and those of health arises clearly in Galen's charge of overeating, which, oddly enough, was one of the main indictments against athletes in antiquity; it recurs again and again in the literature. Perhaps at a time when hunger was a very present fear, before refrigeration, rapid transportation of food, or other means of mitigating the effects of famine or scarcity, the spectacle of athletes gorging themselves repulsed ancient observers. Nobody today faults pros for

stuffing many thousands of calories down their throats each day—in order to pack on an extra thirty pounds of muscle or just to sustain long days of training—nor do we imagine that doing so is ideal for their long-term health. And Galen surely has a point when he says that athletes who eat for maximum "physical mass" take little pleasure in their bodies: those who do often experience sleep apnea, lethargy, high blood pressure, swelling, and other consequences of obesity. From antiquity until the dawn of the New Frontier, bigger was usually assumed to be better when talking about raw strength. In recent years, however, people have begun to realize that lean body composition is not only healthier but also no less effective than a corpulent combination of muscle and fat in the pursuit of peak strength.

Although we tend to join the word *Roman* with *orgy*, conjuring a society of decadent excess, the reality for the vast majority of the population was far more sober. A good citizen regulated himself in all areas of life, especially his or her body, and this meant a cautious, even ambivalent, attitude toward working out. The Greek ideal of physical excellence, and the love of pain and struggle that went with it, was utterly foreign to the Roman sensibility. Plutarch writes of his countrymen that "they believe nothing has been so much to blame for the enslavement and effeminacy of the Greeks as their gymnasia and wrestling schools, which engender much listless idleness and waste of time in their cities, as well as pederasty and the ruin of the bodies of the young men with regulated sleeping, walking, rhythmical movements, and strict diet." Training will wreck your body and lead to indecent practices—unless you adhere faithfully to the ethos of moderation.

According to Galen, overexertion forces athletes to sleep too much, making them too lazy to contribute to society, when, presumably,

they're not tortured by aches. But what, we might ask, is *over*exertion and how would we know when it happens?

If we consider again that exercise is a *pharmakon*, which is to say, a medicine and a poison, then the answer presents itself as a problem of dosing: how much is too much of a beneficial thing? When, for instance, you train hard over a period of weeks or months, and fail to recover adequately—eat properly and enough; get sufficient, high-quality sleep; and take rest days—your body will rebel. You will likely experience weight gain, lethargy, depression, and weakness, perhaps even the dreaded rhabdomylosis—the death of muscle fibers (from overuse) and the leaking of their broken-down components into the bloodstream. Though incredibly rare, rhabdo, as it is known, can cause renal failure and even death. But I can't help thinking that Galen believes that there is a danger in pushing oneself too hard in any given workout, and this is an unlikely scenario—it will not cause smoke to pour from your ears or explode your lungs. In fact, only a vanishingly small minority of people are capable of pushing themselves anywhere close to their physical limits, for this, too, is something you need to train in order to do.

Far more likely, it seems to me, is taking so moderate an approach that you fail to get a minimum dose of exercise. "Becoming fitter" is just another way of describing your body's adaptive response to the stress produced by exercise: panting from a sprint will signal your cells to manufacture greater numbers of mitochondria to allow you to use more oxygen, and fatiguing your muscles will signal the fibers to grow and get stronger. To trigger such adaptive responses you need to push your body hard, induce a sufficient level of stress. It took millennia for people to begin to understand this process, which is why it is only since the opening of the New Frontier that its explorers have promoted intensity in workouts. And still the prejudice

against intensity, favoring the easy path of moderation that goes back to Susruta, if not before, remains the conventional wisdom.

To my mind, there is no better illustration of the sorts of low-to-moderate-intensity exercises recommended by Galen than the benign and beguiling fresco known as the "Bikini Girls," found in the fourth-century CE Villa Romana del Casale, in Sicily. It depicts a parade of young women wearing what look like modern-day two-piece swimsuits: one taut-bellied girl with her blond hair worn long and loose brandishes two lightweight dumbbells that resemble something you might today find at SoulCycle; her neighbor holds a discus in two hands, while two others with their hair up toss a small ball between them. The fresco suggests that women, at least those high-born enough to have some independence, partook of exercise in the empire, though these were not the only activities the average person might pursue. The statesman and philosopher Seneca, like many of his compatriots, ran to stay in shape, using a slave to set his pace. He also swam regularly, well into old age.

Yet where the physicians see too much or too vigorous exercise as akin to overdosing, Seneca expresses other common biases against being too athletic. "It is foolish and quite unfitting for an educated man to spend all his time acquiring bulging muscles, a thick neck and mighty lungs," he writes, for those who dedicate themselves to fitness "have to submit to trainers of the lowest class, men whose minds cannot rise above the boxing ring and the bar, whose highest ambition is to get up a good sweat and then starve to make room for enough drink to put moisture back. Drink and sweating—one might as well have malaria." That working out might cause one to mix with those beneath one's station is a charge that will remain current well into the twentieth century, as will the related distaste for muscles, since these will mark you as a laborer. Hard work—exertion, in other words—

was, and in many instances continues to be, seen as something only for the working classes.

As with laborers, people who dedicate themselves to strenuous fitness regimes will be drained of energy and time for intellectual pursuits, or so Seneca argues: "There are the hours of training that exhaust them and render them unable to concentrate on any worthwhile studies. The large amounts they are compelled to eat make them dull-witted." Socrates, Plato, and Aristotle all believed—rightly, recent studies have shown—that regular, vigorous exercise sharpens the mind and primes one's engine for intellection. In Seneca's criticism of athletics (he calls athletes "imbeciles"), we can already detect the opposition between brain and brawn, or jocks and eggheads, that continues into our own time. Except that in place of character types, we should understand

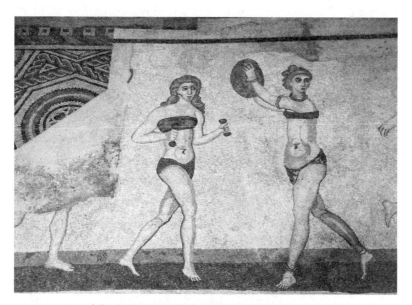

A portion of the "Bikini Girls" fresco in the Villa Romana del Casale, Sicily. (Courtesy of Paul Asman and Jill Lenoble/Flickr)

that this is in fact a clash of training practices—and it registers what will become a widening gulf between the regimens of the mind and those of the body in Western and also in Eastern cultural life.

Perhaps the most extreme example can be found in China, after the Han Dynasty (206 BCE–220 CE) and the era of Hua Tuo. In that time, "Confucian scholars increasingly frowned upon physical activities, regarding them as lowly and ungentlemanly," writes historian Ma Mingda, noting the class prejudices associated with working out. After the Song Dynasty (960–1279) and Yuan period (1271–1368), Mingda tells us, "the majority of Confucian scholar-bureaucrats opposed all forms of physical competitions—philosophers of the Li school in particular espoused the notion that 'action should be replaced by stillness' and regarded young men engaging in physical activities as a sign of deviancy. Social prejudices, combined with official intervention and prohibition, led to proscription of all kinds of physical competition . . . [including wrestling]. In time, espousal for civility and literary cultivation became dislocated and evolved into a cultural prejudice against all martial and physical activities. . . . Physical culture was relegated to a subsistence zone and appeared in public only as festive entertainment." This inclination toward literary, intellectual, and spiritual practices, amounting to a denigration of the body, did not, however, predominate at this time in the non-Han cultures of mainland Asia, where traditional tests of strength as well as riding, wrestling, and archery continued to be valued.

The rise of Christianity in the Roman Empire during this same period also results in a turning away from body culture and toward the cultivation of spiritual exercises. Christianity itself was influenced away from corporeal practices by its Jewish roots, for Judaism, too, initiates a skepticism of the body in reaction to Greek culture. The biblical author of Maccabees, for example, singles out a Jew named

Jason, who became high priest of Jerusalem but nevertheless established a *gymnasion*—at a time, from the first century BCE to the first century CE, of strong Hellenistic and Roman influence in the area—and thereby "he straightaway converted his countrymen to Greek customs . . . the priests no longer wanted to perform liturgies at the altar but disdained the temple and neglected the sacrifices in their haste to participate in the illegal activities of the *palaistra* whenever the diskos drew them." For such an insular community, *conversion* to the Greek love of the body was a bit like cultivating in them a taste for bacon—an affront to religious and community values. Rather than the regimens of the gym, Jews were typically trained by and in the Law, although the language used still borrows from the Greek terminology of athletic practice, as is evident in 4 Maccabees: "It [the Law] teaches (ἐκδιδάσκει) us self-control so that we overcome all pleasures and desires, and it also exercises (ἐξάσκει) us in courage so that we endure all pain willingly; it trains (παιδεύει) us in justice so that in all our dealings we act impartially, and it teaches (ἐκδιδάσκει) us piety so that we worship the only living God in a way that befits his greatness."

Denizens of pre-Christian Rome, who were perhaps followers of such Stoic thinkers as Epictetus or Seneca, were led to explore an art of living that, in Foucault's words, "defines the aesthetic and ethical criteria of existence." This art, like the Greek inner statue, requires a certain amount of self-forming, Foucault explains: "As for the definition of the work that must be carried out on oneself, it too undergoes, in the cultivation of the self, a certain modification: through the exercises and control that constitute the required *askesis*, the place allotted to self-knowledge becomes more important. The task of testing oneself, examining oneself, monitoring oneself in a series of clearly defined exercises, makes the question of truth—the truth concerning what one is, what one does, and what one is capable of

doing—central to the formation of the ethical subject." Once again, the language of this practice, this *askesis*, is taken from the *gymnasion*, yet now the exercises one does and the questions one asks oneself are more exclusively intellectual and spiritual; physical practice has been downgraded to daily maintenance rather than striving for an ideal. In a sense this splitting off of spiritual practice from athletic practice opens the way for Christianity's wholesale elevation of the spirit and denial of the body.

By the time Christianity became the official religion of Rome in 381 CE, the Greek notion of athletics, always a strange and foreign influence, had long been in decline. And when the emperor Theodosius I issued edicts in the years 391–393 proscribing sacrifices and other pagan rites, he essentially banned the games at Olympia and other sites, too—for athletic contests were always also religious festivals, where pagan gods were worshipped and sacrificed to. Of athletic competitions, Cyprian of Carthage, a Christian bishop in the second century, preached, "True Christians must shun with eyes and ears those vapid, dangerous, tasteless performances."

Still, the Christian denigration of the body as inherently sinful, the doctrine that worshipping and developing the figure is a sin and that one's attention should be focused on the spirit and the afterlife, certainly contributed significantly to the deterioration of athletics in the Roman era as well as in the Middle Ages. Paul writes, in his first epistle to Timothy, "For bodily exercise profiteth little: but godliness is profitable unto all things, having promise of the life that now is, and of that which is to come."

Indeed, from the late Roman era up through the Renaissance, most people cease cultivating their bodies either for aesthetic ends or for health. If people do at all, it is in a military context, as discussed

in the following chapter. For early Christians, however, Paul's athletic metaphors urge them to continue working out in a sense, yet to shift their practice from the physical to the spiritual realm. Heeding his appeal, early monks called themselves "athletes for Christ" and joined together in *asketeria*, places set apart from worldly affairs where one could withdraw into oneself in a spiritual practice. This idea of spiritual training as a sort of athletic practice occurs in other religions, too: a yogic spiritual training center, or *ashram*, in Hindu means "place of exertion." In both types of retreat, the *ashram* and *asketeria*, there was little fear of training too hard, for in the minds of these spiritual athletes no dose was too high.

3

FEELING, BREATHING, GOING TO WAR

Immediately upon meeting Mark Divine, a former U.S. Navy SEAL commander, he challenges me to a seven-minute plank hold. "You up for it?" he asks through a wide grin.

"That sounds horrible," I reply. I'm in pretty solid shape, working out five or six times per week, and I know that even a one-minute plank will have me shaking. Two minutes sounds like a torturous trial. I've never contemplated seven minutes.

"You'll be fine. We'll get you through it," he says with gruff certainty armored by that lupine smile. I'm not quite sure how anyone can get me through such an individual ordeal—massage my burning shoulders midway through? Yank my buckling hips up by the waistband of my shorts? But I'm game for the pain: exercise masochism is what I do. Or maybe I'm just lulled by the idyllic setting, this garden of a town where fragrant flowers mask any whiff of discomfort. We're in Encinitas, California, a small, sandal-thronged surfing village that might seem entirely too laid-back to be the home to Divine's company, Sealfit, which provides training in high-level military fitness to prospective special forces operators as well as to ordinary civilians. Mellow though it may be, this stretch of coastline from San Diego up to Camp Pendleton,

where U.S. Special Forces training originated, is like a sacred spawning ground for health reformers and fitness trends—everyone seems to end up here. CrossFit headquarters and its founder, Greg Glassman, are nearby; Jazzercize founder Judy Shepard Missett lives up the road in Carlsbad; and fitr.tv, producers of webcast *Barbell Shrugged*, perhaps the premier chronicler of New Frontier Fitness ideas and personalities, is now based in town.

I'm not given much time to absorb the chill vibes before some ten men and two women, all clad in black military-style pants and white T-shirts with their names scrawled in marker on the backs, assemble in the open courtyard of the Sealfit training center, known affectionately as the Grinder. A long, black metal pull-up rig lines one edge of the plaza, across from a small CrossFit gym, from which people occasionally carry barbells and bumper plates in order to work out in the sun. Sealfit offers a number of multiday programs for group training, for instance an academy for introduction to fundamentals, and Kokoro, which is akin to the SEALs' hell week. The group today is from the academy: they're not athletes or military, just normal people hoping to learn skills that will make them better at life. They range in years and experience, from a young man recently out of college to a physician who will soon graduate out of middle age.

In the Grinder there's a brief discussion of standards. Ordinarily the plank entails holding oneself prone on toes and hands (or, in a slightly easier variation, elbows), while keeping the butt and stomach muscles tight so as to pull yourself into a gentle bow, what gymnasts call the hollow position. For this evolution (SEAL terminology for a particular exercise or training module), we will be allowed to shift our weight onto one arm and then the other, alternate resting on one or the other foot, or pike up, in order to get a little relief. I join the class as they form a rough semicircle around Divine. Someone

counts off three-two-one, and we all drop to the ground and push up to a plank.

Almost all NFF phenomena share a familial relationship with military and martial fitness approaches, with common genetic traits discernible in the recent turn toward functional exercise, community, and regimen. Participants in Spartan Race, Civilian Military Combine, and other obstacle courses recognize that life is not a gravel track or wooded path; there are things we must vault over, crawl through, or carry. CrossFit was born out of the need to better train military service members, police, and other functional athletes. That the very word *exercitus*—closely related to our word *exercise*—means "army" in Latin points to the fact that working out for martial purposes likely predates all other types: we once needed to be fit primarily to fight our enemies and to hunt. When life is stripped of filigree, fighting and hunting remain. Thus, from the end of the Roman Empire until well into the eighteenth century, the pursuit of fitness on a culture-wide level was largely restricted to the martial realm. Exercise for health or aesthetic reasons tends to occur only at times when there is a reasonable expectation of a long life and when people have the material abundance and leisure to formulate conceptions of what the Greeks called *eudaemonia*, the good life.

The primary feature of the Roman army and its approach to warfare was the group: in battle cooperation, appearing in fearsome formations and moving together as one, is far more decisive than the strength or prowess of any one man. "Team trumps the individual," Divine tells me. "Nobody cares how much you can deadlift on a team. Yes, it's nice to know you can pick up heavy objects, but so can Joe over there. The question is: are you a well-rounded enough military athlete?

Can you do the things that will make you useful? It's all about mission first, team second, and the individual last."

Yet, from the historical record, it's difficult to distinguish the special character of group fitness. The Late Roman writer Vegetius, for instance, speaks of the empire's army running, doing the long and high jump, and carrying heavy packs. We know too that they trained in riding, archery, javelin, swordplay, and swimming. All of these were essentially done as individuals. During the summer, however, soldiers had to march twenty Roman miles (18.4 miles/29.6 km) within five hours. Long marches, likely with heavy packs, are one of the only group activities mentioned, though certainly the Roman army drilled extensively, too.

Both drills and long summer marches speak to the need for durability, one of the five components of military fitness Divine enumerates, the others being strength, endurance, stamina, and mental toughness. As in a team, no one component stands alone: durability, which is what the seven-minute plank hold develops, requires mental fortitude as well as structural stability, or deep muscular strength. Divine elaborates: "You might be setting up a fighting position for hours and hours or you might just have to do work, like offloading a ship or loading an aircraft. You can train for that, and you can extend the thresholds of how much work your body can do and not flame out." A team, when training together, can unite to push the threshold of each individual farther than he can probably do by himself.

Seconds after we've set our planks, Divine explains that, while this exercise might seem difficult and will certainly be painful, "We don't have to go through it alone." He instructs us to call out after him, "Easy work. I got this. *Hooyah*." Throughout those elastic seven minutes, Divine will vary the intonation of this call and response,

often to humorous effect: "*Easy* work. I got this. Hoooooeee-*ya*." The repetition of the phrase takes your mind off the discomfort you're experiencing, at the same time reinforcing your will to get through it.

Helping others persist through trials is the keystone of team training. This is a process of emotional development, something that, frankly, I hadn't considered until Divine pointed out that it has historically been an important, though implicit, part of military training. Using the group to temper feelings of panic in battle or the desire to quit during a march or plank hold is a skill team members hone. And if supporting others forms one pillar of emotional integrity, accountability is another: fail to do your part in a firefight, and people die. The call and response during the plank hold reminds you that not only can others hear you, they can see you—so if you fail or cheat, they will witness your shame.

This scaffolding of emotional integrity also structures other group workouts in the New Frontier: it is a pungent ingredient in the Cross-Fit stew and a notable flavor of such military-inspired team challenges as Goruck and Tough Mudder. In the former, the strong communities that develop in the box (gym) help encourage attendance (you're far more likely to show up if you know people are expecting you), and the coaches as well as fellow CrossFitters police movement standards, sometimes casually, sometimes by having athletes count and judge each other's reps (are your hips below parallel in a squat, your arms locked out on a press?). In the latter, mutual emotional investment ensures that everyone, even the slowest and weakest members of the microcommunity of the team, completes the race. Contrast this with a twentieth-century workout, such as aerobics, where there is no monitoring dynamic within the class and where each member faces and mimics the instructor, who acts as a mirror rather than a coach checking movement standards or effort.

L ate antiquity saw the decline of large-scale armies with tight drills. And for a thousand years, until into the Renaissance, conditions of abundance and ease hardly existed in Europe, while elsewhere it was cultural norms and religious beliefs that relegated fitness to a martial context. Conceptions of exercise did not advance beyond what Galen had adduced and, like other classical learning, much of it was lost, forgotten, or ignored in the pre-Renaissance period.

An exception can be found in some of the caliphates of the Islamic Golden Age. The thinker Ibn Sina (aka Avicenna; 980–1037 CE), for instance, who wrote in Persia, saw exercise as therapeutic and medicinal, recommending mild—fishing, sailing, and other mostly passive activities—and brisk exercise, such as "interchanging places with a partner as swiftly as possible" as in a dance or game, for most people, including the aged. Still, most of what he considers vigorous and strenuous exercise is martial: wrestling, boxing, quick marching, running, as well as stone and javelin throwing. Indeed, Ibn Sina's notion of exercise was not appreciably different from that of Western knights. Squires looking to be knighted were expected to become proficient in seven skill areas: swimming, archery, climbing, jousting, wrestling, riding, and courtly behavior, such as dancing. Presumably fencing, the principal form of exercise for knights and others at the time, was too basic, too widespread to be counted among the seven special skills. Swordsmanship was also a fundamental element in the Chinese martial arts, or *wu shu*, which began to be codified around 960 CE, though it wasn't until the fifteenth century that books describing its various manifestations appeared. Exercise in the Dark and Middle Ages was not seen as a withdrawal from daily life but existed only by necessity, as a by-product of it: to the extent one worked out, one did it to improve specific, usually martial, skills.

As the seconds bite at my joints and sap my muscular stamina, I marvel at Divine's calmly held plank. In his early fifties, the former SEAL is tall, with long, lean, yet muscled limbs. His hair, full, curly, and tightly cropped, is rust colored, which lends his tanned skin an orange glow. Unlike the rest of us, who are groaning and twisting about, he hasn't piked up to ease pain in his back or shifted his weight from one arm to the other. He remains stock still on both hands the entire time, though he does place one foot on top of the other every once in a while. Throughout the trial he is a picture of stoic and cheerful hardiness. Divine has trained extensively in both the military and martial arts. As a young man he studied Seido karate, through which he learned Zen meditation, and went on to practice a number of other martial arts, including *ninjutsu*, the arts of unconventional, guerrilla warfare; he has also been a longtime yoga devotee. He supplements these with CrossFit in a unique, multidimensional practice. What he's distilled from this combination of Eastern and Western disciplines is the mental toughness on display in the plank session.

During the grueling final two minutes, Divine's calls of *easy work* and *hooyah* come more frequently, so as to distract us from our aching shoulders and failing abdominal muscles. Vocalizing this certainty as a group proves amazingly effective. When time is called, everyone has survived without breaking his or her plank, and I've found the experience has passed far more quickly than I'd expected (while the soreness in my rib meat and shoulders in the days that follow testifies to how punishing it was).

Say *feelings* and it is tears, not military training, that probably come to mind, but of course emotions grease the gears of cooperation, without which armies can't function. It's not until I watch Divine and his instructors take the group through Log PT (physical

training) that I begin to comprehend how, as Divine puts it, "team training, when done with a wise coach and structured properly, can be an extraordinary tool for developing emotional depth, emotional resiliency, even intuition and awareness." The reason, he continues, is that "you can design team training to have a lot of perceived risk."

The members of the academy class, arrayed in two groups by height before a pile of dense and menacing logs, look newly vulnerable. To a former tree trunk weighing some 350 pounds, a femur is a twig. The risk to the teams is evident: slip or otherwise fail to do your part, and a hand, arm, or skull can be swiftly crushed. "We can have a lot of dynamic things happening where you have to plan and coordinate efforts, and so we get into leadership questions, and how to be a good teammate," Divine says to me, as he details how the group must function as a single unit to raise the log first to their thighs, then to their shoulders; from the shoulders, they press the log overhead, holding it for a beat before bringing it down on the opposite shoulder. An hour spent coordinating difficult and dangerous maneuvers with huge logs opens a direct pathway to the emotions by way of the muscles: the more exhausted your arms, legs, and back become, the more you need to fight against becoming frantic and wanting to give up. Any outburst of frustration or chiding of teammates will only increase the time under tension, punishing everyone further. The leader leads or the mammoth wood weight drops. Everyone needs to execute precisely.

During the plank hold, I wondered how Sealfit differed from familiar corporate team-building exercises. Log PT provides a vivid answer: Sealfit and other NFF phenomena like obstacle races and CrossFit ask us to accept, even embrace, difficulty; to overcome the seemingly impossible and in so doing overcome the selves that we are today. Making things tougher isn't merely a technique, it is a coun-

tercultural ethos—a rejection of the ideology of ease, the belief that if we can just find the right technology or hack, life will be untroubled, convenient, pain-free. It's an ethos in opposition to a culture that seeks a balm for every burden, one the philosopher Peter Sloterdijk describes when he writes: "warriors and athletes . . . gain degrees of freedom from the burden character of existence by consistently outdoing the difficult through the even more difficult."

This constant upping of the ante doesn't necessarily mean simply finding bigger obstacles to hurdle or crazier tricks to master. More commonly, fitness programs in the New Frontier employ skill acquisition as the metric of increasing difficulty. Rather than plod from machine to machine in a circuit (which is the earlier, postwar model, where machines explicitly remove skill and danger from a lift), one works on new, high-skill moves each day, practicing the snatch, the muscle-up, and the handstand walk, among many others.

Although the era of military exercise—from the end of the Roman Empire to the eighteenth century—is generally regarded as a fallow period for fitness, it nevertheless sees an increase in skill development, precisely because those few people who work out at this time do so with specific goals in mind, usually getting better at fighting. This is the period when the martial arts are formalized in East Asia, and when warriors from China to Japan to Europe perfect the techniques of archery and swordsmanship.

Progressive resistance, which entails various levels of skill, especially in the martial arts, is one of the most basic means of structuring difficulty, outdoing oneself each day by moving a little more weight. Log PT is, for example, a type of weight training that also hones group skills. Medieval knights in Europe sometimes practiced with weighted swords, thus combining strength efforts with skill, and chronicles of the period are rife with fanciful tales of men who wielded

double-hand swords, and in the case of Sir James "Black" Douglas, a two-*man* version. Chinese martial artists brandished large iron battle-axes known as *wukedao*, weighing forty pounds or more (which is what the Scottish hero Sir William Wallace's seven-foot-long sword weighed). A practitioner might wave or chop with the *wukedao*, but he can also perform complicated moves such as balancing the blade on his upper back and spinning it.

Most heavy implements can be employed at various skill levels. The Chinese Stone Locks, so called for their resemblance to traditional padlocks (stones carved into rectangles with space open toward the top for gripping), have been used by the military and by martial artists for strength training from at least the mid-tenth century until today. The Stone Lock is flipped up in the air and caught as it falls, which demands accuracy as well as agility; it can be pressed like a dumbbell or held in each hand for a punching exercise called A Golden Dragon Thrusting Out Its Claws. Such adroit appellations—others include A Sphinx Spreading Her Wings and A Hungry Tiger Seizing a Lamb—reflect the refined literary culture in which these exercises were developed.

Similarly, weighted pots and Stone Wheels (barbells made from wood or iron poles with carved rock weights on the ends) can simply be lifted for strength or incorporated into elaborate acrobatic routines. One early-twentieth-century account of the Stone Wheel describes a practitioner who takes "the pole in his two hands, raises it up to his knees, then to his body, to his breast, to his face and then finally above his head. He pushes it out in front at arm's length, and often uses it in performing various feats of skill, such as resting it on his shoulders and neck and whirling it round."

The Chinese military also trained with sandbags, as many a military has done and continues to do, since they are easily produced.

In fact, shortly after Log PT at the Sealfit compound, the class assembles for Sandbag PT. Formed up into a circle, they take turns calling out a movement for the group to perform: a sandbag clean and press, for example, or a weighted sit-up. Any gardener who has tossed seed sacs or anyone who has hugged a laundry bag to his or her chest can understand the efficacy of training with such awkward implements: it requires balance, and you recruit numerous muscles to stabilize the shifting load, particularly through the core. For much of the twentieth century, such humble implements were shunned in favor of the glittering promise of high-tech workouts; only in recent years, since the opening of the New Frontier, have large numbers of people reached again for these highly functional tools.

As with most weighted military implements, like heavy swords or axes, sandbags are stand-ins for things that are swung or hoisted repetitively, and so they're relatively lightweight and thus better suited to developing stamina and endurance than for pure strength. However, in strongman workouts—a primal or throwback NFF routine—people routinely hoist much heavier bags (up to 200 pounds or more) as well as other unwieldy, oddly shaped objects like stones, kegs, and yokes.

Standing in the sun after Sandbag PT, bodies scattered about him sweat soaked and panting like puppies, Divine, who joined the workout yet looks as bright and fresh as the flowers on the courtyard edge, explains that, for SEAL operators and other elite military units, strength is foundational. "In the SEALs, the most durable people are the ones who make it to the other end, and that's part mental toughness but it's also part structural stability, flexibility, the ability to recover really well," he says. To achieve these, as well as what he calls "underlying girth strength," you must train the power lifts: the front squat, back squat, bench press, and deadlift, as well as do strongman

workouts. "These build the type of strength that radiates out through your body, as opposed to bodybuilding work."

But today, as is true historically, the elite units are the exception. The infantry has tended to shy away from serious strength training for the troops, in part because it has long been feared—falsely, as we'll see—by those in the East as well as the West, that heavy lifting will result in bulk that will slow soldiers and sap their endurance. Armies tend to put their faith in technology to overpower opponents. Endurance work, like running and marching; bodyweight efforts, such as push-ups and pull-ups, which require almost no equipment and thus are very portable; and light-to-medium weight implements (like sandbags) are the rule. This approach may suffice for soldiers, but ignoring the heavy lifts is not ideal for those seeking the full spectrum of fitness.

I n Ibn Sina's Persia, warriors and wrestlers known as *pahlavans* trained with war clubs called *meels*, which look like oversize bowling pins and weigh between 2 and 50 pounds. They are swung two at a time up over the shoulder, rhythmically tracing patterns in the air. *Pahlavans* also made use of the implements of warfare, pressing shields overhead and pulling heavy bows, as, we can assume, armies throughout the world did for centuries before and after.

The *pahlavans* are just one subgroup of that most ancient class of martial athletes, the wrestlers. In Turkey, *pehlivans* compete in oil wrestling (like the ancient Greeks in the *palaistra*, they are anointed with olive oil) and have done so at least since 1360, when the first of the ongoing annual Kirkpinar Festival was held in Edirne. During the Mongol invasions beginning in 1250 CE, some *pahlavans* traveled to India and introduced *meel* training into the subcontinent, where it flourished among the military for centuries (and still exists today). In-

dian wrestlers became known as *pahelwans*, while Persian club swinging became known as Persian yoga.

British officers stationed in India toward the end of the eighteenth century observed local soldiers, police, and others training with *joris*, as the *meels* had come to be known in that country. The Indians employed their clubs in two modes: lightweight ones were used to increase flexibility, quickness, and muscular endurance, while men swung heavier clubs to build strength. When, back in England, the British military in the early nineteenth century incorporated the Indian clubs, as they called them, into its training regime, it adopted "a Calisthenic exercise with light clubs . . . more calculated to open the chest, supple the figure, and give freedom to the muscles, than to develop strength," according to Simon Kehoe, who introduced the clubs to America in the mid-nineteenth century.

Beyond the clubs, Indian wrestlers cultivated their own arsenal of equipment. The *gada*, a roundish stone attached to a pole, is a type of mace, and like the *jori* it is swung, though alone rather than in pairs. For the heftier version, which can weigh more than 120 pounds, one grasps the pole with two hands, whirling the weight around the entire body. Athletes also pressed large logs with holes cut into them for handholds, known as *sumtoloa*, over the head, while they pushed lighter versions out to the sides or in a twisting motion. The *sumtoloa* looks almost identical to the logs used in Western strongman workouts, although the contemporary version is more often constructed from welded metal. The logs could also be dragged, like a heavy sled. Another strength implement, a stone circle, like a donut with a wooden handle in the center for holding, is known as a *nal*. Though they are employed in much the same manner as any dumbbell, the shape of the *nal* renders it uniquely attractive: in 2013, a gorgeous mottled black basalt example from the late seventeenth century, with

the central strut carved from the stone, sold for twenty thousand dollars at a Sotheby's auction. A larger version, called a *gar nal*, is placed around the neck as a weight for squatting.

At those headwaters where Indian wrestling meets yoga are the choppy waters of acrobatics. Consider, for instance, the *mallakhamb*, which refers to a range of climbing implements. One type is a pillar— approximately eight and a half feet high—mounted on the ground and oiled to imitate the slickness of a sweaty opponent, which functions as a climbing apparatus to strengthen the grip and leg-clenching ability. Unoiled it can also support pole gymnastics, in which practitioners wave themselves out horizontally in reverse human flags, grasping the pole with their feet; support themselves on its top in straddle positions; stand on it; or clamber up it in groups to form human sculptures. The pole might also be suspended from the ceiling by a rope and similarly climbed. As a silk rope hung from the ceiling, the *mallakhamb* becomes a tool for yoginis and yogis, on which to strike poses, wrapping it around limbs to hold themselves parallel to the ground or seemingly sit in air. Acrobatics is closely related to wrestling, since both entail manipulating bodies in entertaining feats of strength and agility. But what does yoga have to do with martial fitness?

In the West, we tend to associate yoga with serene sages who have played guru to millions of pert, stressed, upscale women in contour-hugging clothes along with skinny, shirtless men. *Yoga*, however, means "yoke," of the sort that harnessed your horse to your war chariot. Rather than being a wellspring of peace, it was a practice that served as a divine chariot carrying glorious warriors to heaven. Poses, or asanas, are a relatively late development in the long and diffuse history of yoga. From the tenth to eleventh centuries, the "yoga of forceful exertion," or hatha, was developed among a group of Indian

warriors who came to be known as the Nath yogis. Hatha was distinguished from earlier manifestations mainly by the regimen of breathing control that we now associate with Ashtanga yoga. "In certain sources, the duration of time during which the breath is held is of primary importance, with the lengthened periods of breath stoppage corresponding to expanded levels of supernatural power," writes the scholar David Gordon White.

Whether or not they are supernatural, Mark Divine's powers are astonishing, and he has developed them by reaching back to the warrior tradition of yoga and its techniques of breath stoppage. On a bench in the shade, where Divine pets a dog—not his, an instructor's—that has gone completely blind and has been forlornly awaiting attention, he explains that the mind, like the bones and muscles, must be toughened for battle, even if our fight is merely the daily struggle of existence. Mental strength requires, in his phrase, "sharpening the sword of the mind," putting oneself through concentration workouts. Conventional "military programs do it by the way that they organize their training," Divine says. "They throw a lot at you, and you've got to learn to concentrate in order to survive—if you can't, if you don't have the capacity to deeply concentrate on the task, such as learning how to shoot a sniper rifle and to concentrate intently, develop that frontside focus, then you fail, you go away." The military, then, has traditionally used "skill-based training to develop concentration. They put you under extreme loads and use simulated combat scenarios like Hell Week to develop resiliency and mental toughness. What they're really doing is completely reframing your paradigm of what's possible for the human body-mind system." In other words, they demonstrate through a practice regimen how to outdo the difficult with the even more difficult.

To facilitate overall concentration and mental acuity, Divine

created something he calls Warrior Yoga, which integrates yoga asanas and breathing techniques with functional strength-and-conditioning work and martial arts. It was something he cooked up in the cauldron of war.

Before founding Sealfit, Divine was a reserve officer for the Navy while studying for a PhD in leadership at the University of California, San Diego. Suddenly, in 2004, he was mobilized back to active duty in Iraq. "I'd been off active duty for about eight years," he says. "I'm still a Navy SEAL, but I don't have a team. I'm out of it, rusty, and I'm alone on a C130 flying into Baghdad, and the nervousness is starting to get palpable. Only a few days earlier an Australian operator had been shot through the ass as he was flying out of the Baghdad airport, and I'm thinking, I don't want to get shot through the ass! I'm flying into a combat zone, for the first time. I have a newborn son at home. I haven't had time to sight my weapon, which is a big no-no. My friend Scott Helvenston was killed and hung from a bridge in Fallujah the month before—I'm losing it. So I go to the back of the plane and start doing yoga, moving with the breath and doing Ujjayi breathing, and after about an hour and a half it was all gone. We land and there are mortars going off, but I'm fine now."

The experience of being able to wrestle control of himself through breathing convinced Divine he needed to continue with yoga. He was housed in the SEAL compound in one of Saddam Hussein's old palaces in the middle of Baghdad, but it had no gym. Within the compound was a lake with a few dachas, shot up, pockmarked, and unoccupied, so he found a space near them, set up the yoga mat he'd brought with him, and began putting together a daily practice. He'd begin with five to ten minutes of diaphragmatic breathing on a 1–1–1–1 ratio (for instance, breathing in for ten seconds, holding for

ten seconds, breathing out for ten seconds, and then holding for ten seconds before inhaling again).

Leading the blind dog on a stroll, he continues: "Then I would do about twenty minutes of standing poses, like Sun Salutations, Warrior One, Warrior Two, getting warm and moving with the breath, ridding my body of anxiety, flexing my spine. After that I would do some conditioning. My only tool was a kettlebell, so for twenty to forty minutes I would do burpees, kettlebell swings, push-ups, sit-ups, and squats, in various combinations. And I'd finish with a bunch of seated poses, a short *shavasana*, and a visualization—of me at home with my family. That became a version of the future me." Once home, the future Divine began teaching this hybrid practice as Warrior Yoga.

Until meeting Divine, I was like many people in the high-intensity exercise community: at once devoted to yoga for stretching and mobility, yet skeptical of it as a fitness program. It was the gung ho, *hooya*-hollering Navy SEAL who convinced me not only that yoga breathing and meditation will improve general functionality, both physical and mental, but that breathing, thinking, feeling, and believing—the soft tissue under the warrior's armor, if you will—are the necessary catalysts of higher performance.

After he's taken the ailing dog on a short tour of the Grinder, Divine brings him and me into a sort of military briefing room—folding metal chairs, photographs of past Kokoro groups, banners and flags, a troupe of rucksacks awaiting their owners—to join the academy class for what will turn into a two-hour lecture on breathing and visualization. On one side of a whiteboard at the front, there's a lot of stuff about breathing, and on the other the words *Mind Gym*. Before addressing these, Divine sketches out what we might call three mental-movement patterns. The first, concentration, he

says, is directed externally, focused on a point. The Sealfit program primes concentration by, for instance, briefing each training session, or "dirt-diving the workout," in which the coach details movements, protocols, goals, and breathing strategy. After the session, they debrief, looking at breakdowns and where execution and visualization didn't meet up. The second, meditation, is internally focused, and we use it for exploring ourselves. The third, visualization, is a mix of the other two, reflecting an internal focus outward. The key to all of them is, he says, that "energy flows where the attention goes."

But we can't direct that energy properly without mastering the breath, which, Divine tells us, drives everything. Our bodies require three types of fuel to survive: breath, water, and food—in that order of importance (you can live for weeks without food, a few days without water, but only minutes without air). And yet how often do we consciously attend to our breathing? How often do we train it? "As any athlete knows, breathing is the key to higher levels of performance," Divine says. "It's also the key to higher levels of awareness and intention. You can use the breath to stimulate the nervous system, to charge you up for battle or for a workout, and also to stimulate your parasympathetic nervous system to calm you down, help you recover. In our daily lives we're couch-potato breathers. *Performance* breathing requires complete conscious control of the breath, being about to use the breath as center pole to ground you during training or, if you're a warrior, in a firefight."

The foundation is what he calls Box Breathing, so named because inhalation and exhalation must be done on the same count (five seconds for instance) as holding the breath with the lungs full and then empty, equilaterally. It is used in daily meditative practice, for calming and for learning to discipline your respiration. As you master your breathing, he tells us, you can harness different patterns for various

purposes, to slow the heart rate during an intense workout, for example. Divine ends the breathing portion of the lecture with a type of breathing meant to amp you up for battle or any all-out effort. He asks the group to stand and suck in air through the top of our chests while opening our arms as though we are preparing to bear-hug someone, then forcefully expel the breath with a grunt. "I want you to imagine we're on a Viking ship, rowing toward the shore where an army waits to attack us," he says, as we, en masse, throw our arms forward with a shouted *ha* over and over. We breathe and gesticulate for several minutes with Divine, as he narrates the scene, "We're gliding in close enough to see their weapons. *Ha.* They're pounding spear poles and shields on the ground. . . . *Ha*." It is, as promised, exhilarating, and the shared shout somehow allows me to meld with the others, just as in a yoga class, when your single expressed *om* vibrates out from your body merging with everyone else's *om*, uniting each individual with the whole.

We can see, then, that it is through the breath, with its consciousness-changing, awareness-concentrating power, that fitness regimes connect with spiritual practice. In fact, the Latin *spiritus* denotes "breath." I say *connect with spiritual practice*, meaning that through the breath our physical practices meet the incorporeal. Being precise about this point is important because historically, fitness regimes and, according to Sloterdijk, other ascetic practices, have become progressively despiritualized since the nineteenth century— despiritualized in the sense of stripped of religious content. Take yoga, which began as a purely spiritual practice and was retrofitted in the twentieth century as a fitness regime. When adepts speak of yoga as "spiritual," they tend to mean it in the way I used it above, as connecting them with the larger world or universe through the breath:

they almost never follow the Hindu religious doctrines on which it is based. This is not to say there are no religious yoga practitioners; only that yoga, like athletics, which was explicitly religious in ancient Greece, is becoming less religious all the time. Even the protocols of World Yoga Day, begun in India in 2015, skip the Sun Salutations because they can be interpreted as poses of worship.

Right now you may be saying to yourself, What about all the religious athletes? Aren't sports one of our last bastions of devotion? A philosopher like Sloterdijk would argue that when they profess their faith, athletes are being neither religious nor "spiritual." Thanking God for a touchdown is a manifest perversion of religion. I agree, but I would add that much of the confusion stems from the fact that, while physical regimens are largely despiritualized ascetic practices, athletes, be they warriors or civilians, continue to use *belief* as a tool for enhancing performance. And yet belief remains a fuzzy concept for most of us, despite it being one of the most powerful forces we know. The problem is that we lack a metaphysics and pragmatics of belief; we've had no rigorous philosophical probing of it.

Divine, as he moves into the visualization part of his lecture, brushes up against the concept. We can use visualization, he says (even as the blind dog wanders among us, crashing into chairs), both to get better at overcoming physical challenges and to draw a picture of who and what we want to be. The techniques of visualization have been in use by elite athletes since the 1970s, when the Soviets first began implementing them, and since then mental rehearsal has proven extremely effective. In one study, new gymgoers were found to increase their strength by some 30 percent by lifting weights, while over the same period of time another group who merely imagined using the weights were able to increase their strength by about 13 percent—not bad for sitting in a chair. As with other tools from the arsenal of

professional sports, visualization, or imaging, as it's often known, has also been adopted by everyday athletes in the New Frontier. Divine tells his own story, how as a competitive swimmer in school he would swim his race stroke by stroke in his mind every day until he was able to do it mentally in the time he aimed to achieve. For a while, he was unable to match that time in the pool. Then he got injured and had to take a few months off from swimming. When he returned to the pool for a race, as a last-minute entrant, he was terrified that he'd fail miserably since he hadn't worked out in months. Instead, he got in the water and fell naturally into the rhythm of the strokes as he'd visualized them, thinking, I've swum this race before—I can do it. He matched the time of the race he'd been swimming in his head to the second and won the race that day.

Later he took that experience and applied it to his training to become a SEAL, imagining the sound of the waves crashing on him in the surf, the smell of the mess hall, the feel of the sand on beach runs, what the dirt would look like as he did push-ups, every detail he might encounter in the grueling initiation process, so that by the time he was actually undergoing these tests, he'd not only practiced them mentally, he'd seen how to survive them.

A "Mind Gym" provides a quiet, designated spot for such interior workouts. "For some," Divine says, "it will just be a metaphor, but if you *believe* it, accept it, it can be much more." Why when you utterly believe in your ability to do something or be something, are you more likely to accomplish it? One answer that seems to apply universally is that belief allows you to commit wholly to a task, holding nothing back from the effort. When an athlete or soldier directs that belief through a deity, he removes much of the pressure from him while allowing him to believe entirely in himself. As Divine guides our group through the construction of our Mind Gyms,

I know that committing, buying into the process, is going to be my stumbling block. I'm a skeptic, and I find groups far more conducive to giggles than to meditation. But, putting aside his name, Divine has little of the guru about him—he's not trying to mesmerize us, and so I'm determined not to let this exercise just be a metaphor.

He directs us down a path, into a valley, and down a hole into another world, where we're to situate our Mind Gym. He helps us outfit it and explore it, erecting a screen on one wall to project our future selves. The process of visualizing these versions of ourselves takes quite a while, but I find I'm able to concentrate, even when the ailing dog bangs against my chair leg and plops down on my feet. I'm able to believe because I can sense the value of what we're doing, and when we finish, when we stand up and shake our limbs out, I feel a rush of transformative energy. Not that I was able to sustain my focus in this gym for long—that too is a skill.

Still, even when belief abandons me, the Mind Gym as a metaphor works: it opens a window on what *functional fitness* means. In recent years, training has been directed toward real-life situations, and one of the arguments behind the new fitness regimes has been that facility with anything in life, from breathing to cooking to self-overcoming, requires practice. Sometimes we need a place to first picture and then practice being the person we want to become.

4

BODYWEIGHT POLITICS

A man executes a sort of freeze-frame, slo-mo pull-up, miming steps as he ascends, as if he were on an invisible staircase. Once his chin crests the bar at the top of his pull, he glides side to side, bending first one arm, then the other; after a few lateral glides, he dips down and, with sudden explosiveness, pops his entire torso into the air, so that, for a moment, he is supporting his weight on straight arms, the bar at the level of his hips, before swinging his legs back, lofting his body into the air again, and, letting go of the bar, turns a full 360 degrees, catching himself once more in that straight-arm, support position.

He might be in Riga, Sydney, Buenos Aires, Madrid—any town or city that has a playground with a horizontal bar. He might be one of the Raw Movement crew at Muscle Beach in Santa Monica, who, when I show up unknown to any of them, happily cluster around to help teach me the L-sit press to handstand on the parallel bars. This involves starting from the L-sit, which looks like what it says—hands on the bars, arms locked out to support your body, legs held out at a right angle from your torso, like an L—then lifting the hips back and up (using a lot of core strength) until you are in a handstand on the bars. I've practiced this inches off the

ground, on paralettes, but higher up on the parallel bars it's scary: I could easily fall over and smash my legs and back onto the steel, then fall another four feet to the ground. But, seeing me attempt the move, the guys, though fearsomely muscled, are happy to give pointers. And yes, it's mostly guys. High up on another bar, there was one young woman doing a difficult dip variation, with her body facing away from the bar, holding it behind her so that it brushed her back as she moved up and down. But so far this sort of workout hasn't caught on among many women, perhaps because it requires extreme upper-body strength that until recently very few women have cultivated.

I say "this sort of workout" because, in certain respects, it's so new that one name hasn't settled into common usage. At its highest level, there are competitions using various tags: the Street Workout World Championship is held each year in Moscow, after a series tour of smaller competitions in cities across the globe, while the World Calisthenics Organization hosts the Battle of the Bars, in which athletes go head-to-head trying best each other with difficult tricks and intricate combinations. But whether you call it calisthenics, street workouts, or playground gymnastics, it entails bodyweight movements performed on a simple apparatus like the horizontal bar or parallel bars, or on the ground. The oldest word for such stripped-down workouts is *calisthenics*, and it's a field that's gone global because it requires no gym, no machines, no weights, no special shoes—nothing, in short, that costs money (although you do see people wearing gardening gloves to protect their hands on the pull-up bar). You can do calisthenics almost anywhere.

But its minimalism also obscures the history of calisthenics, at least in its hybridized, NFF incarnation. Many groups and crews can claim to have been early adopters, and surely these playground gymnasts are the grandchildren of the acrobats who in the late 1930s created Santa

Monica's Muscle Beach; today you can find Frank Medrano, Chris "Tatted Strength" Luera, and other stars of the current scene. But that original Muscle Beach scene lasted only into the 1950s. Today's calisthenics is more likely the inadvertent brainchild of a man named Hassan Yasin-Bradley, aka Giant, who for many years could be found at the Colonel Charles Young Playground in Harlem, working out with his crew, the Bartendaz.

By the early nineties, when he was locked up for three years, starting at age twenty (for a drug offense), Yasin-Bradley had already learned about pull-ups from neighborhood men who had spent time in prison during the previous decade, a period when Nautilus-packed gym franchises were breaking out like pimples across the face of America. Oddly enough, prison was one of the few places where the tradition of old-school bodyweight workouts was maintained, because there were no machines. Soon after he got out, Yasin-Bradley began speaking in local schools, trying to keep kids out of jail. But words weren't enough; he wanted to give them something to do, something to inspire them. His own experience of school was that it "didn't touch the mind or the soul enough for me," he says in the documentary *Mind Up*, so he set out to create a program that would make kids say, "I've *got to* participate in this." He found the solution in the jungle gyms and monkey bars of neighborhood parks, where he began teaching kids versions of his own workout routine: dips on parallel bars, pull-ups, push-ups, and other bodyweight exercises.

In the very late nineteenth century, when the American philosopher and educational theorist John Dewey published a model school curriculum, he declined to include gymnastics or calisthenics because, he said, "children do not like it." This turned out to be a clear example of projecting one's own prejudices onto others. A hundred years later,

Yasin-Bradley had no problem finding kids eager to participate in his exercises. Certainly it didn't hurt that he has the charisma of a natural leader: although not large, his presence commands attention, he flashes a smile often, and you can hear the fervor and emotion in his voice when he talks about helping those in his community through fitness. Such is his athletic prowess and largeness of spirit that, among his followers, he earned the sobriquet Giant.

As his students graduated, some continued with Giant at the park for training sessions; other neighborhood kids followed, and the cadre assumed the name Bartendaz. Part training school and part performance troupe, the Bartendaz' aim, in Yasin-Bradley's words, is "to educate youthful individuals about the inner workings of themselves and their environment through natural movement." They bring their message—one slogan being: *Health is Wealth, Movement is Medicine*—to detention centers, schools, and old-age homes, and also provide classes for paying adults. The name Bartendaz itself is a play on what the group hopes to accomplish: helping the people of their community lift themselves up, literally and metaphorically, on bars, not getting locked up behind bars; or tending the pull-up bar, not the saloon. "It's not just about lifting your body or fitness," says Yasin-Bradley. "It's about lifting your morals, elevating yourself."

Still, what garnered Bartendaz recognition beyond Harlem were the innovations they brought to the pull-up bar, and the videos they made of their fancy routines. Yasin-Bradley knew he had an effective program for helping young people—"Gang members come to us, and after two hours of working out they're too tired to get into trouble," he says—but he didn't recognize how cutting-edge the bodyweight variations he was teaching were until fitness legend Jack LaLanne contacted him. LaLanne, who had never seen anyone incorporate

mimed steps into pull-ups and dips and hadn't imagined shifting left and right with one's chin over the bar, wanted to learn more about Giant and his acolytes, who were flattered by the attention and fired up to continue their work. Those early Bartendaz YouTube videos inspired people around the world to take up calisthenics, extensively expand its repertoire of moves, and ultimately transform it into a professional sport.

But for Yasin-Bradley, the focus remains on motivating kids to free themselves from the poverty and anomie of ghetto life. As one member of Bartendaz explains in a video, if today you can do only one pull-up and tomorrow you can do two, it teaches you that "you always need to progress. The smartest person knows he can know more." In other words, Giant and his group use athletics both as a metaphor for intellectual and emotional development and as a tool for effecting that development.

Why is the body such a powerful vehicle for social and community uplift? How does it combine so neatly the means as well as the metaphor for knitting people together into cohesive networks and like-minded groups? Perhaps because change is a fundamental condition of the body: we are always either improving or decaying (unlike machines, which also provide a metaphor for physical states but, it turns out, are poorer tools for improving them); but also because the body is itself a colony in which individual cells and organs (not to mention other organisms, such as bacteria) work together in unison, just as people might come together to form a community, tribe, or state. This is something that has been implicitly understood, though not necessarily stated, for thousands of years. However, the modern version of this idea of calisthenics as a means of community building—and thus the model for what Yasin-Bradley has done with

Bartendaz—was established some two centuries ago, by a German named Friedrich Ludwig Jahn (1778–1852).

Known as the Father of German Gymnastics, Jahn was actually more instrumental in popularizing physical training and elaborating on the groundbreaking work of his countryman Johann Friedrich Guts Muths (1759–1839). A generation older than Jahn, Guts Muths spent some fifty years teaching in the progressive Schnepfenthal Philanthropic School near Gotha, where he came to believe that the German people (for there was no German nation at the time, only a loose federation of principalities subject to the Holy Roman Empire) had become weak through luxury and indolence. To counteract this growing decadence, Guts Muths began instructing his students in his version of ancient Greek physical training, which included such basic exercises as climbing ropes and poles, jumping, throwing the discus, as well as carrying sandbags and other objects. In 1793 he published *Gymnastics for Youth, or a Practical Guide to Healthful and Amusing Exercises for the Use of Schools*, which was soon translated into English, appearing in London in 1800 and in America two years later.

Although Guts Muths's book had a major impact on Jahn, the pivotal event of his life was Napoleon's defeat of Frederick William III at the Battle of Jena-Auerstedt in 1806, which subjected Prussia, Jahn's home, to French rule. Many Germans felt the loss as a humiliation, and Jahn seems to have been especially affected. Under the French his countrymen were losing their identity, he believed, and he ascribed the defeat to national decline, a weakening of the German character similar to what Guts Muths had diagnosed.

Born in Lanz, Jahn took up residence in Berlin in 1809, where he taught in various schools. On Saturdays he led students on walks outside the city and instructed them in the sorts of gymnastics advocated by Guts Muths, and it was through these sessions that he began

to connect the notions of physical strength with national strength. "The art of gymnastics," he wrote, "should restore the lost harmony in human education, add genuine physicality to merely one-sided intellectualization, provide the necessary counterweight to excessive refinement in regained manliness, and comprise and affect the whole man in the community of the young"—a belief the Bartendaz continue to espouse.

Like many others at the time, Jahn was influenced by the ideas of the French Revolution, in particular doing away with aristocratic privilege and instituting a general-conscription army rather than one of professional, often foreign, soldiers. And he possessed a temperament fiery enough to match his tumultuous era. A friend of the philosopher Johann Gottlieb Fichte and a contemporary of the painter Caspar David Friedrich, Jahn in his passions was a sort of exemplar of that Romantic idealist generation, which combined an admiration for ancient Greek culture and the struggle for freedom from absolute monarchy that, for some like Jahn, devolved into an inward-looking, racist parochialism. The German Romantic writer and scholar August Ferdinand Bernhardi, who knew him, spoke of Jahn's "one-sidedness, intolerance of opposing views, vehemence, rashness, and infringements of finer feelings and conventional forms. . . ." Yet he was also an enormously popular leader. Bernhardi adds, "All of that is virtually of no importance alongside the capability devoted to the cause, the eagerness with which Jahn pursues it, the enthusiasm he arouses, the feeling of love he bears, and the strength with which he puts this into effect."

In a treatise of 1810, Jahn declared, "It is an undisputed right to give a German thing or activity a name from the German language." A year later, when he instituted a training ground for the new, hoped-for German nation and its military in Hasenheide, on the banks of

the Spree just outside Berlin, Jahn chose to call it a *Turnplatz* rather than a gymnasium; the exercises performed there would be known as *Turnen* rather than *gymnastik*.

J ahn's was not the first outdoor gymnasium: Franz Nachtegall, who had also been influenced by Guts Muths, had set one up in Copenhagen in 1799, which led to him being named the first director of the Danish Military Gymnastic Institute in 1804. Whether or not Jahn was aware of Nachtegall's efforts remains unclear, though given Jahn's extreme nationalism, it's unlikely he would have acknowledged any foreign influence.

The *Turnplatz* itself was intentionally situated well outside the city so that younger people could walk there (adults could take a carriage), and everyone could partake of the fresh air. In theory, people of any social rank, and men of all ages, were welcome; women were encouraged to come as spectators. In actuality, the original participants would have been young men from the upper strata of society.

At first Jahn had little more than the pommel horse (which had existed in some form in Europe since antiquity), perhaps some crude dumbbells, and open turf for drills and games. Eventually these gymnastic fields would include tall masts (the scampering up of which was very much a functional exercise in the age of sailing ships), ladders, and ropes for climbing, beams for balancing, vaulting blocks, as well as a shed to store equipment. But Jahn's notable and lasting additions to the stock of gymnastics implements were the parallel bars and horizontal bar. The latter could be employed for swinging or pull-ups. Jahn initially conceived of the parallel bars as a tool for improving performance on the pommel horse, which requires considerable strength in the shoulders, upper back, and arms, as well as core stability. The first example was made by nailing two bars onto four short

tree boles. They proved so useful that they came to occupy a central place in German gymnastics, and Jahn soon began manufacturing them. For most of the nineteenth century, however, the parallel bars had no standard height, nor were the bars of a standard thickness: some were quite high, allowing for pull-ups and swinging below the bars; some had thicker bars, which demand more grip strength.

Soon after their invention, parallel bars also came to play a role in the expansion of exercise to women. As early as the 1820s, doctors in such European metropolises as Berlin, Paris, and London founded special institutes for the rehabilitation of disabled girls, and they used versions of Jahn's parallel bars for exercise treatments. Girls with musculoskeletal ailments supported themselves on the bars as they tried to walk, but young women with less debilitating problems worked with them, too. These private gymnasium-institutes became the first formal workout centers for females.

The more able-bodied participants at Jahn's hypaethral gym could use the parallel bars to perform both static holds—such as the L-sit and handstand I attempted on Muscle Beach—as well as dynamic movements, like using the shoulders to swing the torso back and forth from the support position. Both types of exercise are extremely effective, and indeed using the parallel bars is difficult enough that, until recently, few people other than trained gymnasts ventured to try them. Today you can find Bar-barians, BarStarzz, and other calisthenics posses in parks doing dips and executing such amazing moves as planches (supporting your weight on bent arms while holding the torso and legs parallel above the bars), planche push-ups, and one-armed handstands on the parallel bars. The wider embrace of parallel bars—and their migration from parks and gymnastics gyms into some CrossFit boxes—is part of a more general NFF eclecticism that includes the pursuit of all types of bodyweight exercise as an important component of building

strength, balance, and agility. Of equal importance is the powerful combination of means and metaphor that Yasin-Bradley recognized, and which in the New Frontier is so crucial to the notion of athletic practice as a model of self-overcoming: moving your body in ways you had never thought possible (getting your first muscle-up, pull-up, or dips, for example) and lifting yourself up literally and mentally allows you to achieve new feats in any area of life. For the calisthenics set, the horizontal and parallel bars have become tools for self-expression, even for performance art.

In contrast to today's focus on the individual, people at the *Turn-platz* did not show up to get their sweat on, nor did they exercise to sculpt their physiques or, for that matter, to get healthier. Explicitly aimed at military preparedness, the workouts were performed as a group, with the aim of building character and national strength, or what one Turner called "the cultivation of Germanness." Jahn himself stated his intention was "to preserve young people from laxity and debauchery, and to prepare them to fight for the fatherland in the struggle ahead." The point of these patriotic gymnastics, then, was national fitness, rather than individual physical excellence. In fact, Jahn recommended participating in them only twice per week, and while you can get quite strong—particularly in the chest, upper back, and arms—by pulling nothing more than the weight of your own body up ropes or onto bars and beams, doing so as seldom as a couple of times per week is not going to result in significant physical changes. (The fact that fitness is part of everyday life, that you need to train more days than you rest in order to achieve noticeable increases in your physical abilities, is yet another NFF insight.)

Stoked by his training and incendiary rhetoric, many of Jahn's followers joined him in Lützow's Volunteer Corps when the war to liberate the German states broke out in 1813. And though the war

was brief, victory did nothing to cool Jahn's nationalistic ardor. He threw himself into the fight for unification, helped found the first patriotic student fraternities, and nurtured the growing success of the Turner movement. A year after opening the Hasenheide *Turnplatz*, there were some 80 members; by 1814, that number had expanded to 500, and there were more than a thousand by 1817. Yet the fields of his success were also sown with the seeds of Jahn's downfall.

After the war, the *Turnvereine*, as these gyms were called, continued to provide meeting grounds for people of varying social standing, as well as those with a range of extreme political agendas, from egalitarian democrats to hot-headed nationalists—all of which was dangerous in the eyes of the state. In 1819, as part of the Carlsbad Decrees, the Prussian government, fearing that they couldn't control the political activities of the *Turnplatz*, banned gymnastics on the Hasenheide and in 1820 throughout the land. Jahn was arrested, on vague charges, and brought to prison: he would eventually be placed under house arrest for five years. The ban on the Turners did not, however, spell an end to them: they quieted their activities and reverted to calling what they were doing *gymnastics* rather than *Turnen*. Still, they continued to incubate radical political ideas, and Turners would go on to participate importantly in the revolutionary uprisings of 1848.

The Carlsbad Decrees and the ban also helped spread the principles of the *Turnvereine* through Europe and America. In 1824, for instance, two of Jahn's followers, Charles Follen and Charles Beck, emigrated to the United States, where they initiated what would become the widespread American Turner movement. Two years after arriving, they jointly created the first university gym in America, at Harvard, which was based on the Turner model. Beck went on to

become a founder of the Round Hill School in Northampton, Massachusetts, which also used Jahn's system for its gymnasium. The spread of German gymnastics through Europe was somewhat slower: it made its first Italian appearance in Turin in 1844. The first gymnastics club in Russia didn't open until 1862; in Finland in 1874.

In France, which was a bit ahead of the curve, the first center for gymnastics can be credited to a Spaniard, Don Francisco Amoros y Ondeano, who had collaborated with Napoleon in Madrid before moving to Paris and becoming a naturalized citizen. Having secured funds from the government, he opened in 1820 the Gymnase Normal, Militaire et Civil, which served students and the armed forces and operated much like Jahn's *Turnplatz*. Amoros, however, distinguished his establishment by emphasizing the trapeze, an apparatus developed during the previous century by Italian acrobats. The only mats available to break falls were piles of sawdust, which, according to a witness by the name of Dr. Wauquier, was never changed and became quite disgusting. He described workouts that "consisted of hanging by the hands or the knees on apparatuses suspended from crossbars. These gymnastics could be qualified as 'monkey gymnastics' and consisted of acrobatics and feats of strength; later there would be contests and public shows with parades accompanied by the sound of bugles and flags flying in the wind."

As the French governments changed, Amoros's gym shrunk. He lost funding for the civilian portion in 1833 and was forced to close the establishment in 1837.

B ecause the British had not lost their sovereignty to the French during the Napoleonic Wars, they lacked the same impetus for building national strength. As the historian Eugen Weber has noted, "The Anglo-Saxons paid little heed to physical training." Instead they

developed an inherently elitist games culture, which Weber points out was "a kind of conspicuous consumption," requiring space, leisure time, and often uniforms and elaborate rules, whereas "gymnastics lent themselves better to routine and mass applications, while their social uses appeared more evident."

Jahn's methods did nevertheless make it across the English Channel, in the person of Phokion Heinrich Clias, an American-born naturalized Swiss citizen, who in 1820 was appointed superintendent of physical training for the Royal Military and Naval Academies. Soon after, Clias opened a gymnasium in London, where he attracted a considerable following, due in part to his own physique. One observer wrote: "The forms of Captain Clias are the most perfect of any man who has been exhibited in England. In him we discovered all those markings which we see in the *antique*, and which do not appear on living models, from their body not being sufficiently developed by a regular system of Scientific Exercises." Clias also stands out for being among the very first to recommend gymnastic exercises to women. A *Damenturnverein*, or women's gymnastics club, didn't open in Germany until 1845.

What made the creation of German women's gymnastics possible was the lifting of the ban on *Turnvereine* in 1842, and this also resulted in an influx of new participants from a broader portion of society. Where students had made up the majority of the Turner movement in its early years, they were now joined by artisans, laborers, and members of the middle classes. It's important to recognize, however, that the gyms, the *Turnvereine*, of this era were not commercial enterprises; rather they were like social clubs that operated on municipal or public land. They were meeting spaces, and as such a novel sort of training emerged, called "intellectual gymnastics"— debate and discussion, in effect. And while often nationalistic, the

tenor of these discussions became more explicitly liberal in the years leading up to the revolutions of 1848. Jahn did not join this leftward shift. When the Democratic Gymnasts League, for instance, added its voice to the fight to produce a German parliamentary constitution, Jahn denounced the group as a bunch of "Reds."

The revolutions ignited in Germany and across Europe in 1848, attempts to overthrow old feudal structures, were swiftly put down by reactionary governments, forcing many of these radically democratic Turners to flee. It was this second wave of notably liberal gymnastic emigrants who built the Turner movement in America into an important social and political force.

Looking back on their contributions, Governor George H. Earle III of Pennsylvania in 1938 praised the German-American Turners for repeatedly making "themselves a deciding factor in the preservation of American freedom." He pointed out that American Turners had been at the forefront of the drive to abolish slavery, supporting John Frémont, the first antislavery candidate for the presidency of the United States, and helping to protect antislavery orators from violent, opposing mobs. By the outbreak of the Civil War, in 1860, there were some 150 *Turnvereine* in America with about 10,000 members. One of them, Gustav Koerner, was the first person to publicly moot Abraham Lincoln's candidacy for president; he later became Lincoln's ambassador to Spain and was a pallbearer at his funeral. Two companies of Turners formed Lincoln's bodyguard for his first inauguration, while Constantin Blandowski, a member of the St. Louis Turnverein, became the first Union officer to die in the Civil War.

In America, the social aspect of *Turnvereine* became at least as important as their fitness component, providing meeting places and support for the immigrant community, and this is true of the Swedish and Finish gymnastics clubs that formed across the country as well.

The Turner movement reaches its apex in 1914, with approximately forty thousand members. After America's entry into World War I, anti-German sentiment dealt it a severe blow. That said, Bonnie Prudden, who would go on to be one of the foremost fitness promoters of the 1950s and '60s, attended a turnverein in the 1920s, and Governor Earle could still speak proudly of the Turners in the late 1930s.

Jahn's Turner system was not the sole gymnastics movement of the early nineteenth century. With Nachtegall as an exemplar, the Scandinavians elaborated a system of their own. In 1815, under the auspices of the Swedish king, Per Henrik Ling (1776–1839) founded the Royal Gymnastics Institute in Stockholm. Having studied with Nachtegall, Ling then deepened his learning with anatomy and physiology, and divided gymnastics into three fields: military, medical, and educational. Jahn concentrated only on the first of these. Yet, as historian Horst Ueberhorst puts it, Ling's "ideological concepts were similar to Jahn's since he was also convinced that the forces of national tradition had to be re-aroused and attention devoted once again to history and Nordic mythology in order to commit the people to the great models of the past in the struggle for Sweden's freedom." Unity of purpose would be fostered, in Ling's system, through tightly choreographed and synchronized movements.

But unlike Jahn, Ling rejected the use of equipment, fearing that it might overstress the body; he allowed no weights, pull-ups, pommel horses, or other strength-oriented exercises that required an apparatus. Ling, then, continued the line of thought that rejected high-intensity, strength-building workouts, and he had a considerable influence for more than a century and a half. The London School Board incorporated Ling's system as their physical education method in 1881. When you think of those images of blond, sun-dusted European naturists engaged in group calisthenics outdoors in the nude, or seminude, it

is Ling's gymnastics that they are practicing. With its regimentation and low-impact workouts, Ling's approach proved quite popular—and continues today to be practiced in Scandinavia.

Because it was relatively nonstrenuous, Ling's Swedish free and remedial gymnastics, as it came to be known, was the model for American women's calisthenics, which Catharine Beecher elaborated in two books, *Letters to the People on Health and Happiness* (1855) and *Physiology and Calisthenics for Schools and Families* (1856). It so happens that Beecher was first introduced to rudimentary calisthenics in 1827 by an Englishwoman who employed them in the treatment of various deformities—much as they were practiced in the gymnasium-institutes for young women at that time. Far from being a feminist, Beecher thought of exercise as training for family life and aimed to teach young women to "move heads, hands and arms gracefully; to sit, to stand and to walk properly." To this end she prescribed deep-knee bends, curtseys, knee raises, leg extensions, as well as hand and arm movements, some with light weights.

By the latter half of the nineteenth century, the ideal of national strength and health had been given fresh impetus from recent fears of racial decline: it was thought whole peoples were becoming decadent. Miroslav Tyrš, a Czech citizen of the Austro-Hungarian Empire, echoed the sentiment: "Only decayed nations perish," he wrote. Having studied philosophy, he became convinced that the health of its citizens was intricately linked to the viability of any country's existence, and so he developed a type of patriotic gymnastics, based largely on Jahn's system but, like Ling's, devised for synchronized mass participation. "There is an inner connection between the elegance of movements and a good structure of the body," he wrote, emphasizing the aesthetic impact of the group's effort over any indi-

vidual expression. "Every harmonious movement requires control of the whole body, not only of the one part by which the movement is being executed."

Tyrš, with Jindřich Fügner, established the first Sokol (from the Slavic for *falcon*) club in Prague in 1862. Liberal, democratic, humanist, though highly nationalist in character, from the start it combined exercising with lectures and discussions. From Prague the Sokol movement spread throughout the Slavic region, to Poland, Serbia, Bulgaria, Russia, the Slovene countries, and to America, where the first Sokol organization was founded in St. Louis, in 1865. It was, however, in the Slavic countries that the system had the deepest impact, as *slets*—mass gymnastics festivals that combined demonstrations, competitions, orations, and performances—were held throughout the Austro-Hungarian Empire. Like the Germans with *Turnvereine*, Czech and Slovak immigrants formed Sokols in the United States, where they exist today.

Both the *Turnvereine* and the Sokols were banned by the Nazis, and the former, with its Teutonic associations, slowly died out in the United States after World War II, while the latter were also outlawed by the Soviet Union. Yet at the same time the Nazis and Soviets adopted many of Jahn's and the Sokols' principles for their respective mass demonstrations. From Jahn to Yasin-Bradley, people have recognized what the Greeks first proposed, that gymnastics is inherently political: the state is not only like a body, it is composed of bodies whose physical expressions can either support or rebel against it. In the twenty-first century, Jahn's methods continue vibrantly in the individual sport of gymnastics, as well as among calisthenics enthusiasts and CrossFitters. And politics courses through all three: gymnastics remains a highly nationalistic sport in international competitions like the Olympics; calisthenics groups aim at community

uplift; and CrossFit (unlike aerobics or boot camps or ordinary gyms) has from its outset been involved with such causes as Wounded Warriors and Barbells for Boobs, and it has been explicitly feminist in its approach. I would argue, too, that even at its most individual, NFF pursuits are a means of resisting a number of sociopolitical forces, from Big Pharma and the sugar lobby to the culture of ease. When bodies speak, it is never with a neutral tongue.

5

HERCULES AND THE ATHLETIC RENAISSANCE

Had you visited the Prada Foundation in Venice, Italy, during the summer of 2015, you would have come upon a room, in an exhibition called "Portable Classic," featuring reproductions from the last five hundred years of a statue known as the *Farnese Hercules*. A massive sculpture in marble standing almost ten and a half feet high, the "original"—itself a Roman copy of a lost Greek work—depicts the mythical hero nude like an athlete, the better to show off his bulbous, rippling musculature. He stands with his left foot forward and right arm bent behind his back, so that the cephalic vein stands out on his biceps, emphasizing the thick ridge of his triceps running up to his gourdlike deltoids. In contrast to his woolly hair and beard, the torso is smooth, rendering the deep lines defining the abdominal, pectoral, and latissimus dorsi muscles clearly visible. His left arm is draped over a club, which crutches his armpit, and his head tilts lazily above it: though built like a deity, he is weary from his labors, and thus very much a man.

Imagine for a moment you were one of those amateur archaeologists who unearthed the statue in 1546 from the Roman Baths of Caracalla. You would likely have never seen your face or body

reflected in a mirror. Your encounters with other unclad male bodies would have been restricted to family members and the occasional river bather, none of whom would have had a developed physique. On the contrary, childhood diseases, poor sanitation, and possibly malnutrition would have left your countrymen scrawny. Consider, then, the wonderment caused by the *Hercules*, which would have appeared like a lost member of some alien race or like a god—it

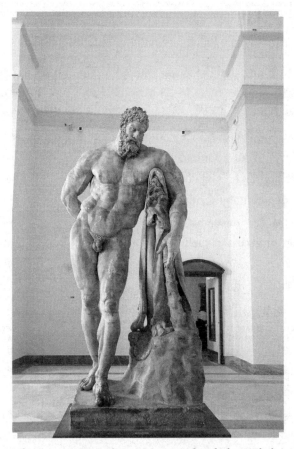

The Farnese Hercules. *(Courtesy of nadiology/Flickr)*

would have suggested heretofore unimagined possibilities of human potential.

One measure of its impact is that the *Farnese Hercules* became one of the most reproduced images of the Renaissance, in sculptural versions ranging from pocket size to scale models—many on view at the Prada show—while printed reproductions, often with the muscles even further accentuated, circulated throughout Europe, influencing the exaggerated musculature of much Mannerist art. The *Hercules* was seen almost exclusively in reproduction because, in the years after it was found, it belonged to Cardinal Allesandro Farnese, who kept it in his palazzo in Rome. Two people who almost certainly encountered the work on an almost daily basis were his physician, Hieronymus Mercurialis, and an artist, Pirro Ligorio, both of whom lived at the palace in the 1560s. During that decade Mercurialis wrote the Latin treatise *De Arte Gymnastica aput Ancientes* (1569), the era's most important book on fitness; Pirro Ligorio provided the illustrations—of nude, hugely jacked men exercising, figures too fanciful to be based on direct observation.

A compendium of ancient athletics, *De Arte Gymnastica* was based on the work of Galen, for almost nothing had been added to the knowledge of fitness in the intervening fifteen hundred years. For his part, Mercurialis concluded that exercise is of primarily therapeutic and preventative value; unlike others who encountered the *Farnese Hercules*, he wasn't particularly concerned with bodily development, yet in time the statue would expand tremendously our sense of physical potential. *De Arte* stands out for being the first such volume to gain a wide readership since antiquity. However, there were others before Mercurialis who gave lip service to the desirability of exercise. As early as 1531, Thomas Elyot, an Englishman who also derived his knowledge of fitness from Galen, had advised "labouring with poises [weights] made of lead or other metal called in latin *alteres*, lifting

and throwing the heavy stone or bar, playing at tennis, and divers semblable exercises." In recommending tennis, Elyot already displays the English penchant for games and sports that would distinguish its fitness culture in the nineteenth and twentieth centuries.

A number of years after Elyot, the German scholar Joachim Camerarius brought together classical knowledge of exercise for his 1544 *Dialogues des Gymnastica*. Still, none of these books inspired people to open gyms, nor did they quickly bring about a change in the understanding of exercise. Mercurialis's recommendation of climbing ropes, for example, was ridiculed by courtiers as "rope-dancing," a waste of effort. Because books, like prints and sculptural reproductions, were rare, circulating only among the elite, few had access to them. Without ideals to compare themselves to, and lacking mirrors to contemplate their own forms (the Venetians began producing flat, mercury-backed mirrors—a process known to the Chinese since about 500 CE but highly restricted in application—with good, undistorted resolution in the fifteenth century, but the process remained tightly guarded for centuries and the objects themselves were wildly expensive), little impetus exists to reflect on one's own physique or its relationship to one's health. Artists who sought out classical sculptures and sketched nude models were among the only people who had the opportunity to compare contemporary bodies with those idealized in marble and bronze. The painter Peter Paul Rubens, for instance, opined, "The principal cause of the difference between men of our age and the ancients is the sloth and lack of exercise of those living; indeed one eats and drinks, exercising no care for the body. . . . By contrast, in antiquity, everyone exercised daily and strenuously in palaestras and gymnasiums." Citing *De Arte Gymnastica*, he makes the novel claim that men can transform their bodies, and that through exercise muscle will grow, "fed by the juices which the heat of activity attracts."

T he mechanism by which muscles are developed wasn't understood until the nineteenth century, but a tiny yet notable number of people before then had the leisure time and inclination to work out. Ligorio's illustrations for *De Arte* depict men in loincloths (the better to show off their comic-book superhero musculature) as they raise sandbags, twist with rectangular plates (presumably iron), and swing halters or primitive dumbbells. His scenes were imagined; in actuality, it was the dumbbell that eventually became the tool of choice for those seeking strength, and again it seems Mercurialis was the impetus.

For more than a century after *De Arte* appeared, scant references to exercise can be found. Yet after a new edition was published in 1672, mentions of dumbbells and other exercises increase considerably. Joseph Addison wrote in a 1711 edition of *The Spectator* that as a younger man he'd learned of a "laborious diversion" from *De Arte*, "called fighting with a man's own shadow; [which] consists in the brandishing [of] two short sticks, grasped in each hand, and loaded with plugs of lead at either end. This opens the chest, exercises the limbs and gives a man all the pleasure of boxing, without the blows." He also recorded that, "[f]or my own part, when I am in town, I exercise myself an hour every morning upon a dumb bell that is placed in a corner of my room, and [it] pleases me the more because it does everything I require of it in most profound silence." Addison here plays on the meaning of *dumbbell*, then a brand-new word referring to something that resembles a church bell but without a clapper, and thus is mute, dumb. And like bells, hand weights in the seventeenth and eighteenth centuries were swung, like Indian clubs, rather than pressed or curled as they are today.

By the end of the eighteenth century, when the English boxer Tom Owens was reported to wield dumbbells in his training and the

American Benjamin Franklin attributed surviving past eighty to his regimen of living "temperately," drinking no wine, and daily exercise with "the dumbbell," the implements were replacing weaver's sticks (usually wooden dowels with a weight appended from a string or rope) as the most common exercise implement. They survived too the popularity of Indian clubs, which the British army took up in the early 1800s, and which became steadily more prevalent (like all forms of exercise) over the course of the century. Indeed as Europe and the United States experienced rapid industrialization in the first half of the nineteenth century, urban centers swelled with laborers and the unemployed, as well as the new phenomenon of white-collar workers forming a burgeoning middle class. Slums were packed, while sewers, garbage collection, and other sanitary measures had not yet been implemented to degrees sufficient to mitigate outbreaks of disease like cholera. Clerks and bookkeepers suffered the consequences of their sedentary existence: obesity, flabby muscles, lassitude. A number of health reform movements arose in response to these conditions, encouraging vegetarianism, temperance, sexual moderation, and exercise.

While today digital media allows us to learn instantly about new acrobatic and strength feats, approaches to training, and research into fitness, the dissemination of such knowledge was slug-slow before the twentieth century. In an 1836 essay called "Economy of Health," Dr. James Johnson complained that gymnastics had failed to take root in Britain because it was far too rigorous for "pallid sons of pampered cits [*sic*], the dandies of the desk, and the squalid tenants of attics and factories." But it is equally likely that most Britons had not yet heard the gospel of exercise and wouldn't have known what to do even if they had. Indian clubs, which can be swung at

home, were largely unknown to the pubic at large until 1838, when Donald Walker published *British Manly Exercises*, which historian Jan Todd calls "perhaps the most influential book on purposive exercise published in English during the 19th century." Yet we need to bear in mind that even periodicals and books like Walker's were quite scarce and not readily obtained until the latter half of the century. It was traveling circuses, and particularly the strongmen among the attractions, that dispersed much of the information about what people could achieve physically and how they might do it.

One such troupe of itinerant Italian performers stopped in Nice, France, in the second decade of the nineteenth century, and acquired from some gypsies a child of six (how is not known: he was either purchased by or abandoned to them). The child, Hippolyte-Antoine Triat, who had been born in 1813 in Saint-Chaptes, performed a wirewalking act with the troupe for seven years under the name Young Isela—they dressed him as a girl. After the Italian group split up, he joined a family known as the Alcides, in a weightlifting and strongman act that toured their native Spain, where Triat became known as the Kid.

After three years on the road in Spain, Triat, whose life was never short on incident, found himself in the northern town of Burgos, where, in the process of saving a woman named Madame Montsento, a runaway horse trampled him. Grateful to Triat, Montsento became his benefactor, paying for the teen's education at a Jesuit college. While there he continued his physical pursuits and, in the school's library, studied the available texts on exercise, notably Mercurialis's *De Arte Gymnastica*. The ideas he sopped up would later help make Triat an exemplary type in the fitness culture of the nineteenth century: an entertainer turned thinker, health reformer, and entrepreneur.

Upon leaving school and Burgos, Triat returned to performing his

strongman act. His sole biographer, Edmond Desbonnet, claims it included a physique-posing component similar to the one the Prussian-born strongman Eugen Sandow is thought to have originated much later in the century—significant since Sandow is considered the first bodybuilder—yet he describes only one facet of his act featuring, "a revolving column from which [Triat] would hang by his hands, feet, or chin and lift horses and men. Thanks to this device he garnered a huge success first in Spain and later in England."

Had he continued his wayfaring, Triat would have had a career similar to other midcentury strongmen, but he was a surpassingly intelligent and forward-thinking individual whose influence is still with us today. It began modestly, when Triat decided to settle in Brussels and, in 1840, open a gymnasium. We know little about the place other than that it was located in a fashionable district and was so newfangled, unlike anything seen before, that it succeeded in attracting many visitors. The world of exercise was heretofore limited to a few implements in a handful of isolated homes and to the outdoor gyms that the Turner movement was slowly introducing to Europe and America.

Over the course of the decade, however, the first indoor training facilities began to open. In New York, where in 1848, for instance, a merchant's clerk and workout fanatic named Edward Tailer wrote in the *New York Enquirer*, "It is particularly recommended to those of sedentary habits, to undergo the training which is to be found [at a gym on Crosby Street near Bleecker Street, in Greenwich Village]." There "narrow and contracted chests are soon turned into broad and expansive ones, and the puny limbs of him who is not accustomed to exercise are soon changed into well developed and finely formed ones, and he imperceptibly finds himself re-established in health and strength."

The Crosby Street gym was probably run like a social club, and we can surmise that, though popular, Triat's establishment in Brussels was probably not operated with profitability in mind, either, for over the course of the nine years the gym existed, he tried and failed to attain government backing for it. The existing models—*Turnvereine*, Scandinavian *gymnasia*, and the gyms that grew up in their wake—were either state-supported, semipublic institutions or dues-collecting patriotic or ethnic societies. But in 1850, Triat changed everything. He relocated to Paris and opened the world's first commercial gym. No longer is fitness just about military readiness or patriotic duty, nor is it merely about health; instead, it is about looking and feeling better. And in 1835, thanks to the development of the first mass-produced silvered-glass mirror, ordinary people could regard themselves at home in private, which meant they could assess how they looked more readily than ever before. Triat recognized that the newly emergent middle class had both the leisure time to attend to such aims and the money to pay for it. In earlier eras, as Catharine Beecher wrote, "We obeyed the laws of health, not from *principle*, but from *poverty*."

Triat understood, too, the inherent entertainment value in watching people exercise—in watching bodies move—and, drawing on his own background, he turned his gym into what the novelist Paul Féval, a visitor, called, "a theater where each participant can be an actor." It was a spectacular place, forty meters long and half as wide, designed, at least to Féval's eye, as a "vast cathedral" replete with nave and transept, "an altar to hard work." Already this description reflects the confusion of fitness with religion that will play out more explicitly toward the end of the century. The ten-meter-high ceiling allowed for observation balconies, as well as a profusion of ropes, ladders, hanging rings, and poles, while the floor boasted the usual

gymnastic equipment—parallel bars, horse, dumbbells, Indian clubs, iron wands—as well as something entirely new: barbells, a tool Triat is credited with inventing. Whether or not they actually originated with him, the barbells at Triat's gym are the first on record. It would be another several decades before the implements became commonplace, even among vaudeville strongmen: Historian Jan Todd notes that the first known strongman to use globe-end barbells was the Austrian Karl Rappo, who died in Moscow in 1854, but they don't appear in illustrations or notices until the 1880s.

Of course, women and men filled the viewing galleries not to see novel instruments but to take in the show. Lit by gas-jet torches placed throughout the space, the workouts were performed as a group in synchronized movements, the rows of men in a uniform of red tights and bare chests, with Triat leading them, a silver-filigreed staff in hand. A snare drum kept time for the ensemble, and the choreography was complex, which rendered it visually appealing though difficult to master. And unlike most of the earlier, Turner-inspired gyms, Triat's gym welcomed not only men of all ages, but women and children, too. For the women, he hired female instructors to lead their classes.

From the start the gymnasium proved a conspicuous success, attracting many from the court of Emperor Napoleon III, including, reportedly, the emperor himself. Maintaining facilities lavish enough for the aristocracy and middle classes was expensive, but Triat's solution was as innovative as any of his achievements. In 1855 he began selling shares in the business, eventually raising five million francs. Purchasers could redeem stock for three-month courses at the gym. Within a few years, others were inspired to open similar establishments, and one, in Liverpool, England, copied Triat's almost exactly. By 1860 there were some twenty commercial gyms in Paris alone, a few exclusively for women.

The one extant photograph of him captures Triat in the nude, leaning against a classical pedestal large enough to hold a statue of a Herculean figure like him. The photo is a side view, with his slablike lats and bunched glutes visible. He leans his bearded, shaggy head on a bent arm, as if in contemplation. It's remarkable not only for being a very early image of a strongman, but also because the photo's staging manages to capture so many of its subject's roles. Showman, charlatan, promoter, entrepreneur, genuine health reformer: Triat, with all his contradictions, is the prototype of the characters who will follow him into the fitness industry he launched.

He was an exemplar, too, of that countercultural spirit that characterizes the pursuit of fitness. Although a pioneering capitalist, Triat sided resolutely with the political left, indeed with revolutionaries. He believed not only in the "regeneration" of bodies, to use his term, but also in the radically democratic project of granting all bodies representation in the political arena. In the turbulence of the early 1870s, he supported the Communards, befriending one prominent figure, the feminist and socialist Jules Allix, whose two daughters came to work at Triat's gym as instructors. Since the early days of the Turners, gymnastics had been associated with social leveling and republican causes: Triat went a step further, giving his space over to the Communards for meetings and becoming, under the brief Paris Commune, the director of physical education. After the Commune was put down, in 1872, the succeeding government confiscated his gymnasium, ruining Triat. He died impoverished, depressed, and forgotten.

The nineteenth-century confluence of liberal or leftist politics and physical training occurred in philosophical waters. Traditionally, it was believed that you were as God made you: good or evil, weak or strong, sickly or robust, ugly or comely. The early nineteenth

century, under the influence of Jean-Jacques Rousseau, established an alternative view, the notion of perfectibility, which argues that people can improve over time. As formulated by such thinkers as William Godwin, perfectibility referred to the moral state of man, but his daughter, Mary Shelley, in her 1818 novel *Frankenstein*, suggests that people also conceived a corporeal dimension of the doctrine. Triat's gym gave practical expression to this notion—that strength, health, and beauty (Triat's watchwords) are attributes that can be acquired and advanced rather than being inborn traits.

Indeed, throughout the course of the nineteenth century, a palpable shift occurs, from thinking of bodies as merely being to imagining what they might become. Perhaps no one social intervention changed *what* bodies represent—potential—more than the advent of photography, which forever altered *how* bodies are represented. The photograph, that "mirror with a memory," as Oliver Wendell Holmes Sr. called it, became commercially available in the late 1840s and, because easily disseminated, spread widely throughout the 1850s, allowing people to make comparisons between themselves and others as well as between earlier and present versions of themselves. Nudes appeared early in the history of the medium, granting widespread access to various physiques for comparison. Memento mori, images of the deceased, were also common, no doubt spurring meditations on health and the fragility of the body. Photographs also helped spur on the era's craze for measurement and evaluation, which is evident in such newly created fields as anthropometry, phrenology, and racial typology.

Photographic images formed the basis of comparison between supposedly "deviant" types—criminals and the like—and normal people, reflecting a theological as well as social change: terms like sin and grace were being replaced in the public sphere by notions of

degeneracy and health. This was part of a general effort to square religion with the booming expansion of scientific knowledge. If humans are perfectible and bodies can improve, then they can, by the same logic, deteriorate—and, it was feared, whole races could also degenerate. Against the possibility of degeneracy, a social gospel arose in England known as Muscular Christianity, which, in the words of its chief exponent, Charles Kingsley, holds "that a man's body is given him to be trained and brought into subjection, and then used for the protection of the weak, the advancement of all righteous causes, and the subduing of the earth which God has given to the children of men." (Like perfectibility, Muscular Christianity traces its intellectual origins to Rousseau, in this case to his concept of heroic masculinity.) It provided a Christian avowal of physical exercise and bodily health, of a sort of masculine self-sufficiency and strength, but also of a bigoted, violent machismo. The phrase itself was originally derogatory, minted in an 1857 review of Kingsley's novel *Two Years Ago*, where the Muscular Christian conjured an ideal figure, a sort of roving, hunting strongman, who "breathes God's free air on God's rich earth, and at the same time can hit a woodcock, doctor a horse, and twist a poker around his fingers."

The irony of Muscular Christianity, however, is that while it is seen as extending Christian tenets to the realm of athletics, it actually provided an excuse for ignoring traditional religious proscriptions against idolizing the inherently sinful body; in other words, it represents a relaxing of theological strictures against attending too much to corporeal and temporal matters, giving believers permission to play sports and work out. Versions of Muscular Christianity thrive today—in, for instance, tattoos popular with athletes that "creatively" translate Philippians 4:13 as "I can do all things through Him [or Christ] who strengthens me" (rather than "through him who gives

me strength"); the "Touchdown Jesus" mural at Notre Dame University stadium; and the professions of faith that inevitably follow a goal scored or game won. I'm not questioning the faith of the Victorian Muscular Christians or today's; rather, I'm describing a theological loosening that began in the mid-nineteenth century, what Sloterdijk calls "the informalization of spirituality," which took place alongside the despiritualization of asceticism. On the one hand, what is permissible under the aegis of religion expands, while on the other people instigate untried ascetic training practices to help them surpass themselves, build "over and above" themselves, in Nietzsche's phrase.

One character in an 1869 novel by Moses Coit Tyler (himself an ex-minister) exemplifies this combination of pliable interpretation of scripture and despiritualized exercises when he argues that "[e]very village that has two churches now" ought to combine the congregations "to worship in one building and to practice gymnastics in the other." Certainly nothing typifies informal spirituality more than the self-help movement, which also originates at this time, with the publication in 1859 of the bestseller *Self-Help* by Samuel Smiles (whose first book, not incidentally, was *Physical Education*). Where religion was once the sole avenue to improving oneself, there is now a multiplicity of exercises, the physical variety foremost among them.

I ncreased leisure time, rising wages, the perils of sedentary work, physical ideals to which one might aspire, and the lowering of religious bars to participation in exercise all combined in a thoroughgoing revolution in the way people in the Western world related to their bodies: it was a sea change that has come to be known as the Athletic Renaissance, a flowering that began around 1860 and reached its apogee at the turn of the century.

Even more than by training in gymnastics, strength, or endurance,

this renaissance is marked by the codification of sports and games. In England, the rules of football (soccer) were formalized, rugby was created, and the modern game of tennis received its guidelines. In 1877, the first championships were held at Wimbledon; the first golfing open took place in 1861 (though it, like croquet, was given formal rules in the eighteenth century); and in 1867 the Marquess of Queensberry Rules for boxing were published. The first official baseball association, the National League, was established in America in 1876, though the sport itself had been born early in the century; basketball was invented in 1891 in Springfield, Massachusetts. The first public exhibition of hockey was held in 1875 in Montreal. And, of course, the first Olympic Games, conceived by Pierre de Coubertain as an international sport competition, took place in 1896.

This book only covers the history of sport in passing, for although you can get fitter by playing sports, fitness is only a small part of why we engage in them—more commonly we train in order to be better at a sport, or at many of them. That said, all athletic activities, from archery to tennis to weightlifting, exist on a continuum, the opposing poles of which are play and work. For some, swinging Indian clubs is pure play, for others utter drudgery. Little surprise, then, that as the Athletic Renaissance surged to multinational proportions in the early years of the twentieth century, those pursuits more commonly seen as training, which falls closer to the work end of the spectrum, attracted fewer people in the broader public sphere than the more ludic sports and games.

At the beginning of this resurgence, however, the question remained: how ought we train? At first, the choices were likely to be determined by background and locale as much as by preference. Per Ling's Swedish gymnastics held sway throughout Scandinavia and in those parts of the United States where Scandinavians had settled,

German gymnastics in German-speaking lands and those areas where Germans had settled, and hybrids of these systems incorporating circus acrobatics, such as trapeze work, had grown up in barns and gyms throughout Europe and America, each with its own emphasis.

Into this mix marched Dio Lewis, whose 1862 book, *The New Gymnastics for Men, Women and Children*, proffered a critique of the older version: "The ordinary gymnasium offers little chance for girls, none for old people, but little for fat people of any age, and very little for small children of either sex." Lewis's popular method, which owed much to Ling's, employed drills with such lightweight implements as wands and Indian clubs, always to musical accompaniment. Soon after the book was published, Moses Coit Tyler introduced the system, under the name Musical Gymnastics, to England, where it was also well received. Yet Lewis is of interest in this story as much for what he abhorred—heavy weights—as for what he offered in their place.

In the summer of 1854, a young man named George Barker Windship was traveling through Rochester, New York, when he joined a crowd that had gathered around an early strength-testing apparatus, of a type that had recently begun popping up in fairs and circuses. The machine was based on a prototype devised in the early eighteenth century by John Theophilus Desaguliers, a French-born natural philosopher living in London, for investigating the feats of such early strongmen as Thomas Topham. Likely a very simple partial-deadlift apparatus, it would have consisted of a platform on which you stood to raise a weight (often a barrel filled with lead pellets) a few inches off the ground, either by grasping a handle with a rope or chain attached to it or by attaching the rope to a belt around your waist.

Windship decided to try his hand—and back, legs, and hips—at the test. Four years earlier, he'd arrived at Harvard a scrawny five-

foot-tall, hundred-pound munchkin, by his account the smallest young man in his class. To bulk up, he devoted himself to gymnastics, and by now considered himself quite strong. But his effort, raising a meager 420 pounds a few inches off the ground, failed to impress both the crowd and himself. (As a point of comparison, in 1930, Ivy Russell, a female English lifting enthusiast who had a svelte 134-pound bodyweight, was able to deadlift—pulling the barbell fully to the waist—more than 410 pounds.) Windship later recalled, in an 1862 essay, that the experience caused him to realize "that main strength, by which I mean the strength of the truckman and the porter, cannot be acquired in the ordinary exercises of the gymnasium." The gymnastics Windship had been practicing emphasized the upper body at the expense of the legs and back (this was common at the time, since people walked considerable distances or rode horses to get around, and thus assumed their legs were sufficiently worked). Nor was he likely to have been wielding heavier dumbbells or other hand weights, which were not in frequent use at the time: although you can get quite strong and muscular doing such bodyweight exercises as pull-ups and push-ups, Turners and other gymnasts were only then beginning to learn that heavier weights will make significantly higher levels of strength attainable.

In the fall, Windship entered Harvard Medical School and, on a visit to the art galleries of the Boston Athenaeum, encountered a statue that completely revised his sense of what is possible muscularly; it was the *Farnese Hercules*, presumably in one of its many reproductions. "From this," he wrote, "I derived a proper conception of the bodily outline compatible with the exercise of the greatest amount of strength." The male physique of his childhood was the opposite of what he here beheld. In 1839, Francis J. Grund noted in a travel book: "An American exquisite must not measure more than twenty-

four inches round the chest; his face must be pale, thin, and long; and
he must be spindle-shanked. . . . weak and refined are synonymous."
Seeing what muscular strength might actually look like decisively al-
tered Windship's approach to training. "Some years earlier I might
have been more attracted by the Apollo Belvedere; but it was a Her-
cules I dreamed of becoming, and the Apollo was but the incipient
and potential Hercules."

I had a similar experience, though in a more contemporary version.
One day in 2008, I ran into a friend who told me she'd come
across a website run by "fitness maniacs, people doing totally crazy
things—they work out so hard they throw up. Anyway, I thought of
you."

In retrospect, I suppose the fact that I sprinted home to find the
site, crossfit.com, without noticing she'd basically called me a maniac
proves my fanaticism. Once home and booted up, I clicked about
through the section of videos, landing at random on one from 2007,
"Heavy Fran (Greg A.)." It begins with some diesel-driven hard rock
and a spartan gym, notably mirrorless. The bare room has some
bumper plates piled against a wall and an open cargo bay door. A
youngish guy, whose bald head made his age difficult to determine, is
standing barefoot, shirtless, and in board shorts. He briefly caresses a
pull-up bar before addressing a brute, 135-pound barbell set up on a
rack next to it. The workout consists of him alternating between rapid
sets of pull-ups with 45 pounds belted to his waist and thrusters with
the barbell. I recall being equally struck by his performance, which I
keenly wanted to emulate, and his physique, about which I was much
more ambivalent. It wasn't admiration at first sight—more like fasci-
nation, tempered by the squeamish sense that someday I'd probably

end up like that. Back then my ideal was, like the early Windship's, closer to the *Apollo Belvedere* or perhaps Michelangelo's *David*. To my eye, Greg A. was very much a mass, but a mass of paradox: heroically muscled yet not like anyone I'd seen at the gym. He was at once thicker and more cut, his musculature dense as iron rather than ballooning out at the biceps and chest, distinctly nonsteroidal. Not a sports car or a Mack truck, but rather a muscle car of a man—built for speed, power, and lethal force.

It turns out many serious male CrossFitters were, for whatever reason, first hooked by that particular video, while females inclined toward another, the equally impressive "Nasty Girls." Nowadays people are more likely to discover CrossFit, Parkour, or Olympic lifting on social media, but it's all a version of Windship's experience. As he says, "We are the creatures of imitation."

And therein lies a truth that hasn't fully penetrated into popular consciousness—that our standards of beauty (and attractiveness), be they for people or artworks, are entirely conditioned by our experience. There is no pattern of the beautiful, no essential form that all people find attractive. When I first saw Greg Amundsen in the "Heavy Fran" video, I thought he was a bit too big; now his body seems entirely common, not unlike mine. If you think muscles on women are too masculine and unappealing, that's almost certainly because you're not around women who lift weights (but you will be and your standards will evolve, or be superseded). Look at Hollywood movie stars, magazine advertisements, or kids' action figures over the last fifty years, and you will find that the men are far more jacked (Sean Connery's 1962 James Bond looks deflated and anemic next to Daniel Craig's chiseled bod of 2006), the women tighter and more cut, and the action figures comically pneumatic.

U rged on by seeing the *Farnese Hercules*, Windship embarked on a series of experiments in weight training. He kicked them off by constructing his own version of the lifting apparatus he'd encountered in Rochester: a barrel sunk into the ground, filled with stones and gravel, with a rope and handle attached to it. From a platform he constructed above it, Windship would grasp the handle and, by straightening his legs, raise the barrel a few inches. After a couple of years working with this equipment, he was able to lift 700 pounds, and by the time he graduated from medical school, in 1857, he'd accomplished an 840-pound lift. The satisfactions of incrementally adding weight enthralled the young Bostonian. "I discovered that with every day's development of my strength," he wrote in 1861, "there was an increase of my ability to resist and overcome all fleshly ailments, pains and infirmities—a discovery which subsequent experience has so amply confirmed, that, if I were called on to condense the proposition which sums it up into a formula, it would be in these words: Strength is Health." He went on to become the first promoter of heavy lifting in America and arguably the most important of the era.

Windship's experience with progressive resistance, adding a little more weight each day or week, also led him to invent devices that would change forever the way people exercise. By 1860, he had managed to get 1,260 pounds off the ground, but his grip strength would allow no more with his handle-and-barrel contraption. After some tinkering, he devised a solution: a wood yoke that fit over the shoulders and had iron chains attached to it. At his best, he lifted some 2,200 pounds with this contrivance.

His feats also gained Windship some local notoriety for his strength. During his first year of medical practice, a visitor looking over Windship's lifting device challenged him: "If you are as strong as they tell me, what is to prevent your seizing hold of me, (I weigh

only a hundred and eighty pounds,) holding me at arm's-length over your head, and pitching me over that fence?" The doctor, who with his yoke had been primarily training his back and legs, told him he could satisfy the visitor in six weeks. He then found an oblong box with handles, filled it with bricks, and began training with it. Windship recalls that when he informed the man he was ready: "He came, when, seizing him by the middle, I lifted him struggling above my head, and threw him over the fence before he was hardly aware of my intent. As he was somewhat corpulent and puffy, and the act involved an abdominal pressure which was by no means agreeable, he expressed himself perfectly satisfied with the experiment, but objected very decidedly to its repetition."

The incident made Windship realize he ought to exercise his upper body in addition to his lower. He acquired some 50-pound dumbbells and, on hearing that a Mr. James Montgomery, owner of the gym at Bleecker and Crosby Streets in New York, regularly used 100-pound dumbbells, found a pair of those, too. More important, Windship apparently developed a barbell—itself highly unusual at this time—with an entirely new and consequential feature: the ability to vary the weight. There were two hollow 68-pound globes affixed to the ends of a bar, but the implement could be unscrewed at the handle and lead shot poured into the spheres; by varying the amount he could change the weight. In 1865, he also patented the design for a graduated plate-loading dumbbell—in which the weight varied by adding or subtracting flat metal plates from the ends. These devices revolutionized weight training by demonstrating that strength could be gained by progressive overload (slowly adding weight to one's lifts), making the theory easily practicable, and eventually allowing for the standardization of lifts.

Although progressive resistance training has been understood

intuitively for thousands of years, since Milo of Kroton, knowledge of it was restricted to disparate pockets of individuals. Through advertising, Windship's devices broadcast the notion of progressive weight training and made the concept underlying them concrete.

Though an innovator, Windship wasn't the sole advocate of heavy lifting at this time. In 1852, the *Illustrated London News* reported that James Harrison, a physical culture promoter and educator who called himself Professor Harrison, routinely swung 37-pound Indian clubs and that his heaviest was 47 pounds. With his 1866 book, *The Indian Club Exercise*, Simon Kehoe—who had met Professor Harrison and learned about the exercise from him in London—introduced club training to the United States. In it he testified that, in an exhibition, strongman Charles Bennett, the "California Hercules," had held clubs weighing 52 pounds "in each hand at arms length, with ease."

Cheaper book publishing, newspaper accounts, and magazine articles such as Thomas Wentworth Higginson's widely influential "Gymnastics" (*Atlantic Monthly*, 1861), which discusses Windship approvingly, opened new avenues for publicizing information about exercise methodologies like progressive overload. Windship, whose exploits would be thoroughly covered in the press, sought to spread the gospel that Strength is Health. Rather than repeat the fat-man toss, however, he decided to give a public lecture. While informative, such lectures and demonstrations were then a form of entertainment, not unlike a television talk show. Windship's first attempt, in June 1859, meant to be a talk and then demonstration of his ability to lift more than 900 pounds with his yoke, went poorly—he fainted, rose, and fled the hall.

One benefit of weight training is that it inures you to failure: few personal bests are achieved without numerous botched attempts, often in public. (Among NFF methodologies, CrossFit is unique, and

thus especially instructive in this regard, because you chase failure on a daily basis. In each workout you go as hard as you can, pushing the intensity level until you can go no more; success means failing better, getting a few more reps or doing them a little faster, until you can do no more.)

So Windship soldiered on, spending nearly every week for the remainder of the season in a different city, speaking to appreciative crowds and approving reviews, eventually becoming known as the American Samson. His feats included jerking a 180-pound dumbbell overhead; raising 100-pound dumbbells in each hand overhead, one after the other; executing twelve single-arm pull-ups; doing a chest-to-bar pull-up with only his pinkie; and climbing an inclined ladder with one hand. Windship is also credited with staging the first weightlifting contest in America, in 1861 at Bryan Hall in Chicago. Considerably larger than the five-foot-seven 150-pound doctor, his opponent, Mr. Thomson, lost the first round when Windship partially deadlifted kegs of nails strung together that weighed 1,100 pounds. But for the second round Thomson had a trick up his sleeve: a hip harness that he would pit against Windship's wooden shoulder yoke. The muscles of the hips and legs being much stronger than those of the upper back, Thomson bested Windship by hoisting 2,106 pounds. Although he lost the contest, Windship learned from the experience, eventually using a hip harness of his own design to raise some 2,600 pounds.

With his exhibitions, lectures, and articles, Windship—along with others—kicked off a fad for lifting heavy weights that spread across America. During the Civil War his travels were curtailed, however, and so the doctor established a medical practice based on weight training and other exercise. A newspaper account from 1863 reports the office was "daily thronged with the curious as well as those who

are desirous of learning the art of how to be strong. In one corner of the room stands his famous lifting machine. This consists of a solid frame-work of wood, about seven feet in height, with a platform about halfway up upon which the doctor stands to go through his daily exercise. A shoulder bar and two heavy chains form the connection between himself and the weights, which by the way are suspended directly under the platform and consist of iron disks of a circular form. . . . They are arranged in this manner so as to graduate the weight."

The commercial success of his equipment aroused others to enter the field, and soon a number of devices hit the market. "Lifting machines sprang up in parla [parlours] and offices and schools everywhere," Dudley Allen Sargent noted. J. Fletcher Paul's Health-Lift Company sold a handle deadlift machine similar to Windship's, though the doctor's primary rival was David P. Butler, who marketed the Lifting Cure, along with his own machine. Butler's company, which by 1871 operated five gyms in New York City as well as branches in Boston, San Francisco, and Rhode Island, lofted the most fanciful claims, asserting that his program would retool its users to so-called perfect form, causing for instance shorter men to grow to average height and taller men to shrink to the norm. More credibly, all three men assured customers that strength is, in Windship's words, "an invaluable aid to medicine in the treatment of asthma, dyspepsia, obesity, pulmonary disease (first stage), chronic rheumatism, neuralgia, torpor of liver and bowels, and 'general debility.'"

During this brief interval in the latter half of the nineteenth century, muscles for a discernible segment of American and European society come to represent positive qualities such as willpower, self-discipline, and the ability to resist sin. Through Robert Jeffries

Roberts, a protégé of Windship who became the superintendent of the Boston Young Men's Christian Association in 1875, YMCAs began incorporating heavy gymnastics into the training programs the organization offered.

The heavy-lifting interlude did not last long in America, however. In September 1876, at the age of forty-two, Windship dropped dead, probably of a stroke. His early death cast a pall over the heavy-lifting community and bolstered the arguments that it is dangerous. Within a year both Butler and Paul closed their gymnasiums, while the YMCA phased out heavy gymnastics for workouts more in line with Dio Lewis's thinking. Field sports, already rising in popularity, became ever more so, while a brand-new activity took off: bicycling. After the invention of pneumatic tires in 1889, and as prices began to drop within reach of the middle class, cycling became an increasingly worldwide phenomenon—improving fitness for some but for many more emancipating them from the tight locus of their previous existence, allowing access to jobs and other opportunities farther away.

Windship's death had little impact on the European interest in lifting weights, though; it thrived especially in Germany, where it had been gaining adherents among Turners for decades. According to Siegmund Klein, who ran an important gym in New York in the 1920s, soon after the first *Turnvereine* were established, "it became evident that many of the members were unable physically to do some of the required feats. A number of leaders resorted to the use of weights to build up their pupils' strength." Over time, some of these early weight wielders "drifted away from the gymnastics which they had originally taken up. Thus weightlifting became one of the leading sports among the German physical culturalists." Some claim the first German weightlifting club opened in Munich in 1878, others that the distinction goes to the Wandsbeker Athletenklub, founded in Hamburg the following year.

Muscles are a problem; they have been at least since people were confronted with their vulgar meatiness in statues like the *Farnese Hercules*. We still can't seem to get a grasp on what muscles mean. Do they represent strength or oafishness? Narcissism or health? Do they masculinize women or indicate vitality and thus make women more beautiful?

For much of our history, both Western and Eastern cultures have suffered from what I call the Popeye-and-Bluto syndrome: the classic cartoon rivals represent the two faces of fitness. Hulking and unintelligent, Bluto typifies strength as brutishness and aggression. He causes harm. His muscularity is ungainly, ugly. On the other hand, Popeye stands for virtuous strength. His humility shows in the fact that his muscles don't—they only appear when he needs them, after eating his spinach and not from lifting weights. In other words, strength and muscles tend to be viewed warily at best, and more often negatively.

There are several reasons for this, beginning with the fact that conspicuous muscularity is not so common that people have become comfortable with it. In Windship's time, muscularity was virtually unheard-of, except among circus freaks, and the doctor's message of health through strength ran contrary to those of other reformers, the majority of whom preached easy calisthenics with either no or very light weights, vegetarianism, as well as abstinence from alcohol and tobacco, and not having too much sex. Heavy lifting was thought to blunt one's mental capabilities and subject the body to dangerous strain, and the gymnasiums where it and "heavy gymnastics" were practiced tended to be no better than dens of ill repute, "regarded in the same light as were billiard saloons and bowling alleys."

Dio Lewis led the charge against what he and others called "the lifting mania," which he felt was an "inferior means of physical training," especially for women and children. Moving great weights, he

wrote, "produces a slow, inelastic, inflexible man." Building muscles will turn you into a stiff Bluto: this is one of those canards that seem never to dissolve no matter how powerful the evidence against them. Just the other day I read about tennis players who avoid weight training because they worry it will slow them down—to which I shouted at my computer screen: have you ever seen a sprinter?

One of the researchers who did the most to disprove many of the myths attached to muscle was Dr. Peter Karpovich, a Russian émigré to the United States in the 1920s. Karpovich began his career as a crusader against "these egocentric exhibitionists, with homosexual tendencies," the "muscle builders." This was in the 1940s, some eighty years after Dio Lewis's screed. There were attempts in the 1930s to ban weightlifting from all YMCAs. At the time it was thought that in addition to the certainty of becoming muscle-bound (coined in 1879)—inflexible, slow, prone to tendon pulls and hernias—weight training could cause heart disease and attracted mostly people of low intelligence. What began to change Karpovich's thinking was an exhibition he attended where he publicly inquired of John Grimek whether the lifter and bodybuilder could scratch his back between the shoulder blades. As Grimek recalls, "Once I'd done all the scratching he wanted, I figured I'd show him who was musclebound. I did a full split for him, all the way down. Then, I leaned over and almost touched my elbows to the floor with my legs straight. We had to hear that stuff all the time, and I was just trying to make the point that it was ridiculous to believe you'd lose flexibility because you lifted and had some muscle." To his credit Karpovich apologized to Grimek and went on to conduct some of the first studies of resistance training. In a series of papers he produced in the fifties, Karpovich knocked down most of the long-standing assumptions about muscle, among them that weight training will make you slower, less flexible, and prone

to injuries and heart attacks, and that it is practiced by, as he put it, "egocentric exhibitionists, with homosexual tendencies."

Which brings us back to the sprinter (or NFL running back or basketball player): far from making you slow, weight training is actually one of the few ways to get faster. Greater contractile tension (the ability to squeeze your muscles harder) is what produces speed, and moving heavy weights very quickly, as in the Olympic lifts, can also transform slow-twitch muscle fiber to fast-twitch. Indeed, the foundations of Olympic lifting are speed and flexibility.

To be fair to Dio Lewis, it is only in recent years that we've come to understand that human beings adapt precisely to what they practice. If you sit at a desk all day, you will become adept at sitting, and this results in tight hip flexors and probably a weak lower back; if you lift with heavy weights but also stretch and attend to your mobility, you will be both strong and flexible. You function how you train. (And it's that adaptability that approaches like CrossFit and strongman training both exploit and subvert: the former by pushing your intensity to a level high enough to trigger an adaptive physiological response, the latter by constantly varying the movement, weight, rep scheme, and time domain so as to always challenge your body, not allowing it to adapt to any one workout.)

Lewis also had no way of knowing how important heavy lifting is to health. One recent study, for instance, demonstrated that muscle mass was a better predictor of longevity than body mass index; another showed that leg strength is a better predictor of longevity than VO_2max (the amount of oxygen you can metabolize, or in other words: endurance). Muscle is also extraordinarily important for optimum health. As Dr. Andy Galpin writes, your muscles form "a giant

endocrine organ" that helps regulate blood sugar and sleep, among many other functions.

R ather than a series of startling new advances, the history of fitness seems to be a cycle of forgetfulness and rediscovery. Consider, for example, the fate of heavy lifting, which remained popular entertainment throughout the late nineteenth century in America and Europe, as the audience for circuses and variety theater expanded; by the 1930s, however, those diversions were ushered aside by newer, higher-tech amusements and the popularity of team sports, and strongman acts too fell into desuetude. Their spirit was revived with the television debut, in 1977, of the World's Strongest Man contest.

Like the strongman acts of yore, which are now known as "old-time strongman," the TV show was initially conceived as entertainment and then, in the New Frontier, transformed into strongman training, an approach that has been popularized by the contests as well as by CrossFit.

Julien Pineau, an imposing Frenchman whose size is matched by his mental acuity, is a coach who specializes in movement, training a variety of athletes in the Los Angeles area while also competing in strongman competitions. As a kid, he explains in a podcast interview, Pineau saw Arnold Schwarzenegger in the 1984 film *The Terminator* and "that was it—I wanted to be big and strong." He began lifting weights but also started wrestling. Later he became so interested in the sport he delved into its history. In the nineteenth century, he explains, the wrestlers were also strongmen, performing in traveling circuses. They'd wrestle in the mornings and do strongmen acts in the evenings. After reading about their considerable feats, he had another aha moment, and the strongman replaced Schwarzenegger as his ideal.

Pineau points out that strongman acts had their roots in ancient manhood tests: who can budge the heaviest rock or flip the largest tree trunk, rites that live on in today's Scottish Highland Games, for example. Today's strongman training still relies on odd objects that are awkward to manipulate, such as kegs, atlas stones, airplanes and trucks, logs, axles, and yokes. But it has been formalized into three modalities: pressing, deadlifting, and moving or carrying.

That the training methodology arose spontaneously from people watching a television show and then going back to history books to better learn how it was done makes perfect sense. Fitness activities tend to spread through artworks, like the *Farnese Hercules* (and what is *The Terminator*, if not a moving reproduction of that statue?) or through other entertaining spectacles, such as circuses or television shows. It is not enough to say I want to be strong or fast: in order to aspire to some height, we first need our ideals embodied and presented to us; we need to give some form to the potential we feel within us. We are creatures of imitation.

6

TRAINING FOR THE MIRROR

The Perfect Man

The aging lothario Fernando Lamas, played by comedian Billy Crystal in a *Saturday Night Live* skit from the eighties, smiles at the camera before pronouncing in a faux Latin accent, "It's better to look good than to feel good." The catchphrase has a satirical edge that cuts to the heart of the post–World War II belief that you can tell people's fortune from the lack of lines on their face; it had staying power because it dug at the potent sentiment that appearance is all, which made people uneasy even as they embraced it. For evidence of the sentiment, we can point to the ascendant exercise regimes of the eighties, bodybuilding and aerobics, for in them there is more than a little of a fake-it-till-it-breaks attitude toward fitness; looks trump health. And today? Are popular beach-body workouts and Spin classes an improvement, or are they best understood as two more of the cosmetic products we've devised, akin to liposuction, bee venom, Botox, and butt implants?

Almost weekly at the CrossFit box a new émigré from that old world of franchise gyms will arrive, his skin shrink-wrapped over an imposingly muscular terrain cultivated by hours of triceps extensions,

calf raises, and ab-machine crunches. To the uninitiated onlooker, his burnished guns and shelflike pecs, seemly hewn from hardwood, might be evidence that this guy is going to crush the rest of us in the Workout of the Day (WOD). But, inevitably, even a ten-minute workout bullies our Adonis into sweaty, gasping submission: it turns out that ballooning biceps are no indication that you can do three pull-ups in a row or a single handstand push-up, or can squat to full depth. Six-pack abs can't tell us whether your lungs will fill with enough air when you're working hard.

That's not to say that our buff Adonis or his counterpart, the trim, spandex-rocking lady toned from the yoga studio and StairMaster, aren't fit. Far from it: they're obviously in better shape than the majority of people walking the streets or, for that matter, standing in line at McDonald's. But seeing men and women fail to execute at the level of their looks should remind us that appearing fit and being fit (or looking good and feeling good) are not the same thing: there are plenty of guys with muscles (some who smoke or take steroids) who can't run a mile; there are sleek women who can't do a single push-up; and there are skinny-fat people who drop dead of a stroke or heart attack, every day.

And then there's Ron, whom I know from the gym, a man whose belly just blares "impending heart attack." Shy of six feet and yearning to drop below 250 pounds, Ron is, to use his word, "obese." After I ran into him at an obstacle race I realized that, appearances to the contrary, he's extremely well conditioned, much fitter than your average American. He used to be "morbidly obese" at 335 pounds, given to yo-yo diets and frustrating bouts on the treadmill, periods when he'd lose 80 pounds only to put on 100 more a few weeks later. It wasn't until he stopped weighing himself and began measuring only his performance on functional exercises that Ron took control of his

body. And so here he is, running five miles, climbing walls, maneuvering under wires, carrying sandbags and lugging tires, scaling ladders, crossing high ropes, and pushing heavy sleds. He may not have been the fastest person in the race, but he was also far from the slowest.

Going to the gym always entails a certain amount of push and pull between the values of aesthetics and performance—wanting to have a physique like the *Farnese Hercules* has led people to become far stronger as well as more cut. But in the twentieth century, the tug of war between looking good and functioning at our best favored the former almost to the exclusion of the latter, and as a result we inherited exercise regimes directed mainly toward aesthetics. It was the search for alternatives that first motivated the opening of the New Frontier.

I recall sensing something wrong, without being able to articulate it, from my first step into a traditional gym: back then it had to do with the restricted range of motion employed by so many of the guys around me. (I was right, I later learned: doing quarter-depth bench presses or push-ups will fatigue the muscles, causing them to grow, but it is not the most effective way to build strength.) Only when I entered a CrossFit gym, where there are no mirrors, did I come to understand that how we look is not an accurate guide to what we can do, and that workouts designed to sculpt the body to a particular standard are not necessarily those that will make us fittest.

Taking those first steps into the New Frontier caused me to wonder what had led us here in the first place. When I turned back to try to figure out what forces had allowed aesthetics to win that tug of war, I found a story of class bias and a misplaced zeal for the promises of technology.

I n 1894, during his first, two-year tour of America, the strongman Eugen Sandow submitted to extensive body-part measurements by Harvard University's first director for physical education, Dudley Allen Sargent. From the forty-two data points taken, including elbow girth and the height of Sandow's pubic arch, Sargent proclaimed his specimen "the most perfectly developed man the world has ever seen."

That our health and physiques can be improved through exercise was accepted by physical culturalists, if not the medical establishment, but with this judgment Sargent voiced a widespread assumption that would long go unquestioned: that there is such a thing as perfection in bodily proportions, a scientifically ratified ideal to which we all might aspire. In Sandow, then a twenty-six-year-old German living in London and soon to be the world's most famous strongman, Sargent found an embodiment of the principles he'd been espousing for years.

Born in 1849 in Maine, Sargent came across an article in his early teens in *The Atlantic* magazine titled "Gymnastics," which fired his imagination and got him started on training. Because of puritanical disapproval (and perhaps xenophobic, anti-German sentiment that linked gymnastics with the Turners) that regarded such activities as narcissistic "monkey shines" and "gymkinks," he and his friends had to practice secretly in the Sargent family barn. He eventually took the classic nineteenth-century route to health reform by running away to join the circus, which led circuitously to Bowdoin College, medical studies at Yale, a brief stint as a gym owner in New York City, and finally to Harvard, at which he arrived in 1879.

By then a book by his friend William Blaikie, called *How to Get Strong and How to Stay So*, had promoted Sargent to the reading public, providing him a certain amount of recognition. The book extolled Sargent's system, an approach to working out that revolves around his chief invention: the variable-resistance pulley-weight machine, which

has done as much to shape the ways we exercise as they have the bodies that use them. Since Sargent first installed them in his New York establishment, the Hygienic Institute and School of Physical Culture, pulley-weight machines have never gone out of use. At the short-lived Hygienic Institute, he set up, along with the usual gymnastics equipment of ropes, swings, and ladders, an array of these devices, each designed to mimic a type of labor that, as he put it in his *Autobiography*, "men in city life necessarily abandoned . . . reaping, mowing, pitching, raking, sawing, chopping," as well as swimming, rowing, and paddling. The irony of Sargent's ambition is that what was radically new in Sargent's system was not imitating actual work but rather abstracting it by taxing individual muscles or muscle groups.

Man using one of Dudley Allen Sargent's pulley weight machines.
(Courtesy of the H.J. Lutcher Stark Center for Physical Culture and
Sports at the University of Texas at Austin)

This was the era that got the snowball of specialization rolling, when PhDs were born and whole areas of research splintered into narrow fields, when what had once been natural science fractured definitively into science's respective disciplines, when doctors ceased treating entire bodies and instead chose blood or gynecology as their knowledge precinct, when machines divided up functions into ever more precise tasks. Sargent's system was entirely consonant with this sort of specialization. As he says, "Any set of muscles could be emphasized in the work."

Machines like Sargent's deflected some of the anxieties about the dangers of heavy weights that had quelled the enthusiasm for them in the United States after George Barker Windship's death, and they also addressed the class markers associated with lifting, which in the 1880s grew in popularity in parts of Europe, such as Bavaria, among brewers, artisans, and laborers. On both continents, the pen-pushing and upper classes, at whom the message of exercise was invariably aimed, viewed muscles as characteristic of the working classes. So while Sargent, according to historian James C. Whorton, had "somewhat more respect for highly developed muscular strength than did the typical physical educator" of the era, he strove to paint a picture of it that would flatter the prejudices and desires of his audience. What laborers lacked was balance across muscle groups, whereas Sargent's system was designed to make you "equally strong all over," as Blaikie put it. "No man stands up straight and mows. When he shovels, he bends more yet," he continued. "Chopping is excellent for the upper man, but does little for his legs," and "scarcely any work on a farm makes one quick of foot. All the long day, while some of the muscles do the work, which tends to develop them, the rest are untaxed, and remain actually weak."

Balance, then, is the holy grail of exercise. "Perfection of man

on earth," Sargent writes, "whatever may be his condition hereafter, comes not from the surpassing development of his highest faculties, but in the harmonious and equal development of all." The problem with *perfection* is that it assumes, a priori, that such a thing exists—and that that thing or bodily form inevitably conforms to ideological preconceptions. In this case, you can see what Sargent and Blaikie esteem by what they define perfection against: the type of body that they imagined results from blue-collar labor. Sargent's system of harmonious development is really meant to promulgate a middle-and upper-class ideal in which the male physique is of average proportions yet keyed up to the highest degree of productive energy. Whether intentionally or not, this ideal dovetailed with a widespread discourse promoting energy in the individual and efficiency in the workplace. William James defined the problem of modern times as, "how can men be trained up to their most useful pitch of energy? And how can nations make such training most accessible to all their sons and daughters. This, after all, is only the general problem of education, formulated in slightly different terms."

For Sargent, the lifelong physical educator, balanced strength does not result from continually outdoing the difficult with the even more difficult; it is not the strength of improbable feats: rather it produces the vigor to be a productive member of society. In *The Body Electric*, which traces this discourse of energy and efficiency, Carolyn Thomas de la Peña (now Carolyn Thomas) argues that for Sargent, exercise allowed individuals to be better integrated "into a mechanized modern world." Useful energy helps people compete with newly mechanized industrial processes, making them more machinelike. Sargent made the analogy of integration manifest: just as a machine is made up of individually functioning components, his thirty-six different pulley-weight apparatuses train each individual muscle or muscle group

with the greatest efficiency. Any other type of resistance effort, be it manual labor, George Barker Windship's Health Lift, or free weights, wasted energy and left you unbalanced in your development.

However, perfection, or rather "perfection," tends to distort. This is clearest in the realm of beauty. During the Song Dynasty in China, the standard of beauty demanded that women display the wealth of their families by binding their feet, which meant they had no need to work. Other cultures invest beauty in corpulence for the same reason of signaling wealth. In the West, we believe in ornamentation, so we puncture holes in our earlobes and inject ink under our skins. The drive for ever-larger muscular amplitude—ignited by Sargent's anthropometric studies, even though he didn't endorse it—leads, three-quarters of a century later, to steroid taking by bodybuilders in pursuit of wildly engorged physiques.

You might imagine that for any promoter of exercise, the athlete would be held up as an ideal, but athletes don't fare any better than laborers in Sargent's estimation, for their "overdevelopment" causes them to wobble through life. Athletes are *too* developed—"better really than they need be," he says. Being too strong or fast "may be far from the safest or wisest course," for the effort to be so leaves athletes depleted and weak.

Coaches will often tell concerned newcomers that CrossFit won't make you big; instead, it reveals your body at *its* best: if you're thin, you'll probably gain some muscle; if you're carrying too much fat, you'll lean out. By substituting performance for cosmetic ideals, NFF regimes, whether it's obstacle racing or a calisthenics practice, generate bodies adapted to the variety of efforts they're exposed to, instead of bodies adapted to such preconceived, abstract frames as aristocratic leisure or the modern mechanized worker. In this sense, NFF prac-

tices do uncover a sort of ideal, indwelling you, the physique only you will have.

What I find particularly fascinating in this process of moving from what we might call an abstract ideal to a functional ideal is how thoroughly preconceived, or ideological, models of perfection have twisted our expectations of feminine beauty. Sargent and Blaikie commendably urge daily exercise, rare enough at the time, for women and girls, but of course the bar of strength was set far lower than for males. The point of working out for the female is "unbending the bow for a little while," Blaikie wrote, "taking the tension from the brain for a few minutes, and depleting it by expanding the chest to its fullest capacity, and increasing the circulation in the limbs—these, instead of impairing that brain, will repair it, and markedly improve its tone and vigor." Since women at the time aren't intended to be strong or energetic, exercise is for tempering those female nerves, unbending the bow. The last decade and a half have shown that women benefit at least as much as men from serious lung-scraping, muscle-churning workouts, and the assumption that engaging in them will cause women to get big or become masculine has no more truth to it than the fear a hundred years ago that running would cause the uterus to fall out.

S argent was actually not the most famous inventor of exercise machines in the late nineteenth and early twentieth centuries—that distinction must go to Gustav Zander. A Swedish physician and follower of Per Ling, Zander did for what is now thought of as physical therapy what Sargent did for physical training: introduced the lure of mechanical gizmos and implanted in the public a belief that mechanical interventions for health are somehow an improvement over the nonmechanical. In Stockholm in the 1870s,

he founded the Zander Therapeutic Institute, which was organized around twenty-seven machines intended to cure various ailments by imitating everyday activities. These were of two types: electrical passive exercise contraptions that mostly provided automated massages, and pulley-resistance machines that used either the weight of one's body or light external weights to impart some therapeutic exercise. At the institute you could find a mechanical horse to simulate riding; strap yourself into a device that vibrated the shoulders and hips; have yourself punched in the stomach, albeit rhythmically; or thread your forearms into a kneader.

After exhibiting his mechanical devices at the 1876 Centennial International Exposition in Philadelphia, Zander began opening branches of his institute worldwide, beginning in New York City in 1880. He managed to seed some 146 countries with Zander Institutes by 1906, yet these were essentially medical spas, attracting a far more affluent clientele than gymnasiums, and thus were designed for rehabilitation and healing. An 1895 announcement in the *New York Times* assures readers that the institute is particularly set up "for the treatment of such diseases as nervous exhaustion and paralysis, and for those produced by the sedentary life." Zander, though his devices were therapeutic, helped propagate the notion of mechanized workout machine systems, including Sargent's.

However, Sargent's reach was ultimately more extensive than Zander's. His directorship at Harvard, held for some forty years, provided him a platform to broadcast his views, especially on physical education—thereby ensuring that his ideas of balance and perfection were inculcated in generations of students. High schools and colleges across the country purchased and implemented his exercise machines, and because Sargent never attempted to patent his designs (which he'd promised Harvard not to do), they were also freely copied

and marketed by various equipment companies. His pulley-weight system quickly spread to some fifty colleges and institutions by the mid-1880s, and it only expanded from there. His students—several thousand in his estimation—included Booker T. Washington; Helen C. Putnam, one of the first gynecologists; and Luther Gulick, who shaped YMCA training protocols, which led to the association buying his machines. Indeed by the 1890s, Jan Todd reports, the exercising public had accepted light calisthenics and the weight machines to

Advertisement for a Sargent pulley weight machine. (Courtesy of the H.J. Lutcher Stark Center for Physical Culture and Sports at the University of Texas at Austin)

such an extent that heavy dumbbells and barbells were almost impossible to find in the United States.

Those who adopted Sargent's apparatus were implicitly ratifying a vision of modernity propelled by scientific progress, through specialization and technology, in which ever more efficient humans would have to do less and less work. A critical component of this outlook was—and remains today—statistical analysis. In Sargent's system, taking extensive anthropometric statistics of the sort that led him to pronounce Eugen Sandow "perfectly developed" informed the use of his machines. As they arrived, Sargent took measurements of each of his students—the same forty-two he took of Sandow—applied them to an anthropometric chart to determine how closely each body part conformed to the average, and then gave the student a prescription for using the right machines to enlarge those areas deemed too small. Thus the average size of a set of body parts became the minimum standard of the ideal.

Thanks to Sargent, human form was rendered as digits, dissolved into abstractions and plotted as vectors to establish norms. If you say to me 36–24–36, I can scroll back to my adolescent *Playboy*-"reading" years and summon a curvy female figure. To some men, reporting a 44-inch chest and 17-inch biceps will be equally evocative. But what can such numbers actually tell us?

In the case of dimensions, the answer is that these numbers reveal little about health, athletic performance, or even your elemental strength, with the exception of waist size. Consider strength, for example. You simply can't judge a person's might by their visible musculature. While it's true that if *your* muscle gets bigger it is also getting stronger, it does not follow that the person with the largest biceps, pectorals, or any other specific muscle is stronger than someone with smaller measurements. Functional, usable strength results

as much from muscle recruitment (meaning both how many of the fibers within a muscle you can contract—most untrained people can only recruit a small percentage of them—as well as how many individual muscles you can consciously contract at all) as from size. So a person with mountainous traps and pumped upper arms might not be able to lift large weights overhead due to a lack of strength in the back, which helps you stabilize. As much as it is a physical adaptation, strength is a skill, or set of skills (from muscle recruitment to efficient movement)—and recognizing this is one of the traits that defines NFF.

But while those pushing out into the newest fitness territory place little value on determining the size of individual body parts, there is no lessening of the fervor for quantification in the New Frontier. Today we tend to concern ourselves with internal data—triglyceride levels, free testosterone numbers, vitamin D concentrations, and the like—or on performance stats, be it how many steps I take each day or how many sets of box jumps and push presses I can do in a given amount of time.

In the early nineteenth century, the German Turners first began keeping thorough records of lifts and other such performance data, yet at the time weights and movements were not at all standardized. In his metrics in the late nineteenth century, Sargent avoided some of the inaccuracies inherent in using the barbells and other weights of the day by employing machines that measure force, called dynamometers, to test his students' strength in some areas. Still, the bulk of Sargent's efforts were focused on anthropometrics, body-part sizes. His was part of a late-nineteenth-century passion for quantification that expressed itself in phrenology and other forms of pseudo-positivisms, which often used such measurements for racist ends like eugenics (a term coined in 1883). Sargent himself never expressed any such

racial notions, though his project seems to be consonant with the ideas in vogue at the time that imposed a directional end point—a teleology—onto the recent theory of evolution, so that the *fittest* was seen as the most perfect (rather than adapted to a particular biological niche or most likely to produce offspring).

Sargent's enumeration of body-part sizes and strength results situates his studies within the turn-of-the-century trend toward greater industrial or workplace efficiency through "scientific" means. As Carolyn Thomas has pointed out, Sargent's project shares much with Taylorism, or scientific management, which "sought to measure the exact movements of industrial workers to determine the path of least resistance in manufacturing." It must be understood, too, as part of a broader cultural interest in "breaking down bodily processes, internal and external, into their constituent elements," one exemplified by the English photographer Eadweard Muybridge's studies of human and animal locomotion. Breaking the body down into constituent parts that could be quantified was an important precursor to creating a culture-wide sense of the perfect physique, what in a few short years would come to be known as a bodybuilder's physique. And as I'll discuss later in this chapter, the aims of efficiency and that of aesthetic perfection are related endeavors.

James Joyce's novel *Ulysses*, which follows its protagonist, Leopold Bloom, through a single June day in 1904, includes a Sargent-inspired "chart of measurements" of Bloom "compiled before, during and after 2 months of consecutive use of Sandow-Whiteley's pulley exerciser (men's 15/-, athlete's 20/-) viz., chest 28 in. and 29 1/2 in., biceps 9 in. and 10 in., forearm 8 1/2 and 9 in., thigh 10 in. and 12 in., calf 11 in. and 12 in." Bloom, we learn, has been following the exercises detailed in strongman Eugen Sandow's 1897 book *Strength*

and How to Obtain It, which were "designed particularly for commercial men engaged in sedentary occupations, were to be made with mental concentration in front of a mirror so as to bring into play the various families of muscles and produce successively a pleasant relaxation and the most pleasant repristination of juvenile agility."

Unlike the fictional and somewhat diminutive Bloom, the real-life Sandow boasted stats almost all above the 95th percentile (with some notable exceptions: mouselike knees, 10th percentile; mediocre "head breadth," 70th percentile; and pedestrian shoulder-to-elbow length), proportions that made him an exemplar of what some scholars call a "machined figure." All well and good, except that Sandow almost certainly did not attain his physique through mechanical resistance. The misunderstanding came about because Sandow, through the force of his considerable fame, spread Sargent's ideas and inventions like a tornado scattering dust. He promoted various workout devices and borrowed much from the American's approach. For example, the "pulley exerciser" that Bloom employs in the novel was based on Sargent's design but produced by the entrepreneur Alexander Whitely and marketed under Sandow's name.

Born Friedrich Wilhelm Müller in the east Prussian port city of Königsberg (now Kaliningrad, Russia) in 1867, Sandow—whose biography and name were as deliberately fabricated as his body—cast himself a "delicate" child who had no notion of strength until, he says, he "saw it in bronze and stone." His father took him to Rome and Florence, where Sandow encountered muscular statues like the *Farnese Hercules*. Although his biographer, David L. Chapman, and others find this story apocryphal, given that his father sold vegetables from a stand in the market, it remains significant that Sandow felt the need to tell it: more than any body artist of his time, he understood the power of images to impart aspirational

ideals. As for his exceptional physique, the almost certainly untrue story he tells in *Strength and How to Obtain It* is that through the study of anatomy he "invented the system of giving each individual muscle a movement, and of so arranging the form of the exercises that when some muscles are brought into play others are relaxed and left without strain." In all likelihood he began his training in a local *Turnverein*, where he would have learned bodyweight exercises and dumbbell work, the sorts of functional, strength-building exercises touted by current NFF promoters.

The young Müller (Sandow, a Germanized version of his mother's Slavic maiden name, Sandov, was a stage name adopted early in his career) had grand ambitions and felt constricted by life as a grocer's son with a common name in a provincial city. At eighteen, he took the well-trod route into the entertainment world by joining a traveling circus, as an acrobat since neither his strength nor his physique was at that point fully formed. When the circus went bankrupt, he found himself in Brussels, where he had the good fortune to meet a well-known strength performer and teacher of physical culture who went by the moniker Professor Attila. One version of their meeting has Sandow making ends meet by posing nude for art students who were also studying with Attila, and who told the professor that this young German model had a great body. Accurate or not, the tale gets at an important truth: Sandow was endowed with a propitious genetic makeup. He had a mesomorphic frame—not too tall or short—low body fat, and muscles that responded visibly to training, meaning that as he matured into his twenties, almost any style of lifting would have sculpted Sandow's physique into something like its later carved and beautiful form. It so happens that Attila was a devotee of heavy weights, and through the use of them (rather than machines) the young man put on mass and became strong.

Chapman reminds us that the notion of working out purely in order to look like a Greek or Roman statue was an alien concept at the time: "In the early years of weight training there was a great deal of opposition to systems that created purely cosmetic muscles without corresponding strength. A thick and muscular physique was all very well, but the true test of a strongman was what he could lift. With his mentor's [Attila] help, Sandow eventually freed himself from the restrictive bonds of this belief." This seems anachronistic: the evidence in fact suggests that Sandow embraced the notion of cosmetic musculature because audiences responded to him. If Attila did help

Eugen Sandow, circa 1894.
(Courtesy of B.J. Falk/Library of Congress)

his protégé formulate bodybuilding as an end in itself, it was probably not through novel training techniques but by encouraging Sandow to include posing in his act.

Under Attila's guidance, Sandow went on tour, proving more than competent at the stunts and shifting of weights expected in a strongman act, and he bested a number of other strength performers along the way. But what soon made him the most celebrated of all the strongmen was his heroic physique. His colleagues in the circuses and vaudeville music halls, as well as those who came before Sandow, tended to be stout, if not fat, built for power, not for pleasing the eye; they and their audiences gave little thought to what their bodies looked like, since what was required of them was the ability to bend iron or support whole families on their back. They often had names like Cyclops and Cannonball—need one say more about their self-presentation? Although as strong as any of them, the young Sandow, with his eight-pack abs, looks as if he stepped out of last week's Abercrombie & Fitch ad, and, in a sense, he created that cut look in the modern media by modeling when he could for distinguished painters, sculptors, and photographers.

After touring England, Scotland, and Ireland to sold-out crowds, Sandow ventured to the United States, where he eventually met Sargent. In New York in the summer of 1893, he was booked in a theater that was running a musical farce, *Adonis*. At the end of the play, the curtain fell on the principal actor posing as a statue on a classical pedestal; it was then raised to reveal a barely clad Sandow in the actor's place. The press went wild, saying the young German was "not only inspiring because of his enormous strength, but absolutely beautiful as a work of art as well." One doctor, it was reported, never having seen prominent abdominal muscles, mistook them for ribs. It was this incident—and similar ones that followed—that persuaded Sandow to incorporate posing in his strongman act. So many of the strength

shows of the period were rigged or used sleight of hand rather than actual might for their effects that a weariness had set in among audiences. But Sandow, with his lean muscularity, was something they were unprepared for; he was as shocking as an antique sculpture come to life, and as alluring. Women were known to slip backstage to feel up his biceps and run their hands over his naked torso.

One of the people who caught the strongman's act was Florenz "Flo" Ziegfeld, the theatrical impresario who was later celebrated for the Ziegfeld Follies. He quickly assumed management of Sandow, proving himself a master of publicity: he arranged for the German to fight a lion, had him romantically linked in the press to the musical star Lillian Russell, assembled a traveling revue around him, and honed his stage appearance into that of a professional "theatrical athlete." But one of Sandow's most significant publicity coups owed more to Thomas Edison than to Ziegfeld. In 1894, the strongman performed for Edison's kinetoscope in West Orange, New Jersey. For a few seconds, or fifty feet of filmstrip, Sandow, naked but for revealing brief shorts, flexes his arms then turns to ripple the muscles of his back. These images constitute the first commercial film footage ever produced. The kinetoscope sequence played on some nine hundred viewing boxes across the United States and was later adapted for a short projection film, giving Sandow more eyes and a larger place in public consciousness than any strength performer before him.

The combination of the film, his Ziegfeld act, and the widespread distribution of postcards with his image turned Sandow into an international sensation—due to his physique, not his strength. Not unlike Arnold Schwarzenegger in the last quarter of the twentieth century, Sandow wasn't just an astute businessman-performer; he understood that his own desire to rise in the world could be furthered through the desire of others to improve themselves. He deliberately set out

to make himself an aspirational model for average, though relatively moneyed, people. From the storm of requests for training advice that blew his way, he knew there were people who wanted to achieve a physique like his; now he just needed to make the urge respectable. In posters for his act he billed himself "The World's Most Perfect Man"—not the strongest.

After returning to London, where he lived for the rest of his life, Sandow sought to capitalize on his fame by opening in 1897 the Institute for Physical Culture on St. James's Street in Piccadilly, just steps from the Royal Academy of Art and the high-end Mayfair neighborhood. The other gyms that then existed were located in working-class areas to the east and south. Knowing that upper-class gentlemen thought lifting a barbell was too similar to manual labor, he outfitted the institute with pulley-weight machines, light dumbbells, and Sandow Developers (a chest expander produced by the Whitely Exerciser Company). He made sure, too, that the institute had the tony décor of a gentleman's club: a grand entranceway, wood paneling, smoking rooms, baths, and Oriental carpets marking individual workout stations. The gambit worked, to a certain degree: the German set off an exercise trend, driving up enough demand for Sandow Institutes that, at the apex of their popularity, some twenty existed in Britain.

Once the first institute was up and running, Sandow further expanded the opportunities for displaying wrought physiques, not to mention his own brand, beyond the music hall stage by publishing the first issue of a new magazine, *Physical Culture*, in 1898. (He changed the name shortly thereafter to *Sandow's Magazine of Physical Culture*.) Less than two years later, Eastman Kodak brought out its revolutionary new Brownie, a cardboard camera cheap enough for almost anyone to buy and which birthed the snapshot. And with the Brownie's arrival, Sandow began inviting readers of his magazine to

send in photos of their progress: this not only gave people the opportunity to compare their body with those of others; it also suggested that improvement through exercise could be measured primarily in changes to one's appearance.

Around the turn of the century, Sandow's act came to rely almost exclusively on what Chapman calls "fancy poses and elaborate stage tricks rather than legitimate lifting feats." This stage routine, with its emphasis on posing, is generally considered the origin of the bodybuilding show as we know it, yet there were precedents that influenced Sandow—particularly the nineteenth-century French tradition of *poses plastiques* or tableaux vivants, in which live performers, costumed as scantily as possible, re-created well-known historical scenes. Sandow also used the pretext of historical or mythological scenes, in his case to display his muscles rather than seminude women.

T he stage show, the posing, and the invitation to his readers to send pictures of their bodies in to *Sandow's Magazine* all culminated in the world's first bodybuilding contest, the 1901 Great Competition. It was a smash success—nothing like it had been seen before. Held at the largest arena in London, Royal Albert Hall, it easily sold out its fifteen thousand seats, and mobs were turned away at the door. The participants were culled from some two years of smaller local contests held throughout Britain and from the images sent in to the magazine; they were judged by Sir Charles Lawes, a sculptor, and Dr. Arthur Conan Doyle, author of the Sherlock Holmes stories.

Sandow would forever view the event as the pinnacle of his contribution to physical culture, and the retrospective gaze of history sees in it the birth of a sport and pastime. But among those actually watching the proceedings were quite a few who found that the highly unusual examples of bodies forged by iron might look like living statues, but

statues of freaks. The *Times* of London wrote of "abnormal" development and asked whether "such extraordinary muscular deviation" could be healthy. From our vantage, these men appear like exemplars of healthy living—sinewy strong, not wildly muscular—yet their arrival in the world kicked off an arms race among a certain segment of the male population to get bigger, more defined musculature.

Although pure bodybuilding would take more than thirty years to catch on as an idea, a vogue for lifting weights took hold in Britain—as seen in the success of Sandow's institutes and magazines—and in the United States in the years leading up to World War I but which would not survive the Great Depression.

Bernarr Macfadden, Sandow's chief rival (in business, not self-display), became bodybuilding's most prominent American booster. He first encountered the man he would shadow for years at the World's Columbian Exhibition, held in 1893 in Chicago, where Sandow plied his muscles a few booths down from Alexander Whitely's, and where the young Macfadden was demonstrating the Whitely chest expander (the same one marketed a few years later under Sandow's name). Toward the end of the decade, Macfadden moved to London to market his own chest expander, an attempt presumably foiled by the Whitely-Sandow team because soon the American was costumed in leopard skin, presenting himself in a physique revue reminiscent of Sandow's, wherein, according to a magazine account, he "knotted up his muscles, individually and in groups, and did 'living statues' on the order of Atlas Supporting the World, Achilles Disposing of Hector. . . . etc." Then, having cashed in sufficiently as an entertainer to expand his business, Macfadden published his own magazine, *Physical Development*, less than a year after Sandow's had appeared.

Macfadden returned to the States intending to build on the work he'd done in London. He transformed his one magazine, the re-

launched *Physical Culture*, into an empire that eventually included such titles as *True Detective, True Story, Sport,* and *Photoplay,* among others. In 1903, two years after Sandow's Great Contest, Macfadden mounted a competition seeking "the most perfectly developed man in the world" at the old Madison Square Garden in New York, the first bodybuilding pose-off in the United States.

But if Sandow aimed to make exercise gentlemanly, respectable for the middle and upper classes, Macfadden, a wild-haired, Missouri-born eccentric, sought guru status. His one purpose, he said in his frequent lectures, was "to bring health and joy through exercise, diet, and the simple life." His pitch reads almost as a parody of huckster-charlatanism: "The world has become stupidly complicated. Get outdoors. Forget politics and economics. Don't stand on your rights, stand on your head. Weakness is a crime. Put yourself in my hands, at a hundred and ten dollars for the full course . . . and I'll make a new person out of you. If you wonder what I can do, have a look at Me." Although his modus operandi was that of a snake-oil salesman, Macfadden was a believer, and his ideas were genuinely cutting-edge, far ahead of their time. He fought prudery and puritanism all his life. He espoused eating very little, mostly raw vegetables, and in 1902 he opened a chain of vegetarian restaurants in New York; he was a nudist and was arrested for pedaling obscenity more than once; he fought against restrictive women's clothing and for the rights of women, and proselytized for exercise of all sorts.

His outlook shared much with the *Lebensreform* movement, which arose in Germany in the late nineteenth century, as well as with New York's nascent bohemia, and the era's reformist politics. *Physical Culture* included in its pages essays by such prominent reformers as Upton Sinclair and George Bernard Shaw. Macfadden boasted a large personality, and though one side of him tapped into the countercultural aspect of fitness, the other was no less in step with the era's glorification of

the capitalist ethic. "Be like me," he urged audiences and readers—a wealthy businessman with boundless energy. Indeed he became the first fitness mega-entrepreneur, making his physique a symbol of his success, and in this he was followed by other stars of the fitness business, like Schwarzenegger, Jack LaLanne, and even Jane Fonda.

The Business of Beautiful Bodies

How directly ought we take the simile of business and exercise, the parallel of working the body in order to be a better worker? And would it square with what I've averred is the countercultural attitude that characterizes fitness practices?

Bernarr Macfadden posing as Michelangelo's David, 1905.
(Courtesy of Houghton Library, Harvard University)

Sloterdijk suggests that the trend toward bodybuilding is itself an expression of the spirit of capitalism (to use Max Weber's contemporaneous term). He points to the "inner connection between the worlds of practice and work, of perfection and production." It's a link that, as we've seen, was becoming apparent to the health reformers of the era and one that continues today. Sargent's student Luther Gulick, long associated with the YMCA, wrote a book on health in 1907 called *The Efficient Life*, in which he argues that those who have succeeded in business have done so "because of their vitality, their ability to do things, to push, to stand strain." In our own period, CrossFit aims at allowing people to do "more work in less time," or increasing work capacity—the phrase applies to physical effort, though it's not difficult to argue that an increased capacity for physical exertion might translate to business. Sloterdijk, however, distinguishes between work directed at "perfection," here understood as an ongoing process of achievement, and "production," the making of a product. And these different ends accord with the different goals of exercise, the perfecting or forming of a life (NFF) versus the shaping of the body as an object (bodybuilding).

Both modes "integrate human powers into effort programmes on the grandest scale," he writes. Yet in the latter mode, he continues, "the energies awakened are completely subordinated to the primacy of the object or product, ultimately even to the abstract product known as profit, or to the aesthetic fetish, which is exhibited and collected as a 'work.'" In this argument, Sloterdijk implicitly draws a parallel between strictly aesthetic exercise regimes like bodybuilding, which are directed toward a finished product, or object, in this case an aesthetically specific physique, and work within the context of capitalism, the aim of which is to produce things for profit. In a more pedestrian vein, Sargent's protégé Gulick asserts that a built

body will help one get ahead: "Muscular development and poise create an impression of manliness, strength and individuality which may stand one in good stead in business."

Sloterdijk contrasts the object-oriented effort with one in which "all powers flow into the intensification of the practicing subject, which progresses to ever higher levels of a purely performative mode of being in the course of the exercises." The regime here is directed at better performances instead of an ideal object, or figure.

Whether or not we accept the most tendentious facet of this argument, that bodybuilding and the like are especially allied with business productivity, the opening of the New Frontier in fitness plays out as an alternative to objectifying the body, treating it as a product of beautifying work.

The keystone of the bridge from the old world into the New Frontier is Sloterdijk's "performative dimension," the shift from exercising for aesthetic ends to working out in order to achieve higher levels of human performance. When I wake up each day deciding I will measure success not in the mirror or on the bathroom scale but by performance criteria (be they faster times, bigger weights, new gymnastic skills, or something else), I am saying I will not treat my body as a product to be packaged in just the right (the "perfect") balance of muscles. An object, like a commercial product, has a use-by date—it gets old and is surpassed by more novel styles and newer, better products. Performance as a goal allows for aging, for the goals are always individualized: you might not get stronger in your eighties but you can learn new skills and get better at them; in middle age you can move better or become a better teacher of skills. Rather than shaping the body, the performative mode shapes a life—its aim is a better person, internally as well as externally.

Taking that bridge into the New Frontier of performance-oriented

fitness means casting a skeptical eye on the ethics of "perfection" (in Sargent's sense of the word). Historically, notions of perfection tend to be marred by prejudice. Even if he had measurements identical to Sandow, no black man would have been judged the "most perfectly developed man" in America or Britain in 1894. Madison Avenue's skinny woman, that late-twentieth-century ideal that remains with us today, is ultimately weak, someone whose self-worth comes not from what she does but from the products she buys (which is why the companies selling those products have an interest in promoting the ideal of the skinny woman in their ads). The mixed martial arts (MMA) fighter (and NFF idol) Ronda Rousey understands that the feminine is as ideologically charged a notion as perfection: "If people say my body looks masculine or something like that, I'm like listen: just because my body was developed for a purpose other than fucking millionaires, doesn't mean it's masculine. I think it's femininely ba-dass as fuck, because there's not a single muscle in my body that isn't for a purpose. I'm not a do-nothing bitch."

This doesn't mean that looking good, by whatever standard you choose to apply, has nothing to do with performance; rather it's a by-product of the practice, not the goal.

The influence of Sargent and Sandow early in the twentieth century got us in the habit of thinking of our bodies as objects, and exercise as a means of producing "perfect" versions of them. Over time in the West—where both body worship and capitalism were strongest—the habit even took hold among athletes, those for whom performance ought to be the clear aim of exercise. The confusion of aesthetics with performance is most clearly seen in the development of the gym, which became a factory for the production of ideal physiques, replete with a host of machines for doing so. But the modern-day body factory as we know it, the franchise or globo gym, didn't

come into being until after World War II. In the meantime, weightlifting and bodybuilding slowly matured as fitness pursuits.

Though the period between 1900 and 1929 saw a considerable expansion of interest in weightlifting and gymnastics, these physical culture pursuits were still overshadowed in America and Britain by the faster-growing popularity of sports. It was in Germany that weightlifting really took hold: in 1900, there were approximately 300 weightlifting clubs, and by the 1920s that number had grown to some 11,000, with more than 130,000 members. And yet none of them would have considered themselves bodybuilders. In fact, bodybuilding in Germany didn't begin until after World War II, when Harry Goldfarb, a Jew who had fled German anti-Semitism for America, returned in 1955 and opened the country's first gym devoted to physique training. Before World War II little distinction was made between physique athletes and weightlifters, as the only people with developed physiques at the time were those lifting weights for strength.

For example, Launceston Elliot, the winner of Sandow's Great Competition, had also taken a gold medal in weightlifting at the first Olympic Games. And throughout Europe and America in this period, weightlifters frequently practiced and held exhibitions of muscular control, which entails the contraction of certain muscles (sometimes rhythmically) while others remain relaxed. Muscle control resembles physique posing, except that it is the specific action of consciously contracting certain muscles that is displayed.

Both aspects of lifting—physique development and strength training—were advanced by improvements made to barbells. In 1901, a German, Theodore Siebert, began selling plate-loading barbells, which employ more precisely calibrated weights than the old shot-loading globe-end barbells of the strongman era; a few years later his countryman Franz Veltum produced the first revolving barbell, which

allows the plates to spin independently of the bar, making it far easier to lift. By 1910 such disc-loading barbells were available in England, Germany, and the United States, which led to the standardization of lifts and drove the transformation of weightlifting from vaudeville entertainment to an international sport.

Weightlifting refers specifically to the sport of shifting loads from the ground to overhead. Although it was included in the first Olympics in 1896 as a field event, it was excluded from the 1900, 1908, and 1912 games. It returned as its own event at the 1920 Olympics and over the course of that decade evolved into something like the sport we know today. Weightlifting was codified in 1928 as three lifts: the snatch (pulling the bar in a single motion from the ground to overhead), the clean-and-press, and the clean-and-jerk (cleaning means hoisting the bar to the shoulders, where the athlete can either press it overhead or jerk it, using the legs to provide momentum). The clean-and-press was discontinued in 1972 because the press portion (which requires no bend in the knee) was too difficult to judge.

Bodybuilding as a discrete activity arose in America around the same time. Siegmund "Sig" Klein, a German émigré to the United States, ran the first gym to specialize in training the physique. Klein fittingly took over the gym previously owned by Professor Attila, Sandow's old mentor, and married Attila's daughter. Beginning in the mid-1920s, Klein's became among the most widely known gyms of the century, its impact surely reflected in the growth of bodybuilding gyms in America. Klein's motto, "Train for shape and strength will follow," indicates why it might have been a lure to the many actors who worked out there, among them Montgomery Clift, Sir Laurence Olivier, and David Carradine. Still, while later stars like

Schwarzenegger and Jane Fonda would help popularize exercise on a broader scale, it remained the pursuit of no more than small coteries of lifters, runners, and gymnasts in the early years of Klein's gym.

The friction that eventually developed between weightlifting and bodybuilding—emblematic performative and aesthetic regimes—was embodied in two men, Bob Hoffman and Joe Weider, who bestrode American fitness culture like two spans of a bridge, one leading to the other, over three-quarters of a century. Ironically, Hoffman, the older of the two and a weightlifting impresario, supplied much of the initial momentum to the bodybuilding revolution. A national canoeing champion who first trained with weights for his sport, Hoffman owned a company that produced oil burners in York, Pennsylvania. In 1932 he purchased Milo Barbell, which had been the leading U.S. weight-producing company, and transformed it into the York Barbell Company; he also began publishing *Strength & Health* magazine the same year, in its era the most widely read physical culture publication.

Hoffman backed Sig Klein as well as the weightlifter and bodybuilder John Grimek at a time when little distinction was made between the two disciplines—it was then all the Iron Game, people moving weights with various motives. Through his barbell company, Hoffman organized weightlifting teams that competed prominently in international competitions—including the Olympics—well into the 1960s. But despite the success of Hoffman's teams, weightlifting was not embraced by the American public as it was in many other parts of the world. The reasons why are manifold, though chief among them are the fact that American boys were, and are still, invariably directed into football, baseball, or basketball (and training with weights for all three sports was, for many years, forbidden); but they also include class prejudice—lifting tends to connote labor—and the xenophobic association of all forms of Iron Game activities

with immigrants (too foreign, specifically too German, Russian, and Polish), which also fueled the denigration of muscled people as idiots and freaks.

It is notable that neither of the two muscled comic-strip heroes of the thirties, Superman and Popeye, attained his hyperstrength through any sort of effort at all, let alone lifting weights. Notable too is the fact that when muscles finally gain some prominence in the United States (largely through bodybuilding), it was in the seventies, at a time of popular celebration of working-class characters and tropes.

From its inception, physique posing was about spectacle, and it matured in a place that was the epicenter of entertainment spectacles: Los Angeles. It also came of age at a time when fitness was conceived as a set of cosmetic activities. Weightlifting, in contrast, continued and continues to suffer as a viewing event from obscurely technical standards; a slow, turtle-like pace; and a cast of characters that only a mother of turtles could love. Indeed, it has a tradition of glorying in ugliness—and that's the judgment of a weightlifter and compulsive fan.

In fact, the early bodybuilding shows were tacked on to weight-lifting events as a way of spicing them up. The first Mr. America contest, held in Amsterdam, New York, in 1939, with Sig Klein and Bob Hoffman among the judges, required its entrants to compete first in the main event, a weightlifting contest. And the best known of the early bodybuilders, John Grimek—who won a number of contests in the 1940s, including the second Mr. Universe title—was primarily a weightlifter.

It was a Canadian, Joe Weider, who perhaps more than anyone else untethered bodybuilding from weightlifting and helped develop it into the sport we recognize today. Already at age seventeen, he

became the publisher of a magazine called *Your Physique*, first appearing in his native Montreal. In 1946, less than a decade later, he and his brother Ben founded the International Federation of Bodybuilders (IFBB), which soon established its own Mr. America contest and later Mr. Olympia. In addition to selling equipment, training courses, and nutritional supplements, Weider's contests and publishing empire—which included such highly influential magazines as *Muscle & Fitness* (the renamed *Your Physique*), *Shape*, and *Men's Fitness*—essentially allowed him to control which bodies got into the spotlight.

He shone that light on the first superstar of physique sport, Steve Reeves—the 1947 Mr. America and 1948 Mr. World, who went on to become an actor, mostly in Italian-made films, and the most famous bare chest of the fifties. Toward the end of the decade Reeves was the highest-paid actor in Europe, famous for such sword-and-sandal movies as *Hercules* and *The Thief of Baghdad*. (Viewing *Hercules* was what lured the young Lou Ferrigno—winner of both the Mr. America and Mr. Universe titles as well as the star of *The Hulk* television show—into bodybuilding, continuing the chain of influence that began with the ancient *Farnese Hercules*.) Reeves injected the built body into the consciousness of a population far too young to know anything about Sandow. But while audiences accepted biceps and bare pecs on movie screens, bodybuilding remained a sort of back-alley activity, tainted by homosexual overtones. It was Weider's protégé Arnold Schwarzenegger, a generation younger, who would transform bodybuilding into a global trend.

The Schwarzenegger galaxy (he was always more than just a star) first appeared to the naked eye in the late 1970s, just in time to become a guiding light to the burgeoning gym-franchise industry. As such, the bodybuilding culture he represented and popularized strongly in-

fluenced the equipment and the types of workouts they fostered in these new establishments. The original pattern for the globo gym as we know it was in fact set shortly after World War II by Vic Tanny. In 1939, he opened what was then a typical gym on Second Street in Santa Monica: male-only, dark, dank—smelling "like a locker room," as Tanny himself put it—and deep in a basement. Many of the local bodybuilders, including Reeves, lifted there, and Tanny, along with his brother Armand, the 1949 Mr. America, maintained close ties to the sport. In 1948, Vic Tanny joined with bodybuilder Bert Goodrich to launch the Mr. and Miss USA Physique and Beauty contest (which Armand won in 1950).

As retail chains began to spread across America in the postwar years, Tanny expanded his gym, opening locations first throughout Los Angeles and then across the country. In doing so, however, he had to overcome two obstacles: the reputation of gyms as nasty rat-holes filled with aggressive, morally dubious characters, and the lack of interest in and awareness of fitness. His innovation was to build modern, luxurious health spas featuring well-lit spaces; carpeting in bright colors; mood music; shiny, chrome-plated pulley-weight machines (one of his gyms boasted gold-plating) and other equipment at individualized stations; plenty of mirrors; as well as swimming pools, steam baths, and sunrooms. And aiming for a "family atmosphere," the health clubs encouraged women to join (though they usually were not allowed in on the same days as men).

Rather than fitness per se, Tanny sold beauty. The company did a survey and found that the main reason people worked out was not for health, but to look good. This proved a crucial insight, propelling Tanny to become one of the first people to sell exercise as a weight-loss method and alternative to dieting. Unfortunately, in the business model he developed, sales weighed far more heavily

than actually getting people to work out. "Good health can be mer-chandized just like automobiles," Tanny liked to say. This meant signing as many people to contracts as possible (knowing that very few would ever use their memberships), using forceful and at times deceitful marketing tactics, pumping up membership numbers through TV ads, and using the guaranteed revenue stream of ex-isting memberships to borrow the money to open more facilities. At its height, there were eighty-eight Vic Tanny Centers. However, soon after reaching that acme moment in the early sixties, he went bankrupt, closing most of the locations and selling others. Tanny proved to be a victim of his ingenuity, ahead of the times by a couple of decades; gym franchises would eventually borrow all his ideas, adding to them only ever more sophisticated sources of financing. Of course, the insight on which he built his empire was itself bor-rowed from Sandow: that the body beautiful is a dream for many of us, and a marketable product for some.

7

ACROBATS AND BEEFCAKE

An inky dusk dissolves the subtler features of Santa Monica beach, leaving visible only the border of white sand and dark sea, lights on sepia hills in the distance up the coast, the silhouette of a pair of palm trees in the foreground, and the outline of two young men propped by their feet and hands in the yawning V of the palm trunks some twenty-five feet above the ground. Nicholas Coolidge, the taller of the two, is higher up, his torso perpendicular to the trees, pressing his feet against one trunk and his hands into the other, forming a sort of crossbar above Travis Brewer, who has one foot and one hand on each tree, steadying himself in an X just inches below his friend's waist. Down the strand, a photographer calls out, "Okay, ready? One, two . . ." At *three*, Brewer pulls his feet and hands in, and falls straight down like a spike, rolling lightly onto a shoulder before springing up. The camera's flash catches him with hands pressed together as if in prayer, floating high in the air just beneath his friend, framed by the picturesque palms. The elements of the picture came together spontaneously, a happy conjunction of light, landscape, opportunity, and some inspired tree climbing. Now it was destined for Instagram, another savory nibble in the brand-building

feast each man assiduously sets out for his followers and potential sponsors.

Brewer and I ran into his friend Coolidge, aka Modern Tarzan, and a photographer friend at the Venice Beach skate park an hour or so before the palm tree shoot. They were there to watch the rail-grinding, bowl-kissing riders. Coolidge has a film-ready California surfer-boy look—sun-bleached, flyaway hair; trim, lanky body; white teeth—and a laid-back yet restless demeanor; he's always climbing, crouching, moving about. He and the photographer had spent the day shooting in downtown Los Angeles: Coolidge doing a flag stand off a fire escape high above traffic; holding a Tree Pose in barbed-wire coils on the edge of a building's roof. For Travis and Tarzan, skaters without boards, the whole city—its rooftops, beach, benches, and streets—is one big stage with unlimited potential for performing.

I've come to Los Angeles to meet Brewer—a remarkable athlete whose practice includes bar calisthenics, Parkour, acroyoga, rock climbing, animal flow, and training specifically for the television show *American Ninja Warrior*, on which he has appeared a number of times—because he exemplifies the promiscuous mixing and hybridizing of disciplines that defines New Frontier Fitness. Yet Brewer and his ilk (like Coolidge) represent a particular faction of NFF explorers, one that avoids the gym and abjures weight training: theirs is a Parkour-calisthenics culture that conceives of functional movement in terms of traversing the environment, built and natural, and using whatever one encounters for equipment or obstacles, rather than replicating real-world resistance under controlled conditions. But they also adopt this attitude of exploiting whatever life presents them because this nascent sport they're trying to establish is so new that nothing has been formalized and scant equipment has been constructed.

"When people began skateboarding, they were building half-pipes in people's backyards, riding in swimming pools. There was no skate park. That's where we are now," Brewer says of the run-flip-swing-grip sport he's nurturing. The comparison isn't prompted solely by the skaters in front of us. Many of the social forces that directed the growth in the 1990s of action sports like skateboarding, mountain biking, and snowboarding also spurred the opening of the New Frontier in fitness in the first years of the twenty-first century: the urge to interact with the world in functional ways, blending sport or fitness with life and with art; a back-to-basics primalism; the desire to attempt the impossible and consistently outdo yourself through extraordinary feats; the sort of cross-disciplinary fervor that produced mixed martial arts; and the expansive, democratic impulse. Parkour, in this view, is just skateboarding without wheels.

As the sun sets, three police cars roll down the sand toward us to close the skate park for the night. The two athletes and the photographer confer for a moment, and then Brewer and Coolidge hop the guardrail, slide into the bowl, and run up and over the other side, stopping on a flat lip in the center of the facility. The photographer takes aim. When the police cars, with felicitous choreography, all stop at the same moment—facing us from the beach—and turn their spotlights on the park, they act as the photographer's flash bulb, capturing Brewer upside down in a handstand on Coolidge's upthrust hands. What an image! I hoot and jump. The police, unfazed by the display, patiently wait for the boys to clear out: the area has a long history of such antics.

"If this were my last day on earth," Brewer told his parents, when they asked what he would do now that he'd earned an MBA, "I'd want to go to Muscle Beach and work out—and that's what I want to do with the rest of my life." He relates this story from

the aforementioned Valhalla of fitness, where all the gods and he-
roes congregate, an open-air carnival of corporeal invention just
south of the pier in Santa Monica, California. This is the site of
the original Muscle Beach, not to be confused with that latter-day
Mecca of anabolic brawn, the nearby Venice bodybuilding pit that
usurped the name in the 1970s and is today far better known,
due to films like *Pumping Iron*. The original Muscle Beach can
lay claim to having been, from the 1930s to 1959 (when it closed
under nefarious circumstances), the world's foremost launching
pad for exercise celebrities and incubator of fresh ideas in fitness
practice. Upon reopening in 1999, the area slowly returned to its
former status, though now as a hot zone of NFF practices.

When he arrives to meet me, Brewer, who with his elfin stat-
ure would never be mistaken for one of the bodybuilders down in
Venice, is greeted like the mayor of Muscle Beach. There are four
distinct groups here: warming up on the horizontal bars is a pack
of guys and one woman from the calisthenics set, including several
from Raw Movement, the crew cofounded by Brewer; on a rectangu-
lar greensward jutting into the sand are women and men balancing
on each other's shoulders, walking on hands, or stretching; creeping
along webbing strung between the permanent metal equipment on
the beach are slack-line enthusiasts, who in the hazy distance seem
to hover in air, their outstretched arms like the wings of a wetlands
bird, as they take deliberate, graceful steps; and others swinging along
a row of metal rings like orangutans. And then there's Brewer, who
seems to stand at the intersection of all of them.

Brewer was raised in Texas, where he did gymnastics for a while,
then played football, soccer, and basketball with the thought that he'd
go pro in one of them. But a catastrophic knee injury playing soccer
shut the door on that dream. He arrived here in 2007, on the spot

where we are standing, by the pull-up bars. "I met four guys right away: Frank Medrano, who is over there," he says, nodding toward a bald, wiry man with a tightly rippling frame, who has since become a YouTube sensation, "Kenneth Gallarzo [who is progressive_calisthenics on Instagram], Warren Lee [Proveit on Instagram], and another guy [Fit to Fly]. And they're like, 'We're starting a calisthenics group.' I didn't know what that was, and they explained that there's this crew in New York, BarStarzz, and they get together, do tricks, routines on the bars, and post videos."

What prompted the four men's interest in Brewer were the gymnastics moves he'd been practicing, which impressed them. Medrano had a test—consisting of, as Brewer recalls it, ten muscle-ups, ten single-leg squats on each leg, ten handstand push-ups, and twenty dips on the parallel bars—which one had to complete in under five minutes to join the group. Brewer powered through faster than any of the others had and became a founding member. As he recounts the story, it occurs to me that the cliques and troupes on the Muscle Beach more than seventy years ago formed in much the same way.

L ore has it that the 1932 Olympics, held in Los Angeles, inspired locals to begin playing around with gymnastics in the sand south of Santa Monica Pier. But the formation of what came to be known as Muscle Beach is more firmly dated to 1934, when several gymnasts from Santa Monica High School began practicing at the playground on the beach. Two years later, one of them, Al Niederman, successfully petitioned the city to build a low platform on which to perform tricks, and two years after that, in 1938, the Works Progress Administration constructed a larger platform. There was already a rug on the sand for tumbling, and soon the city erected some parallel bars, horizontal bars, and rings. At the time, nightclubs featuring acrobatic acts were

popular in the Los Angeles area, and it was around the gymnasts and those performers that the scene at the beach gelled. Beverly Jocher was part of a small troupe and recalls performing around the pools at beautiful hotels like the Beverly Hills Hotel. Not surprisingly, there was overlap between the Muscle Beach regulars and the nascent surfing scene; Jocher moved between the two, and occasionally did acrobatic contortion work on a surfboard as well.

The platform, which eventually drew crowds daily, began as a practice space, as Harold Zinkin recalls in an oral history: "You start putting things together, even unknowingly. You'd have a little sequence, a trick you may have created, a trick you saw somebody do that you liked. Something you polished up. Maybe had a better way of choreographing, getting from one trick to another, and all of sudden you'd have people clapping." What drew the crowds were essentially oddities. History memorializes Muscle Beach as the place that introduced fitness to mainstream culture, mostly through the efforts of people who went on to succeed beyond the beach—people like Zinkin, who produced the Universal Gym machine; Jack LaLanne; Vic Tanny; Steve Reeves; and Joe Gold, owner of Gold's Gym and World Gym. But what is often forgotten in that story is how unconventional their little world was. It may sound glamorous today, but calling the area *Muscle* Beach was a way of denigrating it, pointing out its weirdness. Within two years of the first platform being put up, the *Los Angeles Times Sunday Magazine* named the acrobats there a "public nuisance" and carped about the beachgoer who "struts and bulges his muscles for the amusement of his more normal brethren." As I've suggested, the impulse to overcome yourself, to continually remake yourself in the pursuit of a better iteration, is never entirely normal; instead, it is fundamentally countercultural, it is an impulse at odds with belonging to the crowd, with being average.

The scene south of the pier also pushed against the current in the atypically prominent roles played by the women there. None more so than Abbye Stockton, affectionately known as Pudgy—a childhood nickname that stuck, in all likelihood, because the five-foot-one, 115-pound blond and very attractive woman made it laughable. Her family moved to Santa Monica in 1924, her twelfth year. The man she dated after high school, Les Stockton, whom she would marry, gave her a set of weights. "He brought me some dumbbells and a York training course. I used the dumbbells some, and also did calisthenics, but I quickly discovered that the acrobatic work was a lot more fun to do," she told Bob Hoffman's *Strength & Health* magazine, only a year after she'd begun showing up at the beach regularly. "I worked a split shift at that time for the phone company and so I had my afternoons free," she later recalled. "Les and I and Bruce Conner, a friend of Les's from UCLA, would all gather there and practice in the sand. The summer that I learned to do handstands was the first time that I was able to hold Johnny Komoff in a low handstand while Don Brown did a handstand on my knees."

Pudgy teamed up with Stockton and Conner, and eventually others, to put on appearances in the area, and the sight of this diminutive woman doing acrobatics, supporting bulky men on her shoulders, and exhibiting her strength with weights soon transformed her into a well-known personage in the athletic community. She appeared on numerous magazine covers, and won Bernarr Macfadden's Miss Physical Culture Venus contest in 1948, a year after organizing the first women's weightlifting competition in the United States. She encouraged other women to lift, writing the first column on weight-training for females in *Strength & Health* in the mid-forties. "People used to say that if women worked out, they would become masculine-looking or wouldn't be able to get

pregnant," she told an interviewer. "We just laughed because we knew they were wrong."

Pudgy, then, was a pioneering lifter, too, one of those who put the *muscle* in Muscle Beach. In fact, some argue that the area got the appellation not with the arrival of acrobats but with the entrance, in 1939, of Vic and Armand Tanny, the early physique-training enthusiasts. The Tannys opened their gym and attracted like-minded men, such as Reeves, George Eiferman, and Bert Goodrich, who won the first Mr. America contest. But pinning the name Muscle Beach to the bodybuilders may just be retrospective coloring, for as we've seen from the *Los Angeles Times* piece, even the acrobats were thought of as abnormally developed. Also, in the late 1930s and '40s, bodybuilding

Pudgy Stockton and Steve Reeves in their Muscle Beach heyday.
(Courtesy of the Santa Monica History Museum)

hadn't begun to disassociate from weightlifting per se, as it did after the war, and most people at the beach would have lifted to some extent; weights were used there from the start.

At least some of those lifters were women, like Pudgy. "Women can train like horses, and they just look beautiful," Armand Tanny recounted in a history of the area. "Back then, these were very strong girls, but there were no competitions for them, so it kind of petered out after a few years." Admirable as his sentiment is, I doubt the lack of female bodybuilding competitions contributed in any meaningful way to the failure of weight training to catch on among women, at least until the advent of the New Frontier. That it took hold only among a tiny fraction of the male population reinforces the fact that the athletes of Muscle Beach were thoroughly eccentric, defying conventions of beauty, normality, and acceptable levels of masculine and feminine physical types. So for lifting to become popular among women beyond Santa Monica was unlikely. (Bonnie Prudden, the foremost advocate for fitness in America at this time, and the subject of the next chapter, largely abjured weightlifting.)

And the Muscle Beach community was not able to defy those conventions for long. In the postwar years, as the beach became much more visible in the media, the pendulum swung back toward traditional roles for women: newsreel footage of that period shows men tossing women like sacks of flour, not, as earlier, women lofting men or lifting weights. Working out for women became just another way to slim down and beautify; for men, when they did it at all, lifting meant bodybuilding. And yet here too Pudgy led the way, opening the Salon of Figure Development, "Specializing in Bust Development, Figure Contouring, Reducing," in Santa Monica; Tanny established an empire of slimming and sculpting gyms, while LaLanne pedaled light calisthenics on daytime TV.

The same sun shines over the Muscle Beach to which Brewer introduces me as it did over its first incarnation, nourishing a common spirit (to the prewar years in particular). Acrobatics of all sorts predominate, but the lines of demarcation between disciplines have shifted, and old ways are cast in a fresh light. One of the most obvious alterations that has occurred is weights: now there are none, whereas they'd always been a part of the area's first life.

Steps from the parking lot where the old platform once stood, bar athletes work through dips, pull-ups, muscle-ups, and levers, combining them into expressive routines. Since the era of Jahn as the Father of German Gymnastics, calisthenics has evolved from a set of exercises into a competitive sport. Brewer, for instance, has participated twice (winning the main event in 2014) in Battle of the Bars, an international head-to-head contest judged on the quality of execution and on the artistic merits of the routines each competitor puts together. But as I quickly find, the primary competition on Muscle Beach is for attention: everyone I meet foists an Instagram tag on me as though it were a business card, trolling for followers, likes, hoping you'll click and generate more clicks. Practice flows fluidly into showing off one's skills for friends and onlookers, both present and virtual. Self-branding in this manner—be it calisthenics or any of the other NFF disciplines—represents another way to make oneself into a product, to monetize the artwork for which your body is the vehicle.

Because it requires so much upper-body strength, bar calisthenics is the only NFF discipline that attracts considerably fewer women than men. Alex Bigge, a lithe blonde with a small frame, whom I first meet when she nonchalantly swings Brewer into a standing pose on her shoulders, explains that "it's intimidating for females—it's a size issue. You see these jacked guys doing all this weird crazy stuff. A lot of girls are like, 'I don't want to have those kinds of muscles to do that

stuff.' But you don't have to have that kind of a physique to rock it on the bars."

As Bigge implies, the skewed perception of female strength persists among both sexes. As late as 2012, the *New York Times* could publish an article with the ludicrous title "Why Women Can't Do Pull-ups," in which they reported that while the U.S. Marines require male recruits to be able to do at least three, females are not required to do any. Within days CrossFit posted a rebuttal on YouTube, a video that begins with a voice-over asking women why they can't do pull-ups. "Because I have a vagina?" one responds; another asserts, sarcastically, "Because I make babies." Cut to these and a clutch of other women easily banging out reps in every variation—chest-to-bar pull-ups, strict muscle-ups, weighted pull-ups, kipping pull-ups, and strict dead-hang pull-ups.

A desert of ignorance leads us from the hard ground of women having a very foreshortened history of training for upper-body strength to the arid assumption that they have no potential for it. The truth is we have no idea what the limit is on women's strength. In the fall of 2014, Camille Leblanc-Bazinet, that year's female winner of the CrossFit Games, took part in a coed chest-to-bar pull-up contest (you must touch your breastbone to the bar in order for it to count). One of her teammates, Rich Froning, a four-time CrossFit Games winner, completed 60 without coming off the bar; Camille did 61.

CrossFit, with its attention to bar movements, has brought more women into calisthenics, Bigge tells me: "They're doing the same stuff, the muscle-ups, the cool bar transitions, flips. And a lot of them are doing it in groups with other females, which I think is a huge help—it's slowly catching on with chicks." So it is: there are now no fewer than two bar calisthenics world tours exclusively for women, with championship contests. And the best of the participants seem

able to execute the same types of moves as their male counterparts—single-arm pull-ups, muscle-ups with 360-degree hands-off midair spins, and the like.

From the pull-up bars, Brewer and Bigge steer me to a rectangle of turf abutting the sand, a space known as the Acro Green. Upon it practitioners of what is perhaps the most recent of NFF disciplines, acroyoga, are the most conspicuous of the acrobats, for it is always done in partnership with another person. One, the base, supports the other, the fly, who flips, balances, and holds poses atop the base with their aid. The base often lies on his or her back, hinged at the waist with legs in the air, making the feet a stable platform for the fly.

Because it requires two people, acroyoga is especially social: in just a few minutes I observe a woman volunteer to serve as a base for someone she's just met, and others swap partners and positions (and yes, as the terminology suggests, acroyoga is inherently erotic). It becomes a form of physical communication. Within minutes of us arriving at the green, a chunky young man introduces himself, and, almost without preamble, he flops onto his back pulling a willing Bigge onto his raised feet. They move through an easy, get-to-know-you sequence, from Front Plank (flyer's hips on the base's feet, legs straight back, and hands stabilizing on the base's upraised arms) to Front Bird (same as plank but with the flyer's arms back and slightly out, like wings) to Throne (the flyer sitting with her upper thighs on the base's feet), and soon start improvising a more challenging pose—Bigge inverted in a headstand, resting her skull on one of the base's feet and her hands on his.

The most common acroyoga couples on the green are male bases and female flyers, but gender does not restrict partnerships in the discipline. As Bigge tells it, Brewer and Tarzan frequently practice together: "They're both loose and willing to adapt to each other, so they

don't necessarily plan something out. They'll start with maybe one doing a handstand on top of the other, then throw in another movement fluidly, and then maybe Travis will jump down and Tarzan will jump up to a handstand on Travis's hands—it's playful."

It can also be difficult, repetitive work. Over the course of an hour I watch Travis as he and another man perfect a difficult sequence. From a Throne pose Travis and the base lock hands crosswise, allowing Travis to pop up to a 180-degree handstand, which he holds for several long seconds before executing a handspring (or flip) back into Throne, but facing the opposite direction from which he'd begun. Even in rehearsal it is an impressive and graceful feat, prompting my assent when Travis says he thinks of acroyoga less as a sport and more as a "beautiful art form."

Acroyoga seems to have originated simultaneously in Canada and California. Although the Montreal-based dance team of Jessie Goldberg and Eugene Poku claim to have coined the term in 1999, they didn't solidify the practice until 2003, when they met up with an acrobat friend in a hotel room to explore the shared characteristics of yoga, acrobatics, and dance. That same year, Jason Nemer, a former gymnast and sports acrobat (who's been known to show up at Muscle Beach), partnered with Jenny Sauer-Klein, and they too came up with a couple's movement practice combining acrobatics and yoga, calling it acroyoga. The Canadian version emphasizes the dance influence somewhat more than the Californian version. But any dispute about the origin must proceed from the fact that a very similar practice, down to the terminology used—such as flyer (or flier) and base—has existed since early in the twentieth century. From the beginning of Muscle Beach, in the 1930s, it was called adagio (or adagio dance), a mix of dance and acrobatics that had developed in circuses and among African-American entertainers. The primary difference seems to be

that in acroyoga, bases most often—though not exclusively—operate on their backs, supporting fliers with their feet, while in adagio bases tend to stand. When you come upon pictures from the original Muscle Beach of Pudgy Stockton standing stock-straight, like a wedding-cake figurine, on one of her husband's raised hands, or LaLanne hand-balancing on another man's back, they're practicing adagio. When you encounter similar pictures of eight people in a pyramid formation or people stacked four high on each other's shoulders, it is considered acrobatics—though all these disciplines belong to the same family.

Brewer and Tarzan have performed with the circus Lucent Dossier Experience, which winds the family lineage into a full circle, for acrobatics, acroyoga, and adagio, like weightlifting and gymnastics, all share a common grandparent in the circus. Fitness activities are descended from the practical needs of work and warfare on the one side and, on the other, from the ludic needs of art and entertainment.

The general fascination with entertainers, like circus performers and other artists, stems from their dual nature: at once part of society and commenting on it, of us and apart from us. It bears keeping this dynamic in mind while considering the closing of the original Muscle Beach, for it was always close to Hollywood, a place to which stars could escape and from which others launched careers.

The acrobats who congregated there included squadrons of stunt-men and women. The best known of them, Russell Saunders, became a Hollywood and Muscle Beach legend, doubling for stars in more than one hundred films, among them *Shane* and *The Three Muske-teers* (and serving also as the model for Salvador Dalí's painting *Christ of Saint John of the Cross*). He was frequently at the beach teaching newcomers flips and handstands and other feats, and performing in acrobatic acts, often with Paula Boelsems, a charter member of the Hollywood Stuntwomen's Association. Cary Grant and Douglas Fair-

banks had homes just north of the Santa Monica Pier and would stroll through; Jane Russell could be found watching the acrobats, while actor Ricardo Montalban trained there. By the early fifties, many of the fixtures from south of the pier had made it into the mainstream. Steve Reeves became a movie star, followed by another bodybuilder, Reg Park. George Eiferman, Joe Gold, Armand Tanny, and Mickey

Russ Saunders holding a female gymnast in a hand-to-toe routine on Muscle Beach, Santa Monica. (Courtesy of the Santa Monica History Museum)

Hargitay (who married actress Jayne Mansfield) joined Mae West's touring revue in 1954, at about the same time that Jack LaLanne began hosting his exercise TV show.

Yet while the fame of these musclemen and bohemian acrobats might seem to imply that the broader culture accepted their developed bodies and eccentric lifestyles of ritual training, posing, and play, the reality is they remained, in most respects, outliers. Although shirts started coming off in the sword-and-sandal films made popular by Reeves and Park, putting naked chests, muscular shoulders, and biceps in the spotlight, these films were produced in Italy: to Americans they were exotic, racy fare, and to the Europeans the beefy Americans on-screen were the products of an alien culture. (These films are part of a long tradition, which includes *poses plastiques*, of smuggling scandalous subjects under the guise of classical garb.) And when the beach made it into popular culture, in the early sixties, it was populated by the skinny surfers of the Gidget films, not by acrobats and bodybuilders; recreational sport made far more sense to postwar audiences than training regimens. Meanwhile, on TV, LaLanne maintained an anodyne persona, avoiding too much evidence of his serious training practice by never appearing shirtless or in shorts. The strategy, as explained by Hank Akerberg, president of Jack LaLanne Inc., in 1960, was "to play down Jack's muscles. I don't mean there's anything wrong with having muscles, it's just that people tend to associate a muscular body with a muscle-bound mind."

For the majority of people in the fifties and sixties, having muscles put you in the wrong camp, among those bizarre and unmanly characters who attend too assiduously to their appearance, who are preening and overly self-constructed. Strutting your skin offended puritanical sensibilities or was seen at best as frivolous and improper. "Body worshipers," as *The Saturday Evening Post* labeled them, were

probably not venerating a Christian god. And by the early fifties, muscles and body worship were becoming especially conspicuous at the beach.

The first wave, the founders of Muscle Beach, were getting married, building businesses, and moving away from the coast, and this meant that the presence of acrobats was diminishing while the number of people there exclusively to lift weights was rising. The area became a haven for the bodybuilder, who, Reeves recalled, was "a strange person on other beaches . . . you were an oddity. And at Muscle Beach you were just one of the guys. You had weights in common with the people you were with." At the same time, the aforementioned rivalry between Joe Weider and Bob Hoffman was becoming white hot, with the platform south of the Santa Monica Pier its most contested ground. Both men's magazines promoted the beach as a hub of lifting, using the area to market weights, barbells, supplements, and magazines. And by focusing almost exclusively on bodybuilding, Weider forced Hoffman further into that market, raising its profile well over that of the drab weightlifting world.

Of those who remained, there were a number who lamented the transformation. Ran Hall, part of the acrobatics crowd, "was disappointed when the body builders and no-talent glamour boys and girls started to take over. Until then it was a fraternal group where we taught, learned, experimented, and encouraged each other to develop our talents." Marla Matzer Rose, a historian of the area, points out that bodybuilding is a relatively solitary, less communal activity than acrobatics and adagio, and it was almost exclusively male, which meant there were fewer families on that part of the beach. Plus, men hanging out with each other in skimpy outfits, admiring each other's physiques, posing, and shaving their body hair sent all the wrong signals to an America that was already highly religious and socially

conservative. And Santa Monica was not at all immune to the values of the rest of the country; it was a redoubt of conservative values in the relatively liberal Los Angeles area, going so far as to ban pinball machines in the mid-fifties.

Beyond bodybuilders, and even more out there, was a small though very noticeable band of proto-hippies known as the Nature Boys, who would descend on Muscle Beach during the day from the canyons where they camped. Bearded, with long, unkempt hair and tanned bodies, they adopted a severe version of the German *Lebensreform* ethos, living off the land and extolling the virtues of consuming only raw vegetables, fruits, and nuts. Though they mixed easily with the physical culture crowd, the Nature Boys only added to the impression of Muscle Beach as a magnet for weirdoes.

Because it happened in the absence of an official order or record, on a single night in 1959, nobody knows for certain exactly why the exercise equipment was dismantled and bulldozers leveled the Muscle Beach platform, making way for the current parking lot. Most accounts suggest that a faction on the city council that disapproved of the Muscle Beach crowd colluded with developers who wanted to tear down the cheap apartments where the bodybuilders and acrobats lived in order to build pricier houses and condos. In Boelsems's opinion the city council "had no reason really" to destroy Muscle Beach, "other than they didn't like weightlifting and bodybuilding."

In his memoir, *Remembering Muscle Beach*, Zinkin wrote:

Some believed the city wanted to take over the Beach to create more parking lots. Others blamed influential Ocean Park Pier business owners who didn't like the competition of free entertainment. Still others felt that the owners of the Surf Rider Hotel (where the Loew's Santa Monica Beach Hotel stands to-

day) didn't think their guests would enjoy the unruly crowds. Whatever the reason, the city soon had a legitimate reason to disband the fun at Muscle Beach, or so it seemed.

In fact, the council had seized on two incidents. Four years earlier, in 1955, a boy was hurt trying to pick up a barbell; his family sued the city for two hundred dollars. Then, late in 1958, four Muscle Beach athletes, one an Olympic weightlifting champion, were accused of having sex with two underage African-American girls. What actually happened, if anything at all, remains obscure. The charges against two of the four were swiftly dropped; the third, George Sheffield, pled guilty to possession of lewd material; and the fourth, John Carper, pled guilty to statutory assault, although there is no evidence he was ever sentenced. It was enough, however, to justify the destruction of everything that had made Muscle Beach the staging ground for the physical culture movement of that era.

To the extent it took notice at all, the press cheered the demolition. The *Santa Monica Evening Outlook* applauded the redevelopment project, arguing it would "help clean up the area and eliminate the cheap beach apartments inhabited by undesirable Muscle Beach characters," which it further characterized as "perverts," "sexual athletes," "riffraff," and "followers of all three sexes." *Sports Illustrated* registered its institutional opinion by likening the scene to a "cult" on the "lunatic fringe of fitness."

After years of petitioning by the old guard and newcomers to the area, the exercise equipment was restored to Muscle Beach in 1999, but the performing platform and the weights were never restored. The tribes there today reflect the fact that, while far more democratic, fitness in the New Frontier is anything but a unified field—rather it is a conglomeration of ever-splintering subgroups. In one realm you find a

renewed attention to weight training; elsewhere, as on Muscle Beach, you find varieties of bodyweight purists.

As a young man, Brewer had a dalliance with weights, encountering them first through high school football and then, during his university years, he focused on powerlifting, which he felt left him inflexible. Powerlifting as a sport comprises three events or lifts: the squat, the deadlift, and the bench press. And while these don't require the same range of motion as the overhead lifts, the snatch, and clean-and-jerk, there's no particular reason that any sort of weight training should cause more stiffness than any other—you become inflexible from not stretching or mobilizing, not from weights. When he moved to Los Angeles, Brewer was already years out of school, and he just happened to fall in with the bodyweight tribe. But for too many who abstain from all external resistance, the decision is motivated by the old fears and prejudices against weight training: inflexibility, becoming slow, getting too big, and concerns about injuries.

Brewer would seem to make a fine exemplar of the bodyweight athlete. Not burdened by unwieldy muscles, he is nevertheless exceptionally strong, able to hold a single-arm handstand or pop five backflips in a row. But I confess I'm not fully able to appreciate the logic of forgoing weights, at least for the average person. Sure, anyone who aims for functional fitness, applicable to anything life might throw at us, needs to balance strength to bodyweight: the bigger and heavier you get, the more difficult it becomes to lift yourself up or move yourself around, to hop a fence, pull yourself over a wall, do a pull-up, run a mile. That said, it is extremely difficult to add significant mass by lifting weights. Every few pounds demands hours upon hours of training and, even more important, eating, long days of stuffing your face well past satiation. Legs and a posterior that will weigh you down don't just happen over night or the course of a year—they are deliberately achieved through grueling effort.

Are bodyweight movements less likely to injure you than a barbell? Is a backflip less risky than a snatch? The only studies I've seen suggest that both approaches produce very few injuries. But at my gym, where equal attention is given to gymnastics and weightlifting, it is the former, specifically difficult moves like the muscle-up or stringing together chest-to-bar pull-ups, that results in trashed shoulders. Yet the risk is still low, whereas you can be sure that sitting at a desk or spending hours per day in your car will certainly endanger your health.

After running (which virtually everyone who is serious about fitness does), yoga is the most popular bodyweight practice. And while it began as a salvific religious practice eons ago in northern India, the marketing of yoga as healthful exercise was pioneered just a short drive from the original Muscle Beach, in 1948, when Indra Devi opened a hatha yoga studio in West Hollywood.

Born Eugenie Peterson in Riga, Latvia, to a Swedish bank director and a Russian noblewoman, she was enchanted by India at a young age. Having studied acting and worked as a dancer in Berlin, she took an Indian name, traveled to Mysore, and managed to insinuate herself into the all-male yoga school directed by Sri Tirumalai Krishnamacharya, arguably the most influential yogi of the last century.

Yoga has always been a synthetic discipline, open to an array of influences. Its transmission to the West turns out not to be a one-way story of Eastern importation but rather a fluid two-way trade. The yoga taught by Krishnamacharya—and, through his students, virtually all the Westerners who now practice it—was, according to the scholar David Gordon White, "an eclectic amalgam of *hatha yoga* techniques, British military calisthenics, and the regional gymnastic and wrestling traditions of southwestern India." British military calisthenics were themselves based on Per Ling's Swedish gymnastics. Of

the various yogic traditions, hatha, whose practitioners seek spiritual liberation in this life rather than another through asanas, diet, and cleansing, lends itself especially well to integration into Western notions of exercise. And indeed, one of the reasons yoga caught on in the America of the 1950s was its similarity to the types of calisthenics that were then fairly common.

Devi's version was more radically transformed than Krishnamacharya's, for, attuned to the desires of her urban, secular clientele, she avoided all spiritual guidance, concentrating instead on breathing, relaxation, and health—as well as on the one value Americans share, celebrity. With luck and charisma, Devi soon attracted students from Hollywood, Greta Garbo and Gloria Swanson among them, and their names helped her lure others. Westerners had been aware of yoga as a spiritual discipline for a century; Devi's lasting innovation was to promote yoga throughout America as a means to health and wellness. She taught at the Elizabeth Arden beauty farms and at times teamed up with the premier health food and wellness guru Paul Bragg, demonstrating yoga as accompaniments to his lectures. In the fifties, however, the terms *health* and *wellness* were not associated with exertion or sweat: Devi's was not a yoga of difficult poses that you strained to hold, it was about relaxation.

And for yogis things would get mellower before they got more vigorous. In the sixties and through the early seventies, Western interest in hatha was nearly extinguished by gusts of excitement about meditation and mysticism; the upsurge of self-conscious spiritual seeking in those years—which had little to do with fitness—advanced other yogic traditions. But the Western experiment in Indian religious practice proved to be short-lived—the appetite for despiritualized asceticism had grown too powerful.

Hatha was reinvigorated by the followers of B. K. S. Iyengar, an

Indian who had studied with Krishnamacharya, and who forbade his students from transmitting the trappings of spirituality, such as meditation and chanting. Instead his many Western followers hewed to the physical side of the practice. One of the first, Richard Hittleman, opened the Yoga College in New York City in 1969; created a television show, *Yoga for Health*, which replaced Jack LaLanne's popular exercise show on KTTV in Los Angeles in 1971; and published a bestselling book of the same name in 1983. An antidote to go-go aerobics and the grunting culture of bodybuilding that dominated the eighties, Iyengar became the yoga of mall dwellers, soccer moms, and corporate worker bees, at least for a while.

My first experiences of yoga were with Iyengar, although I admit I was drawn to it by the women who invited me rather than by the contortions I was put through. It was too placid for an overenergized boy in his early twenties. Still, my underwhelmed response set me up nicely for the shock of what came to be known as power yoga, which I encountered at its birthplace, Jivamukti in downtown Manhattan. A descendant of Ashtanga yoga, and the brainchild of K. Pattabhi Jois (yet another disciple of Krishnamacharya), power yoga, with its rapid-fire and challenging asanas, even then felt like an expression of the ratcheted up exertion quotient that characterized fitness culture in the nineties. I walked out of the first session lightheaded and awoke the next morning with my untrained body as sore and stiff as it had ever been.

Ashtanga's sweatier cousin, hot yoga, owes its success to an even more forthright embrace of the Western ethos of discomfort and gain through pain. Devised by Bikram Choudhury, who proudly describes his studios as "torture chambers" and shouts at students like a calisthenics coach, hot yoga exemplifies the marriage of East and West. Choudhury spent his formative years learning from Bishnu Chandra

Gosh, a weightlifting enthusiast considered one of the great physical culturalists of India. Gosh was one of the men who first brought Western fitness practices to his country, primarily in his 1930 volume, *Muscle Control and Barbell Exercise.*

Given its hybrid nature and deracinated spirituality, yoga might be thought of as a precursor of NFF practices. "Just wait a second!" shouts the Devil of Intensity who resides in my belly. "Does yoga even count as exercise?" It provides almost nothing in the way of cardiovascular and strength adaptations. And in at least one study, stretching and balance work were not shown to slow brain aging, while resistance and cardio efforts do. "True," the sage Angel in my mind responds, "but it's all too easy to think of fitness as a matter of mere lungs and brawn, whereas it actually has a number of components. To be complete you also need balance, accuracy, flexibility, and coordination—and yoga, especially acroyoga, hones these well."

I, like many others in the CrossFit and weightlifting communities, practice yoga frequently, for recovery. But Brewer's argument is that I am missing out on the breath-centered, meditative aspect of it, the mental training that can boost all facets of physical performance. And he would add that the cooperation inherent in acroyoga adds an element of emotional training no less important than any other.

Rather than a splintering of fitness tribes, Brewer sees a convergence, at least within the bodyweight contingent. "I've partnered with yoga friends to help bring the flexibility and spirituality of it to my calisthenics group," he tells me between handstands. "You look at a calisthenics guy, he can do pull-ups all day but can barely touch his hands to his chest, so you need to respect the flexibility aspect. Gymnastics blends the two well, but with it you lack jumping ability and balance, which is where Parkour comes in, except that in Parkour you don't get the grip strength needed for climbing. It's funny, I can do

giants [swing 360 degrees around the horizontal bar] all day long, so I thought I had the grip to be a rock climber, but bar grip is totally different than crab grip, which is totally different than finger grip. That's where ninja training comes in; it works the grip a ton, and it's puzzle-solving, like Parkour or free running, in that they are both about trying to get from one place to another as fluidly and efficiently as possible."

All the bodyweight practices to which Brewer introduces me began as alternatives to the indoor gym, including Parkour, even though indoor Parkour facilities are commonplace today.

Despite Paris being the birthplace of the first commercial gym, which was created by Frenchman Hippolyte Triat, the French have long had an uneasy relationship with the gymnasium, be it for weight-lifting or gymnastics. "The urgency and even the utility of gymnastic instruction do not yet seem evident," wrote a French provincial councilor in the mid-nineteenth century. Catholic priests complained that gymnastics prevented children from attending Catechism. Pierre de Coubertin, the French founder of the modern Olympic Games, disapproved of the routinized training implied by the gym. And for at least one segment of the population, grimy, sweat-soaked efforts disrupted their minimalist attitude toward grooming. As Eugen Weber quotes a French historian, "one aspect of the physical exertions involved in gymnastics as in sports was the unusual need for washing they created. This raised difficulties in a France where, 'at least until 1914 people wash practically not at all, they are not in the habit of washing.'"

Georges Hébert feared neither sweat nor dirt. A French naval officer in the years before World War I, he developed—in response to turn-of-the century gymnastics, which he felt didn't prepare one for

real-life situations, and to English sport, which because it was competitive he felt was morally degrading—an approach to training he called La Méthode Naturelle (the Natural Method). The name and the origin story he gave it had a distinctively Gallic flavor, drawing on the Rousseauian penchant for idealizing "primitive" peoples and the state of nature. While venturing with the navy to remote places, Hébert observed how the natives owed their heartiness to the physical demands of their daily lives. In France, apparently, nobody ran, jumped, swam, or carried objects. In actuality, his approach—first detailed in the 1912 *L'éducation physique ou l'entrainement complet par la méthode naturelle*, but elaborated in a series of five books that were published between 1941 and 1955—drew on the long history of French tumbling and acrobatics, which extends back to the Renaissance court of François I; the theories of Francisco Amorós (see chapter 4); as well as on the exploits of the gabiers or topmen he commanded, those sailors who climb masts, rig and furl sails, and generally scramble about ships.

"Being fit isn't about being able to lift a steel bar or finish an Ironman," says Erwan Le Corre, the foremost exponent of the Natural Method today. "It's about rediscovering our biological nature and releasing the wild human animal inside." Freeing your inner untamed beast means that being able to sprint to safety is worthless if you must first put on your shoes; that being strong enough to lift a heavy barbell won't necessarily help you when you need to haul someone over rocks out of the surf. "Be strong to be useful" was Hébert's motto. Adherents of the Natural Method thus subscribe to an extreme form of functional fitness, one that demands training with whatever is at hand in the bush, far from the cloister of the gym.

Hébert distilled our wildness into ten types of functional movement: balancing, climbing, swimming, defending, lifting, throwing,

quadrupedal motion, jumping, walking, and running. And while he did not rule out the use of weights and other implements, the activities do not have equal importance in his system. For Hébert, "It is evident that the exercises which develop physical endurance by augmenting the power of the heart and lungs are the most useful and practical. Running is the primary exercise in our system."

After elaborating his system in his first book, Hébert built an outdoor training park replete with hurdles, ladders, and towers to climb, vault, and maneuver past, sandpits and water pools to cross, rocks and logs to navigate and smaller ones to lift and carry, and poles for balancing. It was, by some accounts, the first obstacle course. The French army adopted its use, though not, Hébert felt, the Natural Method itself in its orthodox form (other militaries, including the American, also incorporated obstacle courses in their training). By the mid-1950s, obstacle courses had been entirely disassociated with Hébert's name and his method all but forgotten, except in the French army. But through Parkour and obstacle racing, his impact is felt more powerfully today than even during Hébert's lifetime.

In 1968, a Swiss architect named Erwin Weckemann invented the parcourse, or fitness trail, with the obstacle course in mind. The idea spread from Zurich, where the first one was built, throughout Europe and the United States. A suburban mainstay of the seventies and eighties, the parcourse features stations along a path with pull-up bars, inclined sit-up boards, small tree stumps to hop on, as well as instructions for various levels of exercise.

One year after the invention of the parcourse, a French fireman named Raymond Belle, trained in the Natural Method while a soldier during the Franco-Vietnamese War, enjoyed a brief moment of fame when a photograph of him graced newspapers in Paris. The pictures showed Belle dangling from a cable attached to a helicopter as he

snatched an illicitly hung Vietcong flag from the Cathedral of Notre Dame. Belle taught the Method to his son Jeff, who passed it on to his younger half brother David (also Raymond's son, although he didn't raise the younger boy). It was David Belle who fleshed out the moves and ethos of Parkour in the late eighties and early nineties, in Lisse, France. In French *parcourir* means to traverse, to travel through or over; Parkour, or Free Running, is the acrobatic artistry of moving over, around, or through obstacles in your environment. Belle took the notion of the military obstacle course and, he says, "transformed it into something playful, like a game. . . . When I say playful I mean it's fun to go out and exercise. My friends and I will see walls and passages that tell us 'you should go like this or like that.' But we say 'no, we can go like this just as well.' People turn their heads to see who is walking above them."

Like CrossFit and bar calisthenics, Parkour matured virally in the early 2000s, from videos of kids outdoing each other's leaps, somersaults, and rolls to the mass-culture entertainment of such blockbuster films as *Casino Royale* and *The Bourne Legacy*, where stuntmen dare impossible flips over gaps between buildings, cat-leap over walls, and fling themselves from balconies and cranes. There are now international competitions for Parkour, like the Red Bull Art of Movement. Indeed, one of the things that distinguishes Parkour as an NFF phenomenon from the original Natural Method is its focus on competitive artistry rather than, say, its application to firefighting. By contrast Hébert denigrated what he called the "sentimental appraisals" of gymnastics and other aesthetic competitions.

True Parkour, the outdoor art of scaling walls, tumbling through the air between buildings, taking shin-shattering leaps, twisting the torso horizontally in dancelike moves on railings and embankments, and effortlessly backflipping off objects, is daredevilry. The barriers to

entry are high and the path within is fraught with injury: these factors restrict it to a relatively small coterie of elite athletes, some of whom are stuntmen and women who spend their off hours on Muscle Beach. Parkour's middle-class offspring, such obstacle races as Tough Mudder and Spartan Race, continue to attract millions of participants world-wide, spawning television programs and professional competitions; there are people who now make their living as obstacle racers, some-thing almost no Parkour athlete has accomplished. But while obstacle races are certainly New Frontier events, they don't constitute training methodologies. Strangely enough, the one stepchild of the Natural Method, and thus of Parkour, to have begun as a TV event, *Ninja Warrior*, has now generated its own unique training methodology.

Ninja Warrior began as *Sasuke*, a Japanese sports entertainment show that first aired in 1997 and has been seen in some 157 countries. Entrants race against a clock to complete each of three stages of an obstacle course. Brewer has appeared four times on the U.S. version, *American Ninja Warrior*, which first aired in 2009. *Ninja Warrior* is, of course, a game show and not an athletic competition. "If you do well the first night but not the second, your results aren't averaged out. You don't move on," says Travis. "There's no point system. And they choose people who have a good story as much as ability." But it has already become an off-screen fitness pursuit, much in the same way that weightlifting and acrobatics began as circus entertainments and evolved beyond the big top.

One afternoon Brewer and Bigge drive me out to a "secret loca-tion" in a downtown Los Angeles neighborhood of modest, single-story homes. We park outside a low ranch-style house with a fading yellow exterior, unhook a gate, trying not to let two barking dogs out as we enter, and head around the back of the house to a shoe-box-size yard into which has been squeezed a ramshackle—though

no less impressive for it—homemade Ninja Warrior course. Four young men are lounging in the shade of a weather-beaten canopy, out of the punishing sun, sipping water. The first structure I recognize is a narrower version of the Warped Wall, one of the show's iconic obstacles—Brewer's signature move on the show is a handstand on the top lip of the wall.

American Ninja Warrior became a national sensation and hit in 2014, when Kacy Catanzaro became the first woman over the wall and into the finals. Since watching the sub-five-foot Catanzaro's feat, I've wanted to give it a try. On TV the Warped Wall looks easy, a gentle swoop. But here, the dizzyingly high parabolic curve of cracked boards and rusty nails looming over the backyard fence defeats my courage.

"Is it taller than the one on the show?" I ask a kid in a blue bandana.

"Nah, I don't think so. Have a run at it—but don't miss at the top."

I imagine falling off this thing that looks like it was hauled away from an ancient amusement park after decades in the sun and rain. At its base is a pile of muddy foam pulled from old packing boxes, probably with staples still stuck in it, and which wouldn't cushion a squirrel's fall.

Next to the Warped Wall stands a long wooden rig with movable pegs and immovable rock-climbing handholds as well as a series of four doors, narrow edge out, which you're meant to traverse in a sort of four-limbed pincer lock. The ground is lined with old mattresses and sofa pillows instead of gymnastics mats. Running up the center of the fearsome rig are a number of grip-testing implements and obstacles, the goal being to travel from one end to the other without falling.

A tall, wiry kid, his dirty-blond hair shaved on the sides and pulled

into a man bun, wearing only a pair of gray, three-quarter-length sweatpants, shows me how it's done. He climbs about seven feet up onto a small platform at one end, takes a few deep breaths, and leaps to catch the first set of grips, two grapefruit-sized red skulls; from there he uses the momentum of his swing to launch himself into the air, grasping the side edges of a swinging, unsteady rectangular frame suspended by two chains with its broad side parallel to the ground, and from there onto thick vertical handles, which lead to two short lengths of rope, and then onto the Salmon Ladder, an unanchored pull-up bar resting on two stubby wood prongs. The aim on the Salmon Ladder is to hang from the bar and use your hips to generate the force needed to fling your body and the bar, which you're still holding, into space, upward, so that bar lands in the next, higher set of prongs.

Once he has lofted himself up six prongs, he is high enough to attempt the scariest and most impressive of the rig's tests, flinging himself off of one Salmon Ladder, across a six-foot gap while spinning 180 degrees in midair, to grab the bar of another, mirror-image Salmon Ladder, from which, after having successfully executed this maneuver, he reaches out a single long arm, palms the top of a cannonball grip (also suspended from the rig), and uses that hand to swing himself along to another cannonball, and onto the far end of the rig.

It's a mind-blowing performance, one nobody else is able to fully complete on this day, despite numerous attempts. I, who have balanced on icy, knife-edge mountain ridges at eighteen thousand feet, am too intimidated even to try—this is a jungle gym for overgrown and fearless chimps, not middle-aged men, no matter how fit.

As we stand around, cheering each attempt on, an older Latino man, a neighbor, wanders into the yard. At a glance, the ninja course must look like the decaying remnant of some childhood playset, because he examines it quizzically, decides it has nothing to do with why

these kids are hanging out, and asks, "You smoking the cheeba?" He smiles and mimes sucking on a joint. It's not an outlandish guess—these dudes certainly look like burners.

A shirtless guy with messy dark hair grins back from atop one end of the rig, slowly shaking his head. "Nah, bro, we're training."

The visitor's face softens into a slack mask of incredulity.

This crew is far from the only group transforming Ninja Warrior from a spectacle into a training practice and, they hope, a full-on sport. Brewer has a more philanthropic vision. He wants to erect movement parks across the globe that would combine the running and scaling features of Parkour with the climbing apparatus of Ninja Warrior—a skate park for people without wheels. "Overcoming obstacles is something that resonates with so many people," he says. "I want to get that promotion at work, to attract that guy or girl, to buy that new car, lose ten pounds. These are all obstacles. But in a Ninja Warrior or Parkour run, you have to adapt to whatever comes at you, to adversity. And that's like life, too—nobody anticipates being in a car wreck or a fire." The gym world is already absorbing the lessons of efficient movement: it's relatively easy now to find Parkour gyms, indoor climbing gyms, and monkey-bar gyms. Whether cities will adopt outdoor versions remains to be seen, but there is the parcourse precedent.

When I ask Brewer how he would describe the type of athlete he is, he responds by saying he doesn't really consider himself an athlete. "I think of myself as an artist, someone creating these beautiful moving sculptures. It's just that my medium is my body moving through space." If the ancient Greeks strove in the *gymnasion* to become heroes worthy of a statue, today's acrobats (from the Greek *akrobatos*, "walking on tiptoe"—in other words, show-offs) seek to be immortalized

in images, an astonishing chain of tricks on the bar, a beautiful line through a given terrain, a majestic pose. This urge to make art of oneself points to how fitness practices—bar calisthenics, acroyoga, Parkour, and Ninja Warrior—allow people not only to shape their bodies but to shape their lives; as training regimes they provide a way of learning how to advance through life along elegant trajectories.

8

THE TYRANNY OF THE WHEEL

During a 1956 radio interview, Bonnie Prudden, a forty-two-year-old mother of two, made a suggestion that came across as distasteful, even perverse: that everyone ought to exercise.

"You think we should have a routine, *all of us?*" came the skeptical and somewhat patronizing response of the interviewer, Mike Wallace (later of *60 Minutes* fame). "A family should pursue joy through strength after the husband gets home at six thirty and before the martini?"

Prudden, who in the previous year had gained some renown as a promoter of physical fitness, concedes, "I'm more convinced than you are."

She was pushing this unpleasant idea on a society that was enthralled with modern conveniences, worshipped the automobile, and valued decorum, decency, and civility—none of which could be attained by sweating. Given the atmosphere of the era, Wallace stands out for his willingness even to entertain the notion that everyone ought to exercise. Many others dismissed it out of hand. The newsman, however, goes on to voice a widely held assumption of the time: "Is it possible that while we are perhaps forgetting to develop our bodies sufficiently, we are devoting

ourselves to developing our minds? And perhaps that is a more important development?" This cordoning off of mind from body had been typical for hundreds of years. In the 1950s, however, it took on a special connotation: that technological progress, in medicine and in industrial food production, would ultimately cure the ills of the body. Sixty years of such technological advancements have taught us to be far more skeptical, for they tend merely to reinforce the increasingly sedentary lifestyles and poor nutritional habits of those with access to them.

For most of the twentieth century—up until what became known as the "fitness boom" of the seventies—very few people believed health and wellness could be achieved by exercising one's body strenuously. Wallace's incredulity at the thought of daily exercise highlights that point particularly well. Almost no one worked out: not the knee-knocking flappers of the twenties, not Rosie the Riveter in the forties, nor the Betty Crockers of the kitchen in the fifties, and certainly not their husbands with their martini-and-cigarette lunches.

Indeed, through most of the century and the millennia preceding it, exertion was understood by all but a handful of people as something to be avoided—it marked one as being of the laboring classes and was considered unhealthful. Doctors especially doubted both the efficacy and safety of working out. In 1942, for example, the cardiologist Peter J. Steincrohn published *You Don't Have to Exercise!* He followed it up ten years later with *How to Keep Fit Without Exercise.* Dr. Kenneth Cooper, one of the pioneers of preventative medicine, recalls that while in medical school in the fifties, "exercise was considered to be dangerous by the medical profession"—so much so that "we were taught that you shouldn't exercise vigorously after forty years of age, you need to act your age, you might have a heart attack."

Fitness also offended the social mores of the era. Sweating in

public was considered socially unacceptable for women until the seventies. In the postwar era, the middle classes of the West, including the United States, remained in thrall to a European (and particularly British) aristocratic physical ideal—exemplified by very thin men, not unlike George Plimpton, who might from time to time engage in light sport but who would never *work out* (work being something other classes did), and housebound women.

Those who did exercise tended to form minuscule subcultures, many of which were the remnants of the influential though never widely popular physical culture movement, which was born in the late nineteenth century. Many of the weightlifting gyms and calisthenics studios were decimated by the economic depression of the thirties, while the gymnastics clubs known as turnvereins, which had flourished in Germany and in the States since the early nineteenth century, were largely done in by anti-German sentiment during World War II. During and after the war, gymnastics itself came under suspicion in the United States as a foreign, Germanic influence. This is significant because the explosion of interest in fitness that later occurred is, initially, an American story.

By the late forties and fifties, a few towns, such as York, Pennsylvania (known as Muscletown, U.S.A., home to Bob Hoffman and his weightlifters), had gyms where men pursued competitive weightlifting or bodybuilding. But these, as well as the few recreational urban gyms that existed—almost all of them exclusively male—were seen as dank, dangerous places where homosexuality or other criminal behavior might be cultivated. They were also located almost exclusively in cities—Manhattan, Philadelphia, Chicago—at a time when many people were moving out to the suburbs. When Jack LaLanne established a coed gym in Oakland, California, in 1936, such a thing was unheard-of. But rather than being upset about the idea of women

working out with men, it was the very notion of hard physical effort that shocked the public. "People thought I was a charlatan and a nut," LaLanne recalled. "The doctors were against me—they said that working out with weights would give people heart attacks and they would lose their sex drive."

Almost no one believed exercise could prevent disease or delay aging; instead, it was actively discouraged as dangerous. Health at that time was something you either had or didn't. Nevertheless LaLanne thrived. Because he lent his name to a successful gym franchise and developed a long-running and popular TV show, LaLanne is often thought of as the major precursor to the sudden inflation of interest in exercise that occurred in the last quarter of the twentieth century. But he had something else going for him, the significance of which I only came to understand after delving into the history of exercise: LaLanne became known as the "Godfather of Fitness" because he was a man.

The history of fitness lays claim to more patriarchs than the early Christian church: self-styled "fathers" have sired everything from gymnastics (Friedrich Ludwig Jahn) to bodybuilding (Eugen Sandow) to wellness (Paul Bragg). Our tendency to think of athletics as a primarily male arena has obscured our understanding of how the culture of exercise was transformed from the concern of a few disparate subgroups into a worldwide cultural phenomenon. The few existing accounts of the origins of the seventies fitness boom have Dr. Kenneth Cooper in the starring role, with LaLanne as a supporting actor. Both are important to the story, as are the long line of fitness promoters and innovators that preceded them. However, men have always had access to exercise; we've been pushing it for decades, even centuries, without notable changes in the general population. Instead, the catalyzing of the mass interest in fitness had to await a

woman. And that woman was Bonnie Prudden, whose endeavors fi-
nally ignited change only toward the end of the sixties, in the context
of the burgeoning feminist movement.

Born the same year as LaLanne, 1914, Ruth Alice Prudden was
raised in a prosperous family in Mount Vernon, New York. A
relatively privileged upbringing marks her as quite different from the
majority of fitness promoters who preceded her, for her background
allowed Prudden to speak to, and for, the establishment, despite re-
maining unconventional in many respects throughout her life.

Her father, an advertising executive, had so wanted a son that he
called his daughter Jack. Eager to please the man she characterized
as "kind and gentle" (but usually absent), Prudden became a tom-
boy: she had boxing gloves and punching bags; she played outdoors,
climbed trees, and was always running. From the age of three she
would, as she recalled, "get out of bed at night, climb out the window,
walk across a six-inch ledge on the roof, slide down a tree and go
visiting." At the time, her rambunctiousness was seen as not merely
unladylike but potentially a sign of a disorder, and so her parents
brought her to a doctor. Lucky for Prudden, the doctor turned out to
be rather progressive and merely prescribed some form of exercise to
tire her out. Her parents enrolled young Ruth, whom they now called
their "Bonnie lass," in a Russian ballet school; later she attended a
turnverein, learned Finnish gymnastics, and took up diving.

These early activities fell victim, however, to changing assump-
tions about athletics as well as proper comportment for girls. At
Marymount College and Academy, where Prudden was enrolled at
age sixteen in order, as she put it, to "become a lady," the physical
education department worried that gymnastics might damage girls'
reproductive organs and so removed all the parallel bars, side horse,

springboard, ramps, beams, ropes, and mats. As Prudden explained, they had replaced the "strength, flexibility, and coordination born of gymnastics" with games. Later, when she transferred to the Horace Mann School, she found that the administration had denuded the gym in favor of basketball. But girls, it was thought, were too delicate for sports and too docile for competition. So Prudden channeled her athletic energy into dance, beginning professionally while still in high school. By age twenty, her prowess landed her a brief dance career on Broadway.

Prudden's dance career was cut short when she married Richard S. Hirschland, an affluent manufacturer of metal containers, in 1936. But Hirschland was an outdoorsman and introduced his new wife to skiing, mountaineering, and rock climbing; the couple honeymooned in Europe, where they climbed the Matterhorn together. Hirschland also introduced her to the man with whom Prudden would form the most important and fruitful relationship of her adult life: Dr. Hans Kraus, an orthopedic surgeon, innovator of modern sports medicine, and pioneering rock climber. They met in the Shawangunk Mountains of New York State, where Kraus served as her rock-climbing mentor over the years.

Within a year of meeting Kraus, Prudden smashed her hip while skiing, an accident that put her in traction for three months and led her doctor to predict she would never again ski, climb, dance, or have children. In fact she had two children, became the first woman to earn a National Ski Patrol Badge, and is remembered as a world-class rock climber with some thirty documented first ascents and at least one route named for her. It was through rehabbing her hip that she developed her interest in exercise as opposed to sport. Although the injury healed, the pain from it did not dissipate, and so she consulted with Dr. Kraus, who prescribed various exercises. "I turned what I

learned there about pathology to the not-so-pathological of the so-called normal," she later said, meaning that the experience led to the realization that working out would be more effective for preventing sickness or injury, instead of for rehabilitation.

The suburb. That is the simplest answer to the question of why America would eventually become the zero point from which mass participation in fitness spread throughout the world. The fifteen years of first the Great Depression followed by World War II had obliterated the foundations of society, unclothing the existence of security. Economic cataclysm now loomed as a very real possibility; seemingly civilized people could wreak brutal horrors upon their defenseless neighbors; to the refugees arriving in the United States and to their American families, even the bedrock of home and village had crumbled. Built to house the rising population in the immediate postwar years, the suburbs offered the hope of realigning all that had gone askew. As planned communities they represented the promise of technocratic foresight. Homes with lawns—row upon row of them—for uprooted veterans and homeless immigrants; safe havens from the crime, poverty, and dour difficulty of life in the city. The suburbs, too, had the glint of technological progress, from televisions to the many laborsaving devices, such as washer-driers, mechanized vacuum cleaners, processed foods, and prepared TV dinners. And, of course, cars—the joy of driving them on the newly created Interstate Highway System, the pride of being able to afford them. No one would ever have to walk again. And why should they? After so much hardship, the very idea of strain seemed suspect.

But the possibilities of the suburbs also constituted an experiment in what reliance on technology can do to the human body, and Americans were the lab rats. The results, we now know, were

ever-mounting levels of obesity, heart disease, cancer, stroke, and diabetes.

Prudden identified the problem earlier than anyone else, perhaps because she was also located in the suburbs, in Harrison, New York, where she and her husband raised their two daughters. In 1945, she began noticing that her children, then eight and four, weren't as physically adventurous or vigorous as she'd been as a kid, so she decided to organize some activity, gathering her daughters and ten of their friends to play. "I got them to run and jump and do all the things any child will naturally do if given a chance, but the disturbing fact was that some of the children just couldn't run. They shuffled, and that seemed to be all they could do," she recalled. To Prudden, who was exceptionally energetic, such torpor in kids was unacceptable.

She blamed their lethargy on what she aptly called the "tyranny of the wheel"—the stroller, school bus, and car, which is to say the inherently sedentary conditions of modern life. Her first act of rebellion against that tyranny was to begin teaching exercise classes of her own devising to her daughters and kids in the neighborhood. Within a few years, she saw results: her kids grew more energetic, fitter. Not that she was the sort to be content with being a suburban mom who taught phys ed to local kids a few times per week. She had a mind to broaden the circle, perhaps even to adults, and liberate everyone from this new oppression of the wheel.

One day, Prudden and her climbing companion, Dr. Kraus, were resting on a ledge "thousands of feet up in the mountains, and I asked him whether there weren't some tests I could give the kids to show their improvement over a year," as she later recalled. Kraus told her about a set of six gauges of muscular conditioning he had developed with Dr. Sonja Weber. When Prudden subjected her physical fitness class to this battery—which, frankly, set the bar absurdly low, assess-

ing if one could touch one's toes or do a couple of sit-ups—she was appalled to find that half the kids failed. If her kids couldn't perform these basic movements well, she wondered about children in the rest of the country or across the world.

It was this that inspired Prudden—along with Dr. Kraus—to begin a seven-year period of examining the fitness levels of children across America and Europe, during which time her exercise program continued to grow as well.

Although the problem of physical fitness during those years was absent from public consciousness, Prudden wasn't entirely alone in recognizing it. During World War II, large numbers of American draftees—nearly 50 percent—had failed their physical examinations, and there were those in government who were aware of and concerned about these statistics. Among them was Thomas K. Cureton Jr., a young associate professor in the physical education department at the University of Illinois, Urbana-Champaign, who saw in the paucity of robust conscripts an opportunity to bring scientific rigor to the problem. In 1944 he helped establish the Physical Fitness Research Laboratory at his university and became one of the first people to conduct serious scientific inquiries in the field. He was the first to run tests on Olympians, including Jesse Owens, whom he'd seen run at the 1936 Berlin Games, and he experimented with treadmills and other such devices. At the lab, Cureton devised early methods of assessing motor skills, cardiovascular health, and athletic performance, and yet his newfangled experiments mostly resulted, he later remembered, in him being called a "wild man" who "will kill a few middle-aged people and then he won't be around to do it again."

As is usually the case with those bearing unwelcome news from the land of the body, Cureton was branded a quack, particularly by

physicians who believed exercise could be damaging to one's heart and who felt that too much activity would deplete your vital energy. Powerfully built himself, Cureton responded to his critics with a pugnacious decades-long barrage of studies and scientific papers demonstrating the importance of exercise for health. Yet for most of that time he restricted his sallies to the academic arena, and while he eventually took his findings to the media, his forays were sporadic and without wide impact.

Prudden, by contrast, proved expert at exploiting the mass media. Physically small, she had a large personality: "she took up a lot of space in a room," says her longtime associate Enid Whittaker. She was pretty in an approachable way, not intimidating. She had a limber mind and an agile way with words (followers collected such "Bonnieisms" as "you can't turn the clock back, but you can wind it up again"). Perhaps not as flamboyant a showman as other fitness promoters who came both before and after her, she nevertheless had a remarkable ability to hold audiences, be they popular or at the highest echelons of society. Conviction, charisma, and showmanship: qualities that in so many of the characters from the history of fitness combined as charlatanism combined in Prudden to make her a formidable leader, marketing wiz, and saleswoman.

Her background also provided levels of confidence and independence unusual for women of her era. In 1954, she divorced her husband, changed her name officially to Bonnie Prudden, and soon thereafter opened a business called the Institute for Physical Fitness in an abandoned elementary school in White Plains, New York. The facility, which had several gyms, an obstacle course, two dance studios, a sauna, showers, a massage room, as well as the first climbing wall in America, attracted men and women in addition to kids.

The following summer, in 1955, Prudden and Dr. Kraus presented

the results of their seven years of research at a White House luncheon hosted by President Eisenhower. According to the Kraus-Prudden Report, an astounding 57.9 percent of American children had failed in one or more of the six *minimal* physical fitness competencies of the Kraus-Weber test, as compared to only an 8.7 percent failure rate among European children. They broke it down further: 44.3 percent of Americans failed in flexibility and 35.7 percent in strength, whereas only 7.8 percent and 0.5 percent of European children respectively came up short. Although far from a perfect test of overall fitness, the "Report That Shocked the President," as it came to be known, managed to begin a conversation about the fitness of all Americans—who, for the first time, were being told they didn't measure up.

According to Dr. Kraus, American kids were "paying the price of progress." As he reported: "The older generation was tougher because it had to undergo adequate physical activity in the normal routine of living. We have no wish to change the standard of living by trying to do away with the automobile and television. But we must make sure that we make up for this loss of physical activity." The report led to the founding of the President's Council on Youth Fitness (PCYF), which operated from 1956 to 1960, when it became the President's Council on Physical Fitness under the Kennedy administration. One can see in the shift from "Youth Fitness" to "Physical Fitness" that there was a dawning realization that inactivity was a problem for the general population, not just for children.

The Kraus-Prudden Report received widespread publicity, whipping up indignant, often hysterical assaults in response. Doctors pointed out that unwitting exercisers could suffer such horrific consequences as charley horses or being hit on the head by stray golf balls while out on the links. There were those who reacted with nationalistic fervor at the suggestion that Americans were somehow inferior to

Europeans. Some educators responded with defensiveness at the implied attack on their effectiveness: echoing Mike Wallace, they raised such incisive questions as, Should kids stop learning to be doctors and engineers in order to chase chipmunks?

At the same time, however, there was a dawning sense that cardiac problems were rising quickly in industrialized nations. And people thoroughly awoke to the issue when, just a few months after the Kraus-Prudden Report appeared, President Eisenhower suffered a heart attack during a vacation in Colorado. This episode seemed to rouse the nation and much of the world to the afflictions of a pampered yet oddly stressful civilization (Hans Seyle popularized the notion in his book *The Stress of Life* in 1956). A couple of years later, a landmark study by the British epidemiologist Jerry Morris correlated activity with the incidence of heart disease. Morris showed that double-decker bus drivers, who sat all day, had a much higher rate of heart attacks than conductors, who spent their days chugging up and down stairs.

Not that Morris's research convinced the medical establishment of any causal link between exercise and a lower rate of heart disease. Many believed it was more likely to cause heart problems than ameliorate them. It was widely assumed, for instance, that any sort of physical training would result in what was called "athlete's heart," an enlargement of the organ, as well as a low resting heart rate—both of which were thought to cause early death (in fact, it is a sign of health, as the enlarged muscle needs to contract fewer times per minute to pump the same amount of blood). Doctors tended to prescribe bed rest, a lot of doing nothing, to cardiac patients—thereby decreasing stress.

It was almost exclusively men who were seen to suffer from stress and to be prone to heart disease, the paramount health issue of the era—yet virtually all exercise and diet recommendations were di-

rected at women. The assumption driving this paradox is telling: exercise was understood to be useful almost exclusively for cosmetic purposes (in other words, for losing weight), and so it fell within the purview of female concerns, along with food and the overall health of the family. Still, this relegation of the bodily issues to the feminine sphere allowed Prudden to start her business, and it did not restrict her influence to women alone. One picture from that time period captures her in mid-jump, inches off the ground, her legs—notably muscular in dark, translucent tights—spread in a wide V, her arms held out to her sides, her halter top revealing defined abs, as she leads a class of young, shirtless men wearing similar tights. The clothes she's wearing in the picture are an early version of the pioneering exercise fashions she designed and eventually sold through Montgomery Ward. Her wide mouth is joyfully calling out the next position, and on the floor in the background stands a case for holding a selection of LPs: Prudden's dance-based calisthenics classes were done to music, years before the invention of aerobics.

And this was far from her only innovation. Her most novel creation, beyond herself, was the Institute for Physical Fitness in White Plains, in particular the fact that it was owned and run by a woman at a time when almost none of the very few gyms that existed even allowed women entrance. It was her ambition, she said, to "put an Institute for Physical Fitness in every city in the country." But it is notable that she located the original in a suburb, White Plains, where such establishments were unheard-of.

In the end, she didn't succeed in replicating the institute in other places—that goal would only be achieved by the women of a younger generation for whom she stood as an exemplar. But the institute, which was unusual for welcoming men, women, and children of all ages, hosted representatives from the national YMCA, who then went

on to collaborate with Prudden in opening the Ys to family fitness. This in itself is far more significant than it might seem, for the YMCA eventually became a primary venue for introducing the wider public to fitness activities.

The early years of the Cold War made manifest to political leaders that lifestyle reflects the ethos of a society—that full supermarkets, highways packed with cars, and fat citizens (not to mention provocative art) signal what a nation values. Prudden was keenly attuned to this. Several months before the Soviets handily outpaced the United States in the medal count at the 1956 Summer Olympics, Prudden was quoted as stating that the low level of American fitness consti-

Bonnie Prudden leads a class in exercises at her White Plains, New York, school, 1956. (Courtesy of Al Revanna/Library of Congress)

tuted a "national emergency." "We were once the greatest nation, to-day we're the weakest in the world," she said, equating—as people have since ancient times—personal strength with national strength, the individual body with the body politic. The crushing of the Hungarian Revolution by the Soviets later that autumn only heightened the urgency of her warning. Fitness came to be perceived as a national security issue.

One response to the events of 1956 was an issue of *Sports Illustrated* the following year dedicated to what it termed a Nationwide Report on Physical Fitness. The cover featured Prudden wearing an outfit of her own design, a tight leotard with a blue star pattern—a first for women on the magazine. Soon after, CBS asked her to present a weekly exercise segment on *Home*, a daytime TV show, which led to a regular spot on the *Today* show, and, in the early 1960s, to her own program.

The international clash of lifestyles became more urgent as the Cold War intensified. In 1960, then President-elect John F. Kennedy echoed Prudden's warning of a national emergency in a widely cited article also from *Sports Illustrated*, "The Soft American." In it he decried the fact that, despite the "increased attention" given to fitness since the Kraus-Prudden Report, "there has been no noticeable improvement" in the actual fitness of Americans. Then, echoing the Duke of Wellington's quote about Waterloo, Kennedy made the connection to the safety of the body politic explicit: "Our struggles against aggressors throughout history have been won on the playgrounds and corner lots and fields of America. Thus, in a very real sense, our growing softness, our increasing lack of physical fitness, is a menace to our security."

Kennedy's assertion is, however, stranger and more indicative than it might at first seem. Athletic practice in youth might foster discipline

and the martial spirit, but it's unclear to what degree physical fitness could matter in modern warfare, when superior technology—bombers, jets, and nuclear weapons—seemed far more decisive. Part of what he meant was indeed the virtues instilled by athletics: in the fifties and sixties, the word *fitness* had stronger moral than physical connotations. The PCYF defined it as encompassing "the total person—spiritual, mental, emotional, social, cultural as well as physical." And President Kennedy wrote that "a healthy body" forms the "basis of dynamic and creative intellectual activity." So while physical superiority in hand-to-hand combat or on long treks wouldn't necessarily win a war today, moral uprightness and mental acuity would.

But there was also an ambiguity dogging Kennedy's famous essay, a basic confusion about what physical fitness is and what counts as exercise. This confusion was endemic to the era. It stands to reason that without a conception of what exercise was, large numbers of people weren't going to be convinced to do it.

9

FROM WOMEN'S WORK TO THE WOMEN'S MOVEMENT

The Training Effect

You might think that the combined levers of mass media and government attention would begin to shift the boulder of inactivity in the United States in the late 1950s, but they did not. Even as a small number of people began to comprehend that they needed to do something to get fitter, there still remained the question: *what should they do?*

No one with a public profile could usefully answer this question. One doctor claimed that the only exercise a man needs is stretching with a towel for five minutes each day while waiting for the bath. And TV personalities like Jack LaLanne intimated that merely bending over and touching your toes a few times was a workout. *Exercise* was a word without a definition.

The Jack LaLanne Show started broadcasting across the country in 1959. LaLanne, who taught calisthenics in the Navy during the war, got into local television in 1953 in the Oakland area. The show offered user-friendly workouts and eating tips to the legions of middle-class housewives whose bodies were presumably spreading

as quickly as the suburbs in which they lived. Clad in a fitted blue jumpsuit open at the chest and with high short sleeves to show off his biceps, LaLanne the peppy TV host took viewers through a routine that was unlikely to cause viewers any strain. "Here's something to firm up the front porch," he'd offer, propping his hand on a chair and swinging a bent knee up across his hips for about fifteen seconds, before moving on to "something to slim down those hips," another half minute of side bends. The leg lifts, toe touches, and jerky, bouncing stretches LaLanne advocated were rarely even as demanding as jumping jacks, the exercise named for him (he popularized it in the United States, though he didn't invent it). And the notion of targeted exercise he perpetuated—such as doing sit-ups to reduce belly fat or side bends to shape the hips—was simply false. (On the other hand, the nutritional advice he doled out on the show—emphasizing vegetables and lean meats—was sound and remarkably prescient.)

By all accounts, LaLanne's *personal* workout regime was strength oriented, effective, and forward-looking; yet such was the state of thought about exercise in the fifties that LaLanne wouldn't have dreamed of foisting real, sweat-inducing movements on the public. Strain was still considered dangerous, and doctors remained skeptical of any sort of exertion.

In the eyes of the general public, the point of exercise, if you accepted there was a point, was weight loss. Which meant people saw it as being mostly a female concern—for beautifying yourself, not primarily for health or longevity. Thus LaLanne called his TV routines Trimnastics, and during the program he marketed a number of products, from vitamins to the Glamour Stretcher (an elastic band) to face lotion to juicers—all of which aimed at improving looks rather than health or human performance.

Improving looks was the explicit purpose of the numerous spas

and beauty gyms that sprouted up across the country in these years, foremost among them Vic Tanny's sleek, machine-age facilities as well as those with LaLanne's name on them. Tanny proved himself adept at marketing but no more able to change public consciousness than LaLanne. By 1961 he'd become so famous for, in the words of one journalist, "promoting and exploiting a kind of health hysteria," that the Wisdom Foundation published a volume on Tanny in its series of popular biographies devoted to influential thinkers. Yet within two years, he was forced to sell what remained of his failing business. Donahue "Don" Wildman, one of Tanny's best salesmen, and the man who ended up buying out some of the Tanny locations and turning

Jack LaLanne before a handcuffed swim from Alcatraz to San Francisco, 1955. (Courtesy of Everett Collection, Inc./Alamy Stock Photo)

them into successful enterprises in the 1980s, recalled that Tanny "just didn't have much faith in the business. People didn't want to work out, no matter how good a service you gave them. They were lazy. It didn't matter if you sold them a lifetime membership—they'd never use them anyway." But whether they used those lifetime memberships or not, the people who bought them—at considerable cost—were outraged when Tanny filed for bankruptcy. Such was the infamy that Tanny brought down upon the industry that LaLanne, too, had to sell his brick-and-mortar enterprises by the mid-sixties.

When the poet W. B. Yeats wrote, "we must labor to be beautiful," he was expressing the convictions of an earlier generation. Strain and sweat offended the automated, *Jetsons* ideal in the era of laborsaving devices. Modern women preferred to *reduce* themselves in beauty spas promising "passive exercise," which held out the hope that contraptions like steam cabinets, electrical stimulation, various beauty stretchers, vibrating belts and chairs, and mechanical massagers would take the effort out of slimming and toning.

A lthough the fitness industry focused on weight loss and other cosmetic regimes for women, men were not immune to the seductions of passive exercise. "Middle-aged men [by which he meant anyone 26–60] just don't know how to exercise," Thomas Cureton warned. "They delude themselves into thinking they can get fit by lying in a steam bath or getting a massage." And the gyms available were no more useful in pushing the notion of an actual workout. As remembered by Bill Starr, who when he joined the Baltimore Colts in 1970 became one of the first strength-and-conditioning coaches in American football: "The workouts were designed so members could go through a workout in a short period of time and achieve the results

they were seeking without any strenuous exertion. The biggest selling point of using the machines was the sessions could be done quickly."

Even when they weren't trying to get machines to exercise for them, men were no more likely than women to hear sound advice on what they ought to be doing. The reason for this is twofold. The fear of overtaxing—of pushing oneself too hard and thereby causing heart attack, injury, or a depletion of one's vital energy—colored much of the discussion and approach to fitness in the two decades after the war. The light calisthenics Prudden advocated were designed to avoid fatiguing any one part of the body, while LaLanne asked his viewers to do little more than any sentient being could do. The second reason is that both Prudden and LaLanne spoke primarily to women, as did virtually all of era's fitness promoters. In a Grape Nuts commercial from the fifties, Prudden demonstrates an exercise for weight loss—a rhythmic twisting of the torso with the hands out—saying, "Twenty times a day, every day, until you work up to one hundred." Then she adds, almost as an afterthought: "And your husband, too." Leaving aside the question of what these torso twists were meant to accomplish (or how your hubby would respond), this ad exemplifies that family health was assumed to be a woman's job. Men were too busy earning a living to bother with their bodies.

I n the sense that my parents were a product of it, I was raised amid this confusion. My mother, having gained weight in pregnancies, and trying to conform to an ideal figure that for her body type was impossible, got snagged in a cycle of fad diets and binge eating. Both she and my father were "active," to use the parlance of the day, playing tennis on weekends, taking walks, splashing about at the pool or beach in the summer, but neither had any sense of training or of what

it was about exercise that made it effective—and these are people with advanced degrees.

While I lived with them, my parents never went to the gym. They had exactly one friend in their wide acquaintance who got into body-building, and he was presented as a figure of amazement—it was as if he'd become interested in big-game hunting or something equally improbable for the Washington, D.C., suburbs. But even then, as a child in the eighties, I had the sense that exercise—aerobics, other classes, even running—was women's work. The sentiment of the day held that women had to keep their figures, while men naturally aged into beer guts and love handles. And if men did hit the gym or the pavement (wearing stylish new running shoes), it was because their wives forced them to do it.

Cureton was one of the very few people who thought otherwise: he'd been trying to reach men with the gospel of exercise since the war, albeit mostly within the academic community—which meant his impact, though important, was not widely registered. Pugnacious and argumentative, he responded to the inevitable, early charges of quackery by lecturing on his lab work to doctors, professors, and anyone else who invited him, while trying to disabuse people of the ill effects of moving. He had the zeal of a believer, one who practiced what he preached. And in fact he did: Cureton ran cross-country and swam at Yale, where he studied electrical engineering, and he continued these physical pursuits for the rest of his life. (All those workouts eventually did Cureton in—he died at age ninety-one.)

By the mid-sixties, rising public anxiety about the incidence of heart attacks in men gave Cureton some new purchase on people's attention. The back cover of his Time-Life book, *The Healthy Life: How Diet and Exercise Affect Your Heart and Vigor*, featured a photograph of the aging professor jogging in baggy sweats. Underneath was

a caption explaining that his "workout takes him through a cemetery where some of his colleagues who once called him a 'health nut' now rest."

As one professor put it, Cureton "brought the notion that physical activity is a preventive form of medicine for all people of all ages to the public for the first time." In *The Healthy Life*, he prescribed what today would be considered real (though low-intensity) exercise: light jogging and swimming as often as six days per week. Yet even Cureton himself was far from immune to the assumptions of the day: he counseled adult men not to engage in what he called "high-tension" activities, like basketball, for fear they could cause heart damage.

In 1966, the same year Cureton's *Healthy Life* was published, a cardiologist named Carlton B. Chapman lamented that "physical vigor was not a concern of the American adult, the topic was more or less suspect; the compulsive focus of health faddists rather than the legitimate interest of the rank and file." Nothing seemed to move the needle and increase the number of people exercising in the fifties and sixties: no amount of lab work by Cureton demonstrating the benefits of exercise, none of the arguments from President Kennedy that the safety of the nation depended on the fitness of its citizens, not the cheerleading by Prudden and LaLanne urging women to move and slim down, and not even the rising number of heart attacks. And because there was no consensus on where the line dividing activity from exercise fell, there were no guidelines for how much effort was necessary or desirable. For example, when an academic paper reports, "In 1960 only 24 percent of Americans claimed to exercise regularly," we don't know whether *exercise* referred to people tying their shoes, stretching, or running hill sprints.

Still, in the space of a generation, from 1960 to 1987, the number of people claiming to exercise nearly tripled. By 1987, 69 percent of

Americans said they worked out. Given the standards of exercise in 1987, it's safe to say that a very low portion of this group was actually performing what could be considered valid exercise—but this rise in itself is a significant marker of shifting perceptions. Add to that the fact that in 1968 there were 350 fitness clubs in the United States, and by 1986 there were more than 7,000, and you can sense the explosion in the appeal of fitness that occurred in the 1970s and '80s.

So what changed? Why did people suddenly take up jogging and yoga beginning in the late sixties? Why did gyms become the enormous business and cultural force that they are today? Why did men, who had never cared how their naked bodies looked, eventually become as physique conscious as women? The answer is twofold, related swells coming together to form a huge wave: one was a clearer, more scientifically based understanding of what exercise is, and the other was a massive increase in participation. Did the first contribute to the second? Yes, though not nearly to the extent that has been assumed in virtually every account of the period.

The standard narrative of what ignited the fitness boom of the seventies rather murkily credits Dr. Kenneth Cooper's 1968 book, *Aerobics*, with setting off the jogging craze. What this story doesn't explain is why people created all the gym franchises or how a book might convince millions of people to exercise. After all, expert opinion does not tend to cause broad shifts in societal behavior: the knowledge that cigarettes kill or that drinking soda and other processed sugars result in obesity did not quickly translate into mass shifts of behavior, nor did grasping the importance of exercise.

That said, Dr. Cooper is an important part of the story. But rather than inducing masses of people to work out, as he and many others have claimed, Cooper first popularized both a specific concept, or definition, of what fitness is as well as the means of achieving it. In

fact, Cooper's thinking, and the book that resulted, benefited from what was already a nascent jogging fad (rather than causing it).

Running has been a human activity for as long as there have been humans. Yet historically it was something done by professionals, be they athletes competing in footraces or the messengers who for eons ran between city-states, fiefdoms, tribes, and kingdoms carrying information and missives. Jogging as a pastime, as a fitness pursuit, developed in response to the cardiac crisis of the postwar era—and it originated in New Zealand. Soon after New Zealand took two gold medals for track—in the 800-meter and 5,000-meter races—at the 1960 Olympics, the team's coach, Arthur Lydiard, was approached by three retired businessmen with heart problems, who had gotten it into their heads that running might help them. Lydiard and the businessmen managed to convince a doctor that using the heart muscle might actually rehabilitate it, and the doctor sanctioned light runs for the men under the coach's supervision.

Coach Lydiard urged moderation on the club by recommending that members maintain an easy, talking pace during their runs. The men began by intermixing walking with short, slow bursts of running, and over time they gradually increased their trotting distances. As they did, the men found that they slimmed down and felt better. Others soon joined them, and the group, which met on Sundays, became the Auckland Joggers Club. By adopting the word *jogging*, which had been in use since the sixteenth century in English-speaking countries to describe brief, gentle runs, they replaced the commonly used *roadwork*, the term employed by boxers and other athletes for their conditioning runs.

Running was so novel at the time that club members were regularly harassed by people in passing cars; at least one was arrested as a burglar for jogging at night. Yet the club grew swiftly. In 1962, a

coach at the University of Oregon named Bill Bowerman, then in his early fifties, visited. By then the joggers were doing so well that some of the over-seventy crowd, many victims of multiple heart attacks, outran the American coach. During the six weeks Bowerman remained in New Zealand, he learned as much as he could about jogging. Upon returning to Oregon, he started a club of his own, and it too began steadily adding members, a quarter of them women. The local paper wrote an article about this strange new phenomenon, and only a month after it began, the club had attracted well more than a thousand people. Partnering with a cardiologist by the name of Waldo Harris, Bowerman brought out the book *Jogging: A Physical Fitness Program for All Ages* in 1967. It sold millions and helped catalyze the first surge of interest in jogging.

In 1960, Dr. Kenneth Cooper was twenty-nine years old, married, and board certified in aerospace medicine—he wanted to work with astronauts. The Texan had been a miler in high school and played basketball at the University of Oklahoma, but by the end of his twenties, after medical school, he had become overweight and out of shape. While waterskiing for the first time in eight years, he suffered a cardiac arrhythmia. He'd become, he said, "a typical inactive, overweight male, lethargic," with high blood pressure and prediabetic conditions. He was, however, atypical in the extreme: not only did he get fit enough to run the Boston Marathon a year later, but he began practicing in the then-scorned arena of preventive medicine. Cooper also realized his dream of working on space travel, assuming directorship of NASA's physical conditioning program for astronauts. His focus was on helping astronauts maintain their baroreceptors, for the loss of these sensors caused the astronauts to pass out when they returned to earth.

After considering the problem, Cooper surmised that improv-

ing the cardiovascular system would mitigate the issue. As a doctor and ex-athlete, he recognized that the heart is a muscle, one that will weaken if not stressed, and he embraced the heresy that, instead of causing "athlete's heart," it would grow stronger through exercise. But, he wondered, how much exercise should one do and what types are the most effective? What made him different than most people asking these questions were the thousands of Air Force personnel at his disposal, men he soon began testing. As Cooper explained, "We went about comparing aerobic exercises, such as walking, running, biking, and swimming," assigning each a number of points depending on the intensity and duration of the activity. Running is more demanding than walking, so you get more points for running a mile than for walking it. He found that the heart and oxidative metabolism adapted to progressively more strenuous efforts, thereby increasing one's aerobic capacity. The more aerobic capacity you have—how much oxygen you are able to utilize—the farther and faster you will be able to run, bike, or swim. Cooper called this adaptation the *training effect*.

This rubric established the first modern fitness protocol. *Exercise* once referred vaguely to any sort of movement, but now it meant training. This is not to say that coaches and serious athletes at the time hadn't understood that in order to get better at running you have to run; but no one before Cooper had conceptualized it in physiological terms. Nor had anyone succeeded in convincing average people that they too need to work progressively like athletes in order to become fitter.

One result from his years of probing endurance was the famous Cooper Test, which is the distance you can run in twelve minutes. Because it was simple and required virtually no equipment, the test became a military—and eventually worldwide—standard for assessing

aerobic capacity. The other product was *Aerobics*, which digested his research for laypeople and provided a version of the Cooper Test. In it he offered easy programs based on age and activity aimed at building up to his recommended 30 points per week (an indication of the low fitness expectations of the period is that later editions of the book recommended 35 points per week). Bill Staub, who owned a manufacturing company in New Jersey, read *Aerobics*, and within the year he had produced the first commercially available, home-use treadmill. However, Cooper had recommended any type of cardiovascular exercise, from swimming to biking to walking. This message resonated with Keene Dimick, a retired chemist who, also in 1968, invented the Lifecycle, a novel stationary bicycle with a rudimentary computer interface that could set a twelve-minute Cooper Test protocol.

Aerobics went on to sell two and a half million copies within a few years; over the next decade its spin-offs sold 12 million. From

Dr. Kenneth Cooper (far left), jogging in New York City, 1969.
(Courtesy of Bettmann/CORBIS)

the small base that Bowerman had established with his earlier book, Cooper blasted information into what had been a vacuum, and from it formed a galaxy of joggers.

Politics by Other Means

The thing is, there had been opportunities for men to run for centuries: it is among the most democratic of activities, requiring no equipment at all. Yet contrary to anything you might read on the subject, including in the previous section, no club or book suddenly inspired millions of people around the world to take up jogging as a healthful pastime or as a recreationally competitive sport. Instead, it was the influence of a movement that ultimately sparked widespread change— and that movement was feminism.

Feminism, which developed at the same time, is the key element that so often remains unmentioned in this story. To be clear, the first mass culture of fitness—the extensive participation that began in the seventies—must be credited to a number of women empowered by the women's movement (most whom were influenced by Bonnie Prudden). Women in the 1960s began to revolt against all sorts of strictures, among them the ban on running long distances (they were thought to be too weak and fragile for anything over a couple of kilometers). New Zealander Millie Sampson became the first woman to compete in an official marathon, in 1964 in Auckland, at a time when females were barred from such races in the vast majority of places, including America. Three years later, as Bowerman was publishing his book, Kathrine Switzer illegally entered the Boston Marathon, as a few others had done in previous years. This time, however, a photographer caught the race codirector on film as he attacked Switzer and attempted to drag her from the field.

The Boston race, America's oldest marathon, had been growing very slowly since its founding in 1897; some 741 people ran in the 1967 race that Switzer crashed. But by 1969, one year after Boston organizers had begun allowing women to race unofficially, the number of starters (1,342) had nearly doubled. Women did not account for the ballooning numbers—only three finished in 1968 and 1969. But their participation attracted attention—and men. The tremendous success of the coed New York City Marathon, which began in 1970—not to mention other coed races across the world, from Toronto to Germany—essentially forced Boston to officially open its gates to women, too. And, despite lowering the qualifying time in 1971 and thus making it more difficult to participate, Boston again more than doubled its starters within two years of admitting females.

The women Cooper inspired would prove even more consequential. For one thing, women turned jogging into a craze merely by joining in. But they were also solely responsible for the mass-fitness movement that took its name from the book *Aerobics*.

Aerobics as a field of exercise was born in 1969, not incidentally the same year that *the personal is political*, the rallying cry of movement feminists, was popularized. As far as I can tell, no connection has been made between these two events. The reasons for this lack of connection are illuminating, however. On the one side, the founders of aerobics never identified themselves as political feminists, and at the time a number of feminist thinkers objected to what they perceived as the body types and general aesthetic aims that aerobics promulgates. On the other side, since the 1980s those writing about the history of feminism have tended to focus on the explicitly political struggles of the movement's leaders or on the problems of working-class women. There has been comparatively little attention given to middle-class women, that is to say the types of professional and business-owning

women who were the clients and founders of aerobics. In hindsight, aerobics turns out to be both a tacitly feminist phenomenon and very much a product of the women's movement. And, as the catalyzing agent of the fitness boom of the seventies, women didn't just open doors for themselves—they fundamentally altered the way a vast number of people in the world relate to their bodies.

I don't imagine that the married Lucille Roberts, founder of the eponymous women's-only gym chain in New York City in 1969—which she proudly described as "the McDonald's of health clubs"—thought of herself as a radical women's libber, but this business movement certainly carried political overtones. Nor was the military wife Jacki Sorensen a political agitator. While she and her husband, an Air Force pilot, were based in Puerto Rico, she read *Aerobics* and determined that it had "revolutionized the concept of fitness." A former professional dancer, Sorensen surprised herself when she scored in the "excellent" category after taking the Cooper Test, despite not having done any running, biking, swimming, or other activities recommended by the book. "She concluded that the dancing she'd done all her life had gotten her in such good shape," Sorensen's husband, Neil, recalls.

Sorensen was energetic and ambitious. Instead of simply continuing to dance, she decided to conduct an experiment, and went so far as to consult with Dr. Cooper, whom she was able to contact through the Air Force. She put women from the base through a twelve-week dance program she devised. Deemed successful, that experiment became the basis of classes she began hosting, as well as a dance-exercise television program she developed for Air Force wives.

In 1970, Sorensen and her husband relocated to South Orange, New Jersey, where she began offering what she called Aerobic Dance

classes at several local YMCAs, colleges, and universities. It was in those places that the seeds of the aerobics movement were planted. She also began hosting workshops primarily for physical education teachers, first in Texas and then throughout the country. With demand for her hour-long classes quickly rising, Sorensen formed Aerobic Dance Inc. (ADI) in 1972 and started training other instructors. Keeping the word *aerobic* in the name proved key, for it allowed ADI to capitalize on the popularity of Cooper's book and its sequels. The business itself spread mostly through YMCAs, although other venues were used, and it had reached most parts of the country by 1975, when ADI opened an office as well as its first dedicated aerobics studio in New York.

Sorensen, along with other women who opened gyms and studios during those years, tapped into the growing urge for self-transformation, which, though ever present in American life, seemed to course through the culture all the more powerfully in the late sixties and seventies. The women who in the preceding decades had been taught to take charge of their families' health, eating, and exercise now led a new generation in remaking themselves. As the historian Benjamin Rader writes, "In the late 1970s, a new ideal woman began to emerge, one who was thin but physically fit, energetic, possessing some muscle definition, and who was more assertive (even in intimate relations between the sexes) than her predecessors." By adding to the potential client base, these new women allowed gyms and health clubs—which even in the mid-seventies remained closed to women (or at best were open to them only on certain days, and were filled with what was perceived as male-oriented equipment, like free weights—in other words no treadmills, StairMasters, and the like)—to proliferate later in the decade as coed establishments. By 1978, for example, there were some 3,000 gyms in the United States, a tenfold increase over the course of the decade.

By 1981, ADI reached a high of 1,500 offices in forty-five states, employing more than 4,400 people, but franchise gyms, a phenomenon formed from the ashes (and sold-off assets) of the Tanny empire, began shouldering in on its territory. Sorensen had failed to get a copyright on the name Aerobic Dance, and this allowed health clubs to absorb her methods and offer unlimited aerobics classes. ADI was also losing a battle with Jazzercise, a contemporaneous version of aerobics that had been copyrighted by its savvy founder, Judi Sheppard Missett.

A dancer in Chicago in the sixties, Missett taught dance between gigs but soon realized that the women attended her classes mainly for the "thinning aspect," rather than to learn the art. In 1969, she shifted to a blend of "jazz-dance choreography, aerobic muscle-toning, and stretching exercises." A few years later, after moving to Carlsbad, California, where the classes filled as fast as she could add them, she named this program Jazzercise.

As the earliest into the field, Sorensen and Missett received virtually all the credit for the emergence of aerobics, but at this point, early in the decade, they were pilot fish at the nose end of a large school of women who, empowered by the women's liberation movement and the example of Prudden, initiated their own aerobics businesses. Arden Zinn, a student and then colleague of Prudden, opened her first gym in 1970 in Atlanta, branches of which would follow throughout the South. Offering aerobics, yoga, and dance, Arden Zinn Studios began franchising in 1979. Her protégé, Martha Pipkin, who had also studied with Prudden, launched Shape Up with Martha in Memphis, Tennessee, in 1972. Within five years, she had 50 instructors teaching 100 classes. Nancy Strong studied with Prudden when they were neighbors in White Plains in the fifties. But it wasn't until 1971 that she created a series of Slimnastics classes in Miami. Slimnastics was an

early 1960s prototype of aerobic dance, created by Martha Rounds, who was also strongly influenced by Prudden. In 1978, Strong incorporated Aerobic Slimnastics in Connecticut; the company swelled to more than 200 instructors in the New York area. Yet another acolyte of Prudden's, Sheila Cluff, appeared in a fitness TV show in New York and Vermont from 1966 through 1969, when she moved to California to expand her aerobics dance business. In 1977, Cluff unveiled the Oaks at Ojai, one of the first wellness spas providing fitness classes. And an Englishwomen, Joni Coe, who studied first with Prudden and then learned Sorensen's aerobics, developed the YMCA's most widely used fitness programs.

Throughout the decade, aerobic dance spread across America on tendrils sent out by these women—but what caused its flowering worldwide was video. Missett was an early and productive adopter. She began taping and distributing training videos for Jazzercise in 1979, which permitted the broad dissemination of her techniques and thereby allowed the franchise to spread faster and more easily. Recognizing the potential of this new technology was only one way Missett proved a more adept businesswoman than Sorensen: she also paid employees better and nurtured her brand more effectively, for instance, by copywriting it. Harnessing video effectively led Jazzercise to be listed often in this period as one of the top twenty-five franchises in the United States. Missett's instructors even performed in the opening ceremonies of the 1984 Olympics. Two years later, President Ronald Reagan honored her as an entrepreneur.

Of course, it was Jane Fonda's videos—which first hit the market in 1982—that imprinted aerobics (and, in some sense, the idea of working out) on popular consciousness. Titled simply *Workout*, starring Jane Fonda, the cassettes provoked not only a frenzy of sales but also of imitators. Her choreography and approach became the

model for the albums and videos she inspired, as well as for the classes that health clubs, hungry for revenues from female members, began rapidly instituting. No doubt the success of the videos—they were the format's first bestsellers and were instrumental in the formation of the made-for-video market—was magnified by the dual nature of what Fonda represented: she was a feminist activist and a celebrated beauty, when women's power was all too frequently regarded as ugly, masculine, shrill, and fleeing from the spotlight, while the women's movement itself was in decline. But Fonda and aerobics in general also arrived at a propitious moment to fulfill the implicit promise made thousands of years earlier by the statues of Greek heroic athletes. While the *Doryphoros* and *Farnese Hercules* kindled aspirations, saying, "Through great effort you can be like me," Fonda became the mirror and the instructor all at once; her videos said not only can you be like me, but you can train with the goddess herself.

C ommercial gyms had existed for well over a century at this point, though as single-sex venues they appealed only to narrow enthusiast subgroups—the weightlifters, the bodybuilders—and for this reason there were very few facilities. Mixed-use health clubs built around tennis, racquetball, and swimming, while also offering some weight and cardio machines, proliferated rapidly once they went coed in the seventies. (In fact, Don Wildman's Health and Tennis Corporation of America bought out Jack LaLanne's European Health Spas, Holiday Universal, and what remained of Vic Tanny's empire.) However, their growth and the model they represented were soon overtaken as aerobics classes brought in the critical mass of women that allowed globo gyms (such as 24 Hour Fitness in 1983 and LA Fitness in 1984, to mention two major players) to mature in the eighties.

Need I say what drove surpassingly large numbers of men into gyms in the early eighties? Apparently what had been missing from the century-old commercial gym model were women congregating in leotards. As it became apparent that "what the singles bars were to the 1970's, the high-tech physical fitness parlors are to the 1980's," as the *New York Times* reported, health club businesses began multiplying like beads of sweat on an overheated brow. In an article titled "The Mating Game and Other Exercises at the Vertical Club," the newspaper likened New York's most popular gym to "today's Studio 54." *Rolling Stone* magazine dedicated an entire series of articles to the dating scene at the Sports Connection in Los Angeles, which became the basis of the 1985 film *Perfect* (a flop starring John Travolta and Jamie Lee Curtis, the latter as an aerobics instructor). Weider Publications brought out a monthly in 1981, *Shape*, to capitalize on the new women's fitness market, and it too touted health clubs as a place to meet like-minded, fit-bodied men. A common theme running through all the articles was that women reported feeling safer getting to know men in gyms, where better lighting meant you could at least see the predators coming at you, and there were no drunks (or fewer) than in bars or discos. Further, the intermingling of sexes at gyms created business-networking possibilities for women that had previously been unavailable in exclusively male social and athletic clubs.

Although fitness and feminism grew up together, as it were, what women brought to and took from the world of exercise presented a tangle of contradictions to the thinkers of women's liberation. For instance, the 1968 protest of the annual Miss America pageant in Atlantic City, New Jersey, a galvanizing event in the women's movement, put the female body in the political spotlight at the same moment that aerobics was being conceived. A pamphlet distributed at the protest, written by the same women who had put the phrase *the personal is*

political into currency, decried the "Degrading Mindless-Boob-Girlie Symbol" that the female body had become. It's easy to see, then, how aerobics and jogging might have be seen as unconscious reactions by women to societal norms of body type, and as an equally mindless effort to conform to the role of sexual object. That was the tenor of many early feminist responses to aerobics, when it was referred to at all: as just another means of slimming down, turning women into more bait for man-trapping. That such fitness practices might have a practical political effect, such as expanding business opportunities for women, was not as apparent; nor were they understood to be counteracting the trend toward obesity, the reliance on industrial food and cars, and the belief in the masculinizing effects of exercise on women. What's strange is that while Sorensen, Missett, Zinn, and the others weren't necessarily placard-waving feminists, they also weren't seen as practicing politics by other means, even though that's exactly what they were doing—and in a context created by feminism.

After aerobics had been around long enough for sociologists to take note, they reported other qualities, such as building strength, self-confidence, and camaraderie. These positive findings, coupled with more practitioners joining in on the commentary, led to the feminist recognition of how exercise helps women to assert control over their bodies and experience euphoria in doing so.

But the feminist critique of aerobics would turn out to be unexpectedly powerful, as seen when a later generation assimilated its arguments into New Frontier Fitness. In a 1988 essay, Elizabeth Kagan and Margaret Morse deplored the tendency in aerobics toward the "denial of functional training possibilities in favor of cosmetic ones." A little more than a decade later, millions of women would look to functional fitness as a means of reformulating the standard of beauty that defined the cosmetic approach.

Already, as the seventies came to a close, one could sense anxieties astir over an element rebelling from within society and jostling conventions—not politically, not in florid new fashions (though with the first sports bras having just come out and the prevalence of joggers in sweats or skimpy shorts, fashion also reflected it), but by a refusal to sit still. This "bizarre behavior," as John Van Doorn called it in a 1978 essay in *New York* magazine, is restricted to a "small band," but one that constitutes a new "physical elite" that is emerging: "a class of American men, women, and children who are taking to the roads, paths, courts, fields, gyms, courses, mountains, pools, rivers, lakes, oceans, and skies of this country in numbers quite without precedent. They are *exercising*," he emphasized, incredulously. So alien and unprecedented are these people that he calls them an "intimidating . . . super-race." But what were these new *ubermenschen* doing to send a journalist cowering? The consensus, he writes, "about the best exercise for real physical and mental fitness" is "running, swimming, and biking"—*oh my*.

Presciently, Van Doorn imagines that someday millions of people will take part in such activities. Right on cue, bicycling got its big-screen debut the following year with *Breaking Away*, and two years after that there were enough longtime runners for *Chariots of Fire* to become an international hit by indulging nostalgia for the sport's early days. But as men followed women off the road and into the gym in the eighties, there remained the question of what would they do once they got there (aside from hitting on said women). Presumably it wouldn't be aerobics. And while treadmills, the Lifecycle, and other cardio machines offered one answer, a more pertinent one was provided by another film: *Pumping Iron*, George Butler's 1977 documentary about bodybuilding and the rise of Arnold Schwarzenegger.

Not that the visibility of bodybuilding suddenly made muscles

desirable for men; that happened gradually. Aerobics had so upended the environment by the mid-eighties in both the United States and Europe that the Swedish writer Sven Lindqvist could muse, "Once only men were entitled to want to be strong, today it's more acceptable for a woman." When I read this sentence it brought me back to my early teen years and the expectation, common then, that men would develop love handles and bellies as they aged. But what I think gets lost in translation is that strength, a traditionally male attribute, wasn't really the issue; Lindqvist means that men weren't entitled to want to *appear* strong, to be caught preening their physiques like cats, whereas for women doing so had long been acceptable.

More than any other individual—except perhaps Bruce Lee, whose leaner, more attainable build had an extraordinary impact on young men in the seventies—Schwarzenegger gave men permission to sculpt their bodies.

Prior to *Pumping Iron*, Charles Gaines wrote in the book on which the film was based that bodybuilding had "advertised itself with consummate tackiness" and, worse for its mainstream acceptance, had played into all the stereotypes of homosexuality and perversion associated with it. Bodybuilding "confined itself to the back pages of pulp magazines and, in the national consciousness, to the same shadowy corners occupied by dildos and raincoat exhibitionists," Gaines said.

Schwarzenegger may have come across as narcissistic, but he did so in a reassuringly straight way—he ostentatiously aimed his huge guns at the girls. He was also intelligent, as disciplined in his strategy to infiltrate popular culture as he was in the weight room. His breakout feature film, *Conan the Barbarian* (1982), played as a sort of loving parody of the sword-and-sandal flicks that starred Schwarzenegger's boyhood idol, Steve Reeves. But two things distinguished the bodybuilding of Reeves's era from that of the Austrian, and they explain

much of the latter's wider popularity. The first is anabolic steroids; the second the romance of training.

Although chemically isolated in the late thirties in the Netherlands, Germany, and Switzerland, anabolic steroids spread first to Russia and only became known to Western athletes after the 1954 Olympics in Vienna. Bob Hoffman had shown up with a weightlifting team that had its own "secret weapon," as he termed the special supplement he was sure would launch them onto the podium: protein powder. The Soviet lifters trounced the Americans. In the aftermath, the team physician, Dr. John Ziegler, had a few friendly drinks with the Soviet team doctor, and pried out of him the confession that the Russians had been dosing with testosterone, among other drugs. Ziegler then spent several years experimenting with the steroids, and in the early sixties Ciba, a chemical company with which he was associated, brought out Dianabol, which quickly became de rigueur for weightlifters and bodybuilders.

Above all, Reeves's Hercules had been handsome—certainly buff and big, though in a relatable way, unblessed by the miracle of steroids; his was a build that, with its ever so slight softness, its margarine smear of subcutaneous fat, hints that, in the words of the film's epigraph, "even the greatest strength carries within it a measure of mortal weakness." *Conan the Barbarian* opens with Friedrich Nietzsche's most abused quote, "That which does not kill us makes us stronger," and in it Schwarzenegger's steroid-enhanced body is unabashedly tumescent, vividly bursting with overripe muscles that threaten to tear apart his skin as readily as the Incredible Hulk rips through his shirtsleeves (the TV show first aired in 1978, starring Schwarzenegger's *Pumping Iron* antagonist Lou Ferrigno). Bodybuilding in the Schwarzenegger era held out the possibility of superhuman transformation, particularly through technology. The hypermuscular bodies

that the public responded to were cyborg-like—in the *Terminator* and *Robocop* mold, be they on-screen or in muscle magazines—a product of machines (and chemicals) hewing flesh.

The second factor distinguishing bodybuilders in the seventies from the earlier generation was the value and mystique conferred on training. According to John Grimek, Reeves did "little if any training," walking around deflated and "skinny" until about two months before a competition, at which point he would hit the gym hard. Athletes in midcentury did little strength-and-conditioning work beyond their chosen sport, as its importance wasn't understood; for the average person it would have been an absurd waste of energy. The implication of Reeve's on-off approach is that there is a predetermined shape one will get into, a sort of mold you fill by working out, whereas *Pumping Iron* made it clear that the new breed of physique athletes was always trying to get bigger, achieve an ever more impressive body. It also provided a very early glimpse of the practicing life, of training as a daily activity, a notion that wouldn't take hold among ordinary exercisers until the birth of the New Frontier, but the documentary was one of a number of films at this time—from *Rocky* to *Marathon Man* to *Flashdance*—that fastened on the allure of training.

Its enormous popularity meant that bodybuilding completely eclipsed any other sort of lifting in popular consciousness, so much so that after *Pumping Iron* the words *bodybuilding* and *weightlifting* became—and remain to this day—synonymous in common usage. Even though the majority of people who bought gym memberships in the eighties had no intention of becoming bodybuilders, aesthetic training became the sole paradigm for resistance work, for both men and women. But for women the implications of bodybuilding would be somewhat different.

I n 1962, a photograph of a woman in a double-biceps pose was rejected from *Strength & Health* magazine for being too masculine. After the passage of Title IX a decade later—a U.S. law prohibiting, among other things, discrimination by gender in sports—women began to gain some experience with weight training for sports and general fitness. The first female bodybuilding contests of the modern era were held in 1978 when it became a sanctioned sport, though simply posing with clenched fists could still result in point deductions for overly masculine poses.

It is astonishing to look back at Lisa Lyon, who won the first International Federation of Bodybuilders Women's World Pro Bodybuilding Championship, held in Los Angeles in 1979, for today you can walk into any Equinox or 24 Hour Fitness and find considerably buffer ladies. That her dainty figure—due more to low body fat, it seems, than to weights—was then considered the acme of female muscularity only demonstrates how incongruous the notions of strength and femininity were. It was her lack of muscles that seems to have made Lyon such an attractive model for photographers like Helmut Newton and Robert Mapplethorpe: they did not, for example, turn their cameras on Jan Todd, the powerlifter whom *Sports Illustrated* had crowned the strongest woman in the world in 1977, with this bizarre caveat: "if the strength being considered is muscle strength." Todd (now a professor at the University of Texas), then five foot seven and 165 pounds, was an exemplar not of the female figure but of female athleticism, a notion with scant currency to the average reader or gymgoer at the time.

But these were still early days for all female fitness activities—the first women's marathon wouldn't be run at the Olympics for another five years. And though female bodybuilding expanded rapidly in the eighties, aided by the long association of cosmetic refashioning as a woman's prerogative, actual strength training gained acceptance

slowly, and discussions of it remain fraught with ambivalence even today. In fact, we're still trying to untangle the perception of women's muscularity and strength that was utterly garbled by the use of steroids in female bodybuilding. When a woman mentions she lifts weights, the assumption is inevitably that she is bodybuilding, and the conjured image is one of bronzed, steroid-distended biceps and massive legs with valleys plunging between muscles like eroded canyons.

Glorified Couches

Sigourney Weaver's character in the 1988 film *Working Girl* keeps a tall pulley-weight machine ostentatiously on display in her office, right next to her desk at which she smokes cigarettes. She's not into conditioning, she doesn't run, and she's not a girly aerobics chick in a sweatband and leg warmers: Weaver plays a high-powered professional in a masculine world, someone who does manly exercises, though probably of the "muscle-toning" rather than building variety. (In point of fact, this a meaningless distinction. The "toned" look is a result of low body-fat percentage, which certainly can be achieved, in part, through the high-rep, light-weight workouts sold to women for toning, but the resistance work is still causing muscle to be built, not lengthened, as is often claimed.) Weaver's device also tells us she's no throwback but an up-to-date body sculptor. If, after Schwarzenegger, the options for working out were cardio or bodybuilding, the preferred mode of doing both was with technological aid. Attitudes toward exercise were changing rapidly, but those toward machines hadn't shifted much over the previous quarter century.

The attraction of the machines in the fifties and early sixties at

health spas like Vic Tanny's was, people believed, that they could do the work of exercising for you, faster and more efficiently than you could do it yourself. Harold Zinkin's Universal machine, which combined the multiple stations of the older pulley-weight machines into a single, self-contained unit, was first patented in 1957 and by the mid-sixties could be found in almost any venue, from gyms to YMCAs to high schools and universities. At the end of the decade, according to Bill Starr, there was "a surge of interest in strength training for athletes, particularly football players," which had the effect of simultaneously multiplying the use of both Universals and free weights for a brief period. A portion of serious strength athletes avoided the machines—until, that is, they learned about an even newer, shinier, *improved* device called the Nautilus.

Invented by Arthur Jones, a man whose life was as colorful as his marketing tactics, the Nautilus was launched in 1970 at the Senior National Olympic Championships and Mr. America contest. Jones had created the prototype years earlier, when he was leading safaris in Africa and needed something to help him keep fit. (While there, he also came up with a nonvibrating camera that could be mounted on a plane or jeep, and profited both from selling footage to the *Wild Kingdom* TV show as well as from the design of the camera itself.) The success of the Nautilus owed more to hype and good timing than its vaunted design innovation, a cam (a pulley wheel) irregularly shaped like a nautilus shell that is supposed to produce consistent resistance throughout the lift (why this should be important was never shown). But that hype was sharp: instead of advertising convenience, like the Universal, Jones marketed the scientific basis of the cam. He went so far as to concoct a "Colorado Experiment," a classic before-and-after play in which a young bodybuilder, nineteen-year-old Casey Viator, used nothing (including no steroids) but the Nautilus for thirty days,

after which he took third place in the most muscular category at the 1970 Mr. America contest (itself remarkable for such a young man). The following year, Viator became the youngest ever winner. (Viator later told at least one person, Starr, that in addition to the Nautilus workouts, he'd been doing full free-weight sessions each night during the experiment.)

To the scientific novelty of his invention Jones added an exorbitantly high price, far too expensive for home use but perfect for establishing exclusivity and difficulty of access. He began by marketing the machines to the gyms catering to serious bodybuilders and weightlifters, moved on from there to professional sports teams, and finally, after building up their aura of expertise and technological novelty, he went after the bigger commercial gyms and, in the process, began his own franchised line of gyms constructed around the machines. Because of the cost, you had to join a gym to use the apparatus.

By the mid-eighties, however, what the pros "all discovered," Starr says, "was that they lost strength when they did the Nautilus routine." The machines may provide constant resistance, but like all such devices they also do a significant amount of the work for you, and in fitness easier is never better because work is what makes you stronger or faster or better able to endure. By isolating muscles or muscle groups, weight machines tend to remove the multitude of stabilizing muscles from the process, and they take the tendons, ligaments, and joints out of the equation as well. Yet to get stronger you need to tax all these elements, for it's impossible to lift up something heavy without using your joints and tendons, unless you have the help of a machine.

Surprisingly few people in gyms at the time noticed or cared that they weren't getting as strong as they could be, however. Nobody

had educated them as to the difference between looking more muscled than you were before you picked up a weight and actually being strong, and even as the Nautilus trend petered out, ever newer, more scientific machines replaced them as glorified couches upon which the gymgoer could toil.

So why did weight machines continue to flourish in gyms? Aside from the gleam of technological novelty, they offer the untaught user a way to lift. Properly training with free weights requires some skill, while the Olympic lifts—the snatch and clean-and-jerk—are highly technical, demanding extensive, long-term coaching to master. It wasn't until quite recently, with CrossFit, that significant numbers of people came to grasp the importance of skill-based work—how, for instance, the neuromuscular integration necessary to control your body in a tightly precise manner while executing a snatch has cognitive as well as strength benefits. Which means: yes, muscle-bound jocks are getting smarter than you just by working out.

But the prevalence of machines helps illuminate the barriers to fitness that persist today. By removing skill, machines essentially turn strength training into a low-intensity activity: you might look better by using them but you're not challenging who you are today to become a better version tomorrow. And while the idea that fitness ought to be a life-shaping practice rather than merely a figure-shaping one—this need for a limitless ladder of achievement and the intensity to force you up it—is a concept as novel as the freshest app to most of us, to some it was visible almost from the inception of the fitness boom, like an embryo in an egg held to a candle. To some, the first joggers were that candle.

In his comprehensive *Running: A Global History* (2009), Thor Gotaas insists that jogging was a fad and that after the initial gush

of excitement joggers in the mid-seventies shuffled home and ditched their sweats. Writing at the time, the historian James Whorton echoed the assessment by differentiating jogging and running. To him it was "a matter of pace—nine minutes per mile or slower is jogging, faster is running. But the runner does not just move faster; he goes farther, and with a far more serious intent. Jogging is merely a fad, one which has improved physical health as an end, but strives for no higher goals. Nine minutes per mile is, after all, . . . hardly the pace of a person who is driving for some form of excellence."

Whorton wasn't alone in feeling the need for something more. In 1974, a San Diego track club held a swim, bike, and running race, the first modern triathlon. Yet within four years a handful of cardio junkies decided that running a fast marathon or triathlon wasn't a difficult enough achievement, so they created the first Ironman Triathlon, in Hawaii. The event had grown out of an argument about who was fittest, bikers, swimmers, or runners, and it consisted of a 2.4-mile swim, a 112-mile bike ride, and a marathon tacked on to the end. By 1981, organization of the Ironman had been taken over by Valerie Silk, owner of a Nautilus Fitness Center.

Jogging may have been a fad, in part because losing weight is a fleeting goal. What the Ironman triathletes began to show is that intensity, which translates on a mental and emotional level to ever-higher levels of achievement and consistent self-overcoming, binds us to the need for exercise. But that microcommunity was at the lunatic fringe, as the fitness avant-garde tends to be. For the vast and profitable sea of exercisers, which recently empowered women had expanded from a small pool, the prescribed methods were low intensity, low skill, and directed mainly at cosmetic changes. One major though at the time overlooked implication of Dr. Cooper's training effect, the

notion that exercise and health advance progressively, is that working out needs to be more than just an occasional activity with short-term goals; it needs to be an integral part of one's life. But more than a decade's worth of unused gym memberships would need to pile up before anyone recognized that the old maps were incomplete, leading only as far as the mirror.

10

PRACTICING AT LIFE

The mercury hovers just above 100 degrees Fahrenheit in the office park off a highway in Scottsdale, Arizona, but the vast black expanse of asphalt has turned kiln-hot, sizzling my sneakers. (That these desolate places are called *parks* seems a particularly bitter irony, given their function is to banish nature to some far-off margin, in favor of macadam, concrete, steel, and glass. And unlike actual parks, these nonplaces induce an overwhelming torpor, a listlessness that saps body and soul—a further irony, since it is in such sites that so many new gyms and boxes spring up, invading these zones of exhaustion like some energizing form of bacteria.) Standing by the weak and bendy excuse for a tree that I hope will provide enough shade to prevent my rental car from melting (I've brilliantly declined all the insurance), I experience a moment of déjà vu: a similarly scorching wind had kissed my cheeks a year before, as I wandered through Athens in the summer. That day I'd come upon the ruins of the Lykeion, or Lyceum, the Ancient Greek *gymnasion* where Aristotle taught circa 335 BCE. The grove of trees in which it sat would not have provided much relief from an afternoon such as this.

Now here I was, shuffling and finding it tough to imagine

mustering the energy to work out in such a swelter. At that moment a figure ambles by, shirtless, looking like the *Farnese Hercules* come to life, except without the beard and wearing a red baseball cap; his limbs make those of the tree I've parked under look like a sapling's by comparison. What the Greeks dreamed of and perhaps occasionally achieved has become commonplace for elite fitness athletes today: there are men and women in almost every city with heroic, divine bodies. This man nods hello and turns toward his destination, with a loglike ripple of quadriceps visible above a striated, vein-streaked lump of calf muscle. Traps like twin African termite mounds rise from the rocky plain of his shoulders. This must be the place.

I follow him through the nondescript door of OPEX Fitness, the gym owned by James Fitzgerald, universally known to the fitness community as OPT, or Optimum Performance Training, his online moniker and the name of his first establishment. At OPEX Fitzgerald coaches pro athletes, trains other coaches, and hosts the Phoenix Rise, the National Pro Grid League team of which he is a part owner and past athlete-coach. Grid, which had its inaugural season in 2014, is the latest manifestation of the sport of fitness. Teams—which are coed and must include at least one person who is over forty, another example of the more flexible parameters of fitness in the New Frontier—go head-to-head in a series of races that might include dumbbell snatches, free-standing handstand push-ups, deadlifts, weighted single-leg squats, and other movements in various combinations. It's a rapid-fire, TV-friendly outgrowth of CrossFit, and in fact almost all the Grid competitors are also CrossFit competitors.

The OPEX workout space is intimate though, given its industrial-garage ambiance, not at all cozy. Its accouterments are typical of gyms in the New Frontier. The ceilings are very high, to accommodate long ropes for climbing and, in place of the machines you might find at a

globo or franchise gym, a raw, black steel rig occupies the center of the space. Spare as a skeleton, it is mostly pull-up bars of varying heights. A few gymnastic rings hang from crossbars in the center, there are a number of squat racks around the edges, and round wall-ball targets crown the poles. On the walls a few whiteboards hang above stacks of aggressively basic equipment: plyometric boxes, barbells and rubber plates, kettlebells, dumbbells, some rowers and bikes. Mirrors are conspicuously absent: what goes on here is not about how you look, it's about how well you perform (and when your body functions near its peak, your weight and muscle definition take care of themselves).

About ten people are warming up, and the guy I've followed in is, I'm amused to see, one of the smaller males. There are a number of faces I recognize, for this, I soon grasp, is the Phoenix Rise team—which explains the cartoonish proportions of the group. The women are almost a new species, like nothing the Greeks or any other civilization ever envisioned, with bodies that bellow power, yet in rounded, expressively feminine masses: thighs and butts that seem filled to bursting with rocket fuel, defined biceps, and marmoreal shoulders. The men are dense and vein streaked, so hard they look armor plated. Next to these hulks, Fitzgerald, when he steps in, appears as angular as a praying mantis. His hair is cropped to a sparse field of stubble; his sunken cheeks are hollowed more by his prominent nose. You'd call him skinny, were it not for the padding of muscle packed onto his runner's frame. Here, while far from the largest creature in the room, Fitzgerald is clearly the alpha dog. The respect paid to him by athletes and coaches alike is palpable, not only because he is providing a living to this group as team owner (and they know they are lucky enough to be the first generation paid to hone their fitness full-time), but also because he helped forge their sport. The birth of the sport of fitness can be dated to 2007, the year the first CrossFit Games was held on a

ranch in Aromas, California. The winner, who earned the title Fittest Man on Earth, was James Fitzgerald.

Before Fitzgerald leads me upstairs to his book-filled office, you might ask what the professional sport of fitness, with its granite-hewn heroes, has to do with the average exerciser. And I would answer that it represents the completion of a circle that began in the early 2000s with the opening of the New Frontier, when the paradigm began to shift from fitness achieved through recreational activities (jogging, softball, tennis, and the like) to training like a professional athlete. By trying to be more like the pros, we ended up forming another pro sport. What's more, the practical implication of this swing into athleticism carries with it real-world ethical, moral, and modal consequences, alterations in how we order our lives and understand our bodies, in our judgments of muscular women, in why we might want to be fit at all.

Pros subordinate everything to their sport for the obvious reason that it's their job, but NFF devotees whose lives are similarly structured by their physical practice—affecting how they eat, how much they drink, when they go to bed and how long they sleep, what clothes they wear, who they spend time with, the sorts of information they might want to gather about themselves, their sense of their abilities and limitations—can seem freakish. Fitness as a life-shaping practice is strange because it is so new and thus unfamiliar.

I suspect, however, that quite a few families harbor at least one bizarre character that disciplines his or her life with monkish rigor. In my family, that freak is me: the guy who *must* exercise, no matter what the occasion that brings us all together; who won't eat grains; who demands to know if the eggs are pasture raised, the beef grass fed. This isn't a phase and I'm not on a diet: this is my life. Yes, I categorically reject

any excuses offered to alter my training habits, because one can always be found (travel, rain, staying up too late, the death of a pet hamster—there's always something). Nor do I need so-called cheat meals because the food I eat—fresh, unpackaged, unprocessed—is delicious despite being green and healthful.

Due to these rites and regulations, my brother-in-law, the son of two Episcopal priests and thus attuned to such things, likes to kid me, albeit in all seriousness, that I am an orthodox adherent of a religion called CrossFit. Not a new thought. Indeed, a quick Google search yields some four hundred thousand entries likening it to a cult. To my mind, calling CrossFit a religion is not substantially different than talking about exercise as an addiction. It's not difficult to see why such comparisons are common: NFF phenomena such as CrossFit set the rhythm of people's daily lives, and it's all they want to talk about.

But people have likened exercise to religion for years. An essay in *The Economist* from 2002, well before the disciplines of the New Frontier had arrived in England, states, "Gym-going, after all, has all the basic lineaments of a religion. Its adherents are motivated by feelings of guilt, and the urge to atone for fleshly sins." This seems correct in that people tend to hit the treadmills and weight machines of the modern franchise gym because they feel compelled to do so in order to lose weight or counterbalance the amount of drink they had the night before. Indeed the business model of the globo gym depends upon this drudgery; it assumes that the majority of its members will not have the discipline or the desire to force themselves to show up and atone for their fleshly sins. If more than a fraction of the membership was to arrive at any given time, there'd be lines ten deep at the elliptical.

However, feelings of guilt and sinfulness in no way explain why, for example, the thirty women and men (approximately 65 percent

are women) in my Olympic lifting class eagerly arrive each night from 8 till 9 p.m., effectively giving up their social lives, solely in order to train nothing but the snatch and clean-and-jerk five nights per week. Or why there is a long waiting list to join this group of supposed penitents. Nor does it explain the cheerfulness with which hundreds of thousands of people across the world show up each day at CrossFit boxes to put themselves through their daily agonies, when there are far easier ways to lose weight. I can see no reason why guilt would drive people to compete in obstacle races—when, again, there are far easier ways to atone for that extra pint.

One might be guilted into the gym for short periods; those who stick with it have better motivations. It seems to me the comparison between religion and exercise approaches the argument from the wrong end of the telescope, as it were. Rather than fitness practices resembling religion, it is more fruitful and accurate to say that religion resembles fitness practices, and for a good reason: both are training regimens, ways of bettering ourselves; they are forms of *askesis*, but the word and the very notion of such training come from athletics.

The confusion of fitness practice with religion—or, for that matter, with addiction, since physical practices in the New Frontier aren't just habits, mere repetitions of the same thing, but efforts to improve the repeated actions and through them, ourselves—stems from this word, *askesis*, or, more accurately, its modern incarnation, *asceticism*. The dictionary definition of an ascetic is someone who applies strict self-denial as an affirmation of personal or spiritual discipline, but we tend to associate the concept with world-renouncing Christian ascetics. Fitness practitioners who recognize that health—physical, mental, and emotional well-being—is holistic, that there are no short-cuts or panaceas, today adopt what I call neo-asceticism, a discipline that "in place of the aim of denial," writes Nietzsche, has "the aim of

strengthening." That philosopher, the essential thinker of the Athletic Renaissance, wrote of wanting to "make asceticism natural again." With him we neo-ascetics say:

> At bottom I abhor all those moralities which say: "Do not do this! Renounce!" . . . But I am well disposed toward those moralities which goad me to do something and do it again, from morning till evening, and then to dream of it at night, and to think of nothing except doing this *well*, as well as *I* alone can do it. When one lives like that, one thing after another that simply does not belong to such a life drops off. Without hatred or aversion one sees this take its leave today and that tomorrow . . . He may not even notice that it takes its leave; for his eye is riveted to his goal. . . . What we do should determine what we forego; by doing we forego.

It's not that I renounce eating pizza or drinking till 2 a.m. out of guilt; rather I affirm a powerful desire to train that is incompatible with the less strongly felt desires to gorge myself on flour or beer. Although it resembles the pro athlete's discipline, neo-ascetic practice is not a banausic choice but a means of enhancing life, of giving it shape through training—we prune the hedge to make it grow.

As a child in Alberta, Canada, where he played all the sports available—hockey, volleyball, basketball, cross-country running—Fitzgerald expected to have a professional athletic career. A compound leg fracture during a soccer match sidelined that dream. It was while rehabbing that he decided to study strength and conditioning, which led to becoming a personal trainer.

As the au courant accessory to your gym routine, trainers hit the

market big in the 1990s, but the industry itself first materialized in Hollywood at the tail end of the seventies, when Hollywood actors began hiring people to help them lose weight or gain muscle for upcoming films. Jake Steinfeld, a bodybuilder with a gift for promotion, is often called the original "trainer to the stars," but the birth of the profession likely ought to be credited to Gilda Marx. An aerobics instructor operating first out of Encino, California, and then in Beverly Hills in the mid-seventies, Marx helped Shirley MacLaine and, by 1978, was working with Jane Fonda, at least a year before Steinfeld landed Steven Spielberg as a client. As soon as celebrities started using them, hordes of others followed suit, hiring personal trainers of their own. By the late eighties, having someone coax you through your workouts and help you stretch had become as recognizable a marker of status as a polo player on your shirt. The pressure to stand out in this burgeoning industry drove much of the personal-fitness innovation of the nineties, as trainers gradually introduced average gymgoers to various training techniques and approaches that had filtered into Western professional sports and university-level strength-and-conditioning programs beginning in the 1970s.

Most of these programs had been developed earlier by the Soviets in the sixties. As early as 1960, for example, the Soviets had incorporated periodization, in which particular types of adaptation are targeted in cycles—building a base, preparation, pre-competition, and a peaking period, for example, or periods of tapering instead of strength building. The West German athletes employed it in 1972, but it didn't reach America until the end of the decade. On a visit to the Soviet Union in the early 1980s, trainer and coach Michael Yessis learned about plyometrics—jump training and other means of inducing a rapid stretch of muscles followed by shortening—and brought it back to American track-and-field programs. Yessis went on

to translate a number of influential articles from Russian and spurred others to investigate and bring back ideas like interval training, optimal work-to-rest ratios, methods of recovery, ideas about nutrition, and the importance of different energy systems.

The most radical of these imported notions was also the most obvious—that strength training, especially the Olympic lifts, is a critical component of virtually any athlete's program, from runners to boxers to skiers. Few did more to infiltrate weights into Western sports training than Bill Starr, who with such books as *The Strongest Shall Survive* (1978) and *Defying Gravity* (1981) introduced fundamental techniques, like the power clean, that remain in common use today. But muscle is a perpetual stumbling block, and there are plenty of sports that to this day shun the use of weights, such as tennis and boxing. Back in 1987, *Sports Illustrated* found champion boxer Evander Holyfield's cutting-edge training method, which whittled down the endless roadwork and sparring traditional to boxing in order to make room for weight training and plyometrics, so noteworthy that the magazine devoted an article to it. Holyfield went on to win and hold the heavyweight title for years, yet three decades on there are still plenty of boxers and boxing trainers who won't go near weights. When Roberto Guerrero chose to revive his championship boxing career with CrossFit in 2014, his trainer resisted, arguing all the weightlifting would make him slow.

Starr had little use for weight machines or glittering shortcuts (*eight-minute abs!*), so his insights had little impact on commercial gyms or personal trainers in the 1990s or even the first decade of the 2000s. "The tools we had were you either lifted weights for certain sets and reps or ran around the track," says Fitzgerald, who worked with or studied the books by the best trainers of era. "It was bicep curls and treadmill work." Bodybuilding provided the directives for

the weight room, and cardio machines were prescribed for weight loss. This division was also largely maintained between the genders: men doing weights, women doing cardio. Men in an aerobics, step, or Spin classes were about as common as women lifting weights.

Personal trainers, Fitzgerald recalls, were trying to figure out how to translate the new Soviet techniques into something for the average person: "The question was how do we take all these numbers and analytics for getting better at bench-pressing for a football player and mesh it into real life? I call it the holistic hokey-pokey route, with the bands, the movements, and the core training." Conventional wisdom assumed that everyday gym clients couldn't master skill-based movements like the Olympic lifts (not to mention the fact that most personal trainers didn't have any background in or knowledge of them) and were unwilling to exert themselves overly much—in other words, the fear of intensity persisted and what was left to clients was a dumbed-down version of fitness. So pieces of the pro athlete's repertoire were haphazardly picked up and touted as *the* way to get fit. Ian King, a respected and influential personal trainer in Australia, championed plyometrics for a while. At the same time researchers in Australia published two articles on the importance of the transversus abdominis, igniting a worldwide fad for core conditioning. But none of these inspired as much devotion as the EFX elliptical trainer, introduced in 1995—a user-friendly, low-impact machine that, like all such devices, also has a low impact on one's fitness.

Greg Glassman, in 1974 a YMCA gymnastics coach and eventually a personal trainer, had the orneriness and oppositional nature to smuggle a number of the new techniques into the globo gyms in which he operated. He experimented with box jumps (plyometrics), intervals, and even lifts like the power clean and the snatch. However,

as today, almost no gyms were equipped with rubber weights (known as bumper plates) for dropping, and they weren't set up for circuits or sprints. Thus Glassman and his clients were causing mayhem, letting weights crash to the floor, springing onto and off boxes before rushing over to the pull-up bar. For his part, Glassman was offended by the business model on which the modern franchise gym depends, maximizing membership while minimizing usage. His clients were loyal to him and kept showing up, which did nothing to endear him to the managers of the gyms that employed him. In 1995, after fifteen years of being kicked out of one establishment after another, he opened his own gym in Santa Cruz, California, calling it "Cross-fit."

Although the methodology had yet to coalesce, Glassman now had a space, a laboratory to tinker in. And he attracted a group of premium athletes from diverse sports on whom he could experiment, including Eva Twardokens, a skier who had competed in both the 1992 and 1994 Olympics as well as on the World Cup circuit; professional rock climber Rob Miller; and Garth Taylor, who would go on to win the 1999 World Jiu-Jitsu Championship, among other titles. He also trained people he thought of as combat athletes—police, firefighters, and soldiers, who all require a high level of fitness to meet their daily tasks—and it was their needs, rather than those of the pro lab rats, who he was trying to serve with his tinkering. In sport you know the day and time on which you will have to perform, you know your opponent, and you know and have mastered all the skills and movements required; first responders, his combat athletes, must perform at the highest level with none of this information: they need to be prepared for what Glassman terms "the unknown and the unknowable." He reasoned that these people need to optimize their general physical preparedness (GPP); they should be fit in the broadest sense possible. What he ultimately concluded was that GPP would sharply improve

the performance of every type of specialist, be they fencers, football players, or desk jockeys.

Glassman isn't a poster boy for CrossFit on the model of a Hippolyte Triat, Eugen Sandow, Vic Tanny, Bonnie Prudden, Jack LaLanne, or Jake Steinfeld. An old injury gives him a somewhat lopsided gate, his barrel chest makes him look portly, he doesn't flash massive biceps. He has the physical presence of a high school math teacher. To my knowledge there is no video evidence of him working out, nor do anecdotes circulate of people working out with him (I'm not suggesting that he doesn't—only that whether he exercises or not doesn't matter). That's not to say Glassman isn't an effective showman. He speaks persuasively, with technical precision and lots of hastily scrawled graphs and formulas on the whiteboard; the podium likes him. But Glassman has never said, "Follow my exclusive plan, and you'll get ripped like me." He relies solely on hard evidence, on the data generated by CrossFitters throughout the world.

In part because it diverges so sharply from the standard fitness-promoter scrawny-kid-gets-big bio, Glassman's story is by now well known. What matters most about those early years is that his father was an aerospace engineer in the San Fernando Valley, and he drilled into his son a reverence for scientific empiricism. CrossFit was born not of out of some transformative experience in Glassman's early life; instead, it came about as something of an engineering problem: how best to achieve maximum GPP. A methodical thinker, Glassman realized he first needed to define his terms, but he was shocked to find that no operational definition of fitness existed, and that what passed for standards seemed myopically shortsighted. His sole prerequisite for the definition he sought was that it be "measurable, observable, and repeatable"—the criterion by which all subsequent CrossFit procedures are judged.

The word *fit* is enormous, packing myriad referents into its three little letters. But deep in its etymological history it harbors the idea of measure: it derives from the German *fitze*, which meant (according to the *Oxford English Dictionary*) the "thread with which weavers use to mark off a day's work." In the 1990s, the only description of fitness, and the most widely applied, was endurance or VO_2max (how much oxygen a person can use). In his 2002 essay "What Is Fitness?"—where he presents the results of his research and which has been downloaded some 50 million times—Glassman took *Outside* magazine to task for naming a triathlete, Mark Allen, "the fittest man on earth" (which since 2007 has been the title awarded to the winner of the CrossFit Games). "Let's just assume for a moment that this famous six-time winner of the IronMan Triathlon is the fittest of the fit," Glassman famously wrote. "Then what title do we bestow on the decathlete Simon Poelman who also possesses incredible endurance and stamina, yet crushes Mr. Allen in any comparison that includes strength, power, speed, and coordination?"

What attributes must a fit person have? To that question Glassman actually found an answer. Jim Crawley and Bruce Evans, two coaches who in 1985 had founded Dynamax, the leading manufacturer of medicine balls, had arrived at ten skills they wanted their product to address: Cardiovascular/respiratory endurance, stamina (a measure of energy storage and use, for instance how long your muscles will allow you to do pull-ups before you conk out), strength (the ability of muscles to apply force), flexibility, power (the maximum force muscles can apply in a minimum time), speed, coordination, agility, balance, and accuracy. These struck Glassman as adequate, and the years since have not disproved that hypothesis. The implication was that a fit person needs to be good at many types of athletic activity—she needs to be much stronger than a great marathon runner, while still being able

to run 26.2 miles; she needs to be able to generate power like a rower, have the flexibility and accuracy of a gymnast, etc. Yoked together, all these attributes contribute to the ability to do work, which a physicist would measure through power output (force x distance / time).

The definition of fitness Glassman thus derived from his investigations: work capacity measured across broad time and modal domains. And yes, it requires a little unpacking. Work capacity is power output, the measure of whatever activity you are doing: How fast can you swim 50 meters? How many pull-ups can you do in 5 minutes? How long will it take you shovel your driveway, if it is covered in 6 inches of snow?

The issue of time domains is the most complex in the equation, for it addresses the physiological concept of energy systems. Humans have three pathways for generating energy. The phosphagen system (which converts creatine phosphate in the muscles to ATP, which is used in cells for energy transfer) applies to the shortest and highest power-output efforts—up to about ten seconds—such as a single heavy deadlift. The glycolytic system, or glycolysis, kicks in at ten seconds and lasts for about two minutes, as in a 400-meter sprint. The third, the aerobic system, is the best known and operates from two minutes onward. Training each of these systems increases their efficiency and one's capacity, but the fitter a person is the more capacity she will have across and through all of them, even when they are mixed together. The implication of mixing energy systems, Glassman recognized, is that the classic model of strength training one day followed by endurance another (lift on Mondays, run on Tuesdays, for instance) doesn't cut it. With that approach, the moment you have to run for distance, then lift something heavy, and immediately set off running with it, you will fall apart. But this is exactly how life works, he reasoned: a soldier slogs all day marching around when suddenly a

buddy is hit by a sniper, and the tired soldier has to hoist him onto a shoulder and carry him to safety.

Modal domains are simply types of activity. A triathlete may be good at running, swimming, and biking, but these are all endurance activities—they don't test strength, power, agility, balance, or flexibility, among other attributes. And the swims, runs, and rides in a triathlon are all relatively long, so they aren't helping you get any better at sprinting or explosive movements. Glassman wasn't saying that any one of these three, or any other exercise for that matter, is detrimental; only that each is a small part of a larger puzzle.

At its most basic level, anything you do to increase your work capacity across a wide range of time and modal domains *is* CrossFit. However, in the course of his experiments Glassman determined that the most effective means of achieving that goal is through *constantly varied functional movements done at high intensity*—which is what those panting nutters you hear about practice in a CrossFit box.

What this prescription adds to the definition are functionality and intensity. Glassman's aim was to improve people's lived capacities—the ability to lift your children or sprint from a burning building with the television you can't live without in your arms—and to him that meant concentrating on movements found outside the gym, unassisted by machines. When you want to shoulder a bag of feed, you will not have a machine stabilizing the load so that you're able to lift it up in a perfectly straight vector. He classifies as functional movements those in which power is expressed mostly from core-to-extremity and using more than one joint. In lectures, Glassman explains the concept by pointing out that you'll never see a person do a bicep curl or lat raise outside a gym, but you will see them jump, run, and heave loads from the ground over their heads.

If functional movements mimic what we as humans do, variance and intensity are necessary because of the way we're constituted. We adapt: on a cellular level, muscularly, psychologically, emotionally. In order to induce the cellular adaptations that translate into fitness— our mitochondrial density, for instance—we need sufficient stress to trigger our cells to react. Once you've adapted to running mile upon mile at a talking pace, or even just a consistently fast pace each day, any further adaptations will come very slowly, if at all. Sprint intervals provide a repeated dose of sufficient stress and so are more efficient exercises. Glassman points out, too, that the heart-rate monitoring trend of the late 1990s and early 2000s did little to ensure adaptations, for heart rate is not a measure of intensity but merely a correlate of it.

Still, your body will acclimate to anything you do week in and week out, and that's why constantly varying the movements and time domains is so important—it forces you to continually refashion yourself at a cellular level. Here again Glassman saw that the standard approach of segmented workouts, inherited by default from bodybuilding—arms and shoulders one day, back another, legs on a third, and cardio separate from them all—does not represent the way humans operate in the wild, where legs, arms, and lungs tend to be called upon in unison. As he puts it, "Segmented training results in segmented capacity." Repeating rep schemes and movements also establish routines that will inevitably produce imbalances in your capacity: any training pattern will become a blueprint of your weaknesses, Glassman argues.

By the late nineties, there was an awareness among higher-level athletes and coaches of the need for variance. Fitzgerald competed, for instance, in the Toughest Calgarian Alive, a contest from that time that would typically test (individually, not at once) a 5K run, a shot put, 80-meter dash, 100-meter swim, rope climb, bench press, pull-

ups, and finally an obstacle course. Yet doing pull-ups or a 100-meter swim while rested is entirely different than having to do them when you're fatigued and want to quit, which is when it is most important to be able to perform—this was Glassman's idiosyncratic insight. Instead of a series of exercises, why not couplets or triplets? Why not five rounds for time of 25 pull-ups, 2 rope climbs, and an 80-meter dash?

Variance makes CrossFit new each day. It demands perhaps more of the mind than it does of the body, for with every new discipline Glassman added to the stew, there was a wholly unfamiliar set of skills to master. And in his search for novel ways to challenge his clients, he brought in tools that had been forgotten or overlooked. The historian and fitness expert Jan Todd pronounced kettlebells "outdated" in 1995; nobody then used those fixtures of old-time strongman acts and Russian training halls. Today no gym is complete without them. Similarly, the chances of coming across gymnastics rings in any but a specialized facility prior to the explosion of CrossFit was close to nil.

Indeed intensity itself is a skill that is complicated by variance, one of many that the person new to CrossFit needs to become adept at. And it's not just in CrossFit that the need arises. As Ido Portal, himself a quintessential multidisciplinary "movement specialist" and NFF teacher, says, "We must antifragilize the practitioner." She must learn that she can safely push herself much harder than she has ever imagined, that she can expand the limits of breathless pain well past the boundaries she feels today. If you don't consistently raise those intensity limits, you stop adapting and your fitness plateaus. But the skill of intensity isn't simply about how hard you can depress the gas pedal; it's also about learning to control intensity within energy systems, which is to say it's about pacing, apprehending when to go all out and when not to, and knowing what these states—maximum output or, say, 80 percent—feel like. The skill lies in understanding how

to expand the limits of each of your energy systems, something that's possible only by coming to know yourself deeply on a physiological and emotional level.

CrossFit initially spread not as a business with new locations but as an idea, a different way of approaching fitness, which, at the time the early adopters came across it, was sorely needed. A pervasive sense of stagnation loomed like a fog over the exercise world: innovation consisted of opening ever fancier and more expensive gyms, although what went on in them hadn't changed. Yet these premium, more exclusive gyms (many were just for personal training, others offered a more pampered spa experience) arrived during a period when those on the advance guard of the culture were getting back to basics, rediscovering local products and artisanal methods in a spirit that seemed very much in accord with Glassman's embrace of functional fitness.

At the time that Fitzgerald learned about CrossFit in 2004, through a friend who was a fighter, he and others in the strength-and-conditioning community were doing circuits that mixed movements, but without "purpose or time goals or any artistry to it," he recalls. Although it was already three years after Glassman had launched CrossFit.com, where he proffered a free daily workout and invited others to post their times to the comments section, a minuscule number of people had heard of the method. Fitzgerald found CrossFit "unique" in the way it upended "the traditional structure of fitness, which was weight training or cardio. You might have done some back-to-back pieces but you'd never, for example, do power cleans and ring dips and running in three rounds for time." Within months he was hooked, posting his times and trying to best others.

The insistence not just on measurability but on actually recording and posting your workouts—if only to demonstrate to yourself that you're getting fitter—inevitably fosters competition. As it did for

the Greeks, that agonistic spirit in CrossFit ensures intensity, driving people to outdo the improbable with the even more improbable, to beat the self you were yesterday and the selves you're surrounded by today. This spirit animated the methodology even before group workouts, and the community element they nurture, became a noted feature of CrossFit, for while the community multiplied beyond Glassman's gym through online competition, he hadn't set out to open franchises.

An inveterate contrarian, Glassman developed CrossFit by taking virtually every principle of the fitness industry and standing it on its head. This is especially clear in the way he does business. He gave away for free—and still does—all the workouts and any information he gleaned about how to execute the movements, proper nutrition, hydration, sleep, and recovery. Rather than open branches of his gym, he established an affiliate model: CrossFit gyms are independently owned and operated entities that license the name and employ coaches trained in the methodology. The parent company determines neither the affiliates' programming nor their interpretation of the methodology, instead allowing competition to weed out poorly run boxes; nor does it sell merchandise through the affiliates.

Yet even as they began to proliferate slowly by 2003, Glassman was telling viewers of his site that there was no need to join an affiliated box or any other gym. You can do CrossFit in your garage or at a park, he repeatedly avowed, and then devoted an entire video series to garage gyms. Yet the more he gave away, the more people joined CrossFit affiliates. And though there is no reason to doubt that his generosity derives from an honestly altruistic desire to see more people improve their health, Glassman from the outset also eagerly participated in the open-source, gratis culture of the Internet, an ethos entirely at odds with that of the fitness industry.

Glassman's own inclusiveness and the expansive spirit of the on-line world that he tapped into drove the democratization of fitness in the New Frontier. Because park workouts are free, they are available to many more people than a high-end franchise gym, while garage gyms require only a one-time investment in equipment. The stress on functional exercise rather than looks has resonated with groups marginalized by the dominant aesthetic, such as older people and the disabled. Moreover Glassman was especially perspicuous in his consistent feminism, which, like that of the founders of aerobics and seventies gym culture, was expressed in actions rather than decla-rations. Previously, even when females had access to exercise, they were an afterthought, held to lower standards and assumed to be less capable than their male counterparts. Beginning with Twardokens, whom Glassman made his primary test pilot for workouts, CrossFit has put women on a rigorously equal and as thoroughly visible foot-ing as men. Women coach men, program workouts for men, compete against men, and at the Games receive equal payouts.

Early on, CrossFit stood out by promoting itself through videos highlighting female strength, an unusual, if not unheard-of, idea at the time. One video pitted Nicole Carroll, a member of that origi-nal Santa Cruz box, against Glover Teixeira, a former member of the Brazilian national wrestling team and professional light heavyweight mixed martial artist, in an overhead squat contest. At six two and over 200 pounds, Teixeira dwarfs the slim, though not short Carroll. The two face each other, lift 95-pound barbells overhead in a wide grip, and then must squat down, their femurs below parallel, before stand-ing again: whoever can do more reps without dropping the bar wins. The drama builds as Carroll moves smoothly through each squat while Teixeira, wobbly and grimacing, his huge arms as thick as one of her legs, is obviously straining. She wins, of course, although only

just barely. But the point comes across starkly—that a small woman can outperform a pro athlete who outweighs her by more than fifty pounds, and with a barbell no less. In the second half of the video, Carroll does a handful of ring muscle-ups, a basic skill for male gymnasts, demanding considerable upper-body strength. Texeira is unable to do a single one. Barbells and bodyweight: the movements were obviously chosen to counter stereotypes of women being weak, particularly in the arms, shoulders, and upper back.

"In the traditional strength-and-conditioning model we were taught you must have women's-only everything, and this was reflected in the globo gym: here's the dirty, sweaty testosterone area and the pretty pink equipment in the women's area," Fitzgerald says. "Glassman made men and women working out together absolutely normal." In the workouts posted on the CrossFit site, there are never female weights and male weights assigned for exercises, only challenging "as-prescribed" standards that most people will need to scale down. Indeed, despite (or perhaps due to) putting considerable emphasis on strength training, CrossFit has long had a female participation rate of over 50 percent.

An image from my first week training with the competition team at my local CrossFit box: a young man, several years out of his college football career, straining in a squat under a bar loaded with 400 pounds, grimacing and sweaty, as our coach, a woman half his weight who probably shops in the petite section, yells at him that it's light weight. "Come on, power it up," she says; "let's see some speed." For anyone with an historical perspective, the thought of young women coaching burly men in a strength session (and doing it exceptionally well, I might add) is staggering, the crashing of an Iron Curtain between the sexes.

This assumption of equivalence extends to the NPGL, the first

pro sport in history to have men and women competing together on the same team. Indeed fitness is the only sport I'm aware of in which women garner at least as much interest and as many fans (male and female) as their male counterparts. And the speed of change has been breathtaking: the equivalent of Carroll's videos today feature women outdoing men in unassisted handstand push-ups (yes, those are handstand push-ups with no wall or other support) or wowing online audiences with backflip burpee muscle-ups.

As the New Frontier grows, women may prove to be more than equal. By defining fitness as work capacity, Glassman let the performance genie out of the bottle, granting the exercise community, many of whose members had not even wished for it, a functional alternative to aesthetically focused approaches: performance goals. For men, performance goals seem to have only a relatively soft impact on bodily ideals, favoring a trend toward leaner, somewhat more muscular, and athletic physiques. For women, even those who haven't adopted performance goals, the consequences of the shift seem more profound, as performance goals scramble assumptions about women and muscularity, and in the process fundamentally alter Western standards of feminine beauty.

Although proceeding rapidly, this revision of femininity is still in its infancy, glimpsed in the myriad female action heroes of the last decade; the magazine articles affirming that "strong is the new skinny;" the T-shirts proclaiming "Traps Are the New Tits"; the commonly seen female mannequins with defined abs, biceps, and deltoids; and the shift from grudging acknowledgment to celebration of such female athletes as Serena Williams (who poses topless, showing her back muscles in the 2015 Pirelli calendar).

The acceptance began, very gradually, in the eighties. As aerobics

popularized a tighter, more toned look than had been the norm in the slimmed-down sixties and seventies, the sudden arrival of female bodybuilding thrust jacked women before the broader public—where they were met with incomprehension, skepticism, and revulsion. But the two types, somewhat athletic and hugely hypertrophic, established the poles of an emerging aesthetic. At century's end sociologist Shari Dworkin looked back on the era's "more muscular bodily ideal," embodied, one might say, by the singer Madonna in her 1990 video for the song "Vogue," or perhaps the character Sarah Connor (played by Linda Hamilton) in the 1991 movie *Terminator 2*. From the perspective of a quarter century on, Madonna, who was then considered to be at the dagger point of female muscularity merely for having body fat sufficiently low to reveal some faint lines of definition on her arms and shoulders, is certainly "lean, thin, and toned," the adjectives used by any number of contemporary journalists and sociologists to describe the feminine ideal of the nineties. But she was far from muscled. Dworkin spent two years interviewing women at various gyms in Los Angeles, and most of them, even those who used weights, expressed concerns about "getting big" and looking too masculine, "like a female bodybuilder." Assessing these responses, Dworkin concluded that social norms (and thus both men and women) impose a "glass ceiling on women's muscular strength," and that women are engaged in a "conscious struggle with what constitutes an acceptable upper limit on women's strength and size."

There can be no doubt that NFF practices have yet to shatter the glass ceiling; that outmoded assumptions continue to define the upper limit of strength and muscularity for most women. But it is equally true that, since Dworkin's study was published, the ceiling has been raised considerably, and the struggle with it has eased. Every day I meet women like Stacey, a woman in her early thirties who "used to

want to be petite and dainty, to take up as little space as possible in the world," until she began weight training. "Now," she says, "I own the space I'm in, I have confidence." Confidence is where the page has turned: female strength so offended societal norms even a decade ago that picking up weights tended to cause anxiety in women; today resistance work is a means of building self-assurance.

Several forces are at work. First, by measuring progress in the gym by performance rather than on the scale, women in the New Frontier effectively remove the internal controls on "acceptable strength and size." Next, without mirrors to remind you every second of how you appear to others, you focus on such markers as how you feel and how your abilities are greater than they were the day before. Added to this is the number of people who are gradually learning that lifting weights functionally will not, in fact, make you big or bulky, *especially* if you're a woman; on the contrary, strength training is a far more effective means of leaning out than cardio alone. Females do not produce high enough levels of testosterone to create large amounts of muscle mass, so the concern should only apply to those who take anabolic steroids or devote their entire lives to training and eating, as pro athletes do.

Annie Thorisdottir, the Icelandic two-time CrossFit Games champion and a coach herself, laughs about the "girls who come in to the gym worried about becoming too big. I'm like, Girl, you're not going to wake up one day and be like, 'Oh my god, I have too much muscle!' That's not going to happen. You won't get bigger, but your body-fat percentage will go down and you'll get a little more cut—you'll see a little more definition."

The notion that strong women are beautiful began gaining mainstream purchase around 2014, when *Vogue* magazine featured Thorisdottir flaunting, in the article's words, "a body built by (and for)

hoisting barbells, flipping tractor tires, hauling sandbags, running, rowing, and, yes, swinging hammers." Already, *strong is beautiful* has become such a catchphrase that we have advertisements pastiching it (Pantene, for example, uses the phrase to suggest that strong hair is beautiful), and we have magazines, such as *Strong*, touting it. So it seems that among women the dialogue about muscles and strength is largely affirmative. Does that mean men find buff women attractive? Certainly not all of them. But I've heard no grumblings from the NFF community about a spate of rejection by males of women with performance-oriented physiques, nor do women in the New Frontier seem to lack companionship. What I do hear are loud voices of encouragement and appreciation from my male peers, who mostly drown out the less evident adolescent protestations of dissenters.

Fitzgerald credits CrossFit women with embracing body-revealing clothing as a step that altered perceptions of female muscularity. Previously, he says, "girls who were physique models or bodybuilders were 'gross'; now there are girls doing squat cleans and ring muscle-ups" and it changes the way we see them. "It's fully acceptable for every female in the gym to walk around with a sports bra on, to expose her belly, and wear tight booty shorts with a bum cliff," he says. "You train with these women, and they will be stronger than you." That they can be stronger than their male counterparts turns out to be one of the more startling revelations of recent years: yes, females tend to be smaller, and thus weaker, than men in the aggregate, but in any given gym there will be women (in the emphatic plural) who are stronger than most of the men. The fact is women have only been engaged in strength training for a very brief period, and the true ceiling on female strength has yet to be found. As male weightlifters like to say, there is always a 100-pound girl somewhere out there lifting more than you.

The gym is, among other things, a laboratory, and one of the experiments we've run in its NFF incarnation has been the rapid evolution of female strength over the past decade. The perceptible adjustments to societal notions of beauty that have followed suggest, for instance, that there are no inherent types to which we are attracted: our desire is conditioned by experience.

For as long as I can remember I was attracted to the extremely thin women splashed across billboards and fashion magazines of the eighties and nineties, women who disappear when they turn sideways. It wouldn't be dishonest to say I moved to New York partially for the hordes of model-skinny women available. But that's all I knew. Women with muscles were virtually nonexistent in my world, and so I associated anyone bigger than a bread stick with slovenly corpulence. It was only after being around high-performance women that their muscles came to stand for vitality, vibrancy, health, and therefore for beauty. Now what passes for conventional female beauty strikes my eye as vitiated, and the soft flesh so many women display seems weak and, to quote Ronda Rousey . . . good for doing nothing.

Being able to do things you've never imagined possible, and the assurance that floods your cells with each broken barrier, is far more powerful than the approval from others that surface beauty briefly brings. Sara, a weightlifter and one of the coaches of our CrossFit competition team, recounts her all-too-familiar story of struggling with weight—despite having an enviable figure—and how focusing on performance and "eating to perform instead of eating to look a certain way completely changed my life. Before I started doing CrossFit, I didn't realize that there is a lot more to exercising than how I look and trying to be skinny."

The crux of the matter, that there is *something more to exercise*, describes the landscape we're trying to map.

I f physical practices can alter something as basic as our notions of beauty and to whom we're attracted, it begs the question what else they might affect.

Charlotte, a CrossFitter from the American South, points out that "[b]eing confident in your body makes you better at relating to your partner, and being strong makes you better at sex, you have more stamina." Beyond sex, we know too that exercise increases neural functioning, helps prevent a host of diseases, slows aging, and wards off depression. But there is a dimension to NFF that, it seems to me, goes beyond these physical benefits to the metaphysical, and it might best be grasped by considering the allure of obstacle racing.

The form was conceived by Billy Wilson (aka Mr. Mouse, a moniker seemingly at odds with his decidedly feline, bushy, gray, chevron mustache), who staged the first Tough Guy race in 1987. A onetime British soldier and a trailblazer of English running earlier in the decade, Wilson organized a winter mud trot through a farm in Wolverhampton, England, spanning some 15 kilometers. It was at first a rudimentary affair, but in succeeding years has grown to include mud bogs, walls, tunnels, and ditches; what has not changed is the playfulness of it, with people dressing up in nineteenth-century British military garb or wearing capes.

Tough Guy was the world's sole obstacle race until 1993, when a group of men from the U.S. military inaugurated the Camp Pendleton Mud Run in California. Yet both of these remained small, local events geared toward men, as the name Tough Guy suggests, until NFF provided a larger and broader array of potential athletes. After that, the sport erupted.

Joe DeSena, a Wall Street trader and ultramarathoner, was seeking something more intellectually as well as physically challenging, not to mention more exciting, than 70-mile slogs. So in 2004, he

announced the first Death Race. In keeping with the general escalation of intensity in the New Frontier, it combines endurance (some 10 miles of mountains and obstacles to cover in twenty-four hours), strength (carrying logs, deadlifting boulders), problem solving (contestants do not know the events beforehand and are often presented with mental tests, like building a Lego sculpture), and grim humor (pulling yourself under a field of barbed wire to find your race number attached to tree stump, which you then have to dig up and carry to the starting line).

The business of obstacle racing descends from these three earlier examples, with somewhat more crowd-friendly trials. The Strongman Run began in Germany in 2007 and is now held throughout Europe; in the United States, Warrior Dash got going in 2009, followed in 2010 by both DeSena's Spartan Race, a less punishing version of his Death Race, and Tough Mudder, the brainchild of Will Dean, an Englishman at Harvard, and explicitly modeled on Tough Guy.

In an effort to explain the surge of popularity that obstacle races enjoyed in their first several years (though growing more slowly, they are now big businesses, with at least one, the Spartan Race, becoming increasingly professionalized; it is televised in the United States, presumably with a similar viewership as other endurance races since watching people run and then crawl through mud turns out to be not much more exciting than watching them run and then bike), Dean opined, "experiences, particularly shared ones, are the new luxury good." I'm not sure the races are luxuries per se, since status does not seem to figure significantly in the decision to enter one. But obstacle races *are* experiences, heightened and simulated forms of the everyday. Heightened in that they—and indeed all fitness contests, from CrossFit to the Highland Games—provide athletes an opportunity to compete. They are a species of play, a forum to test one's training.

Another way of thinking about an obstacle race, or another fitness contest, is that, as a heightened form, it is a microcosm of our general experience. And this serves up the answer to the question with which I opened this book: What are you training for? What are we practicing *for* when we practice movements?

I am asked why someone with a stressful job, who usually works six days per week, spends his free time slithering through mud under barbed wire, carrying buckets of rocks under a punishing sun, clambering over high walls, or dealing with the pressure of a lifting platform. Because these experiences are more lighthearted instances of what we do, or might be called to do, on any given day, NFF regimes partake of practice both in the sense of *training for* and of *doing*: we temporarily withdraw from the rush of existence in order to rehearse its most fundamental aspects—movement, the interplay of neuron and muscle, the presentness and oblivion of concentration—and, bettered by this training, slip back into the stream of life.

ACKNOWLEDGMENTS

Without the example and support of Selma Kunitz none of my endeavors would be possible. I am grateful to her. My deepest gratitude, too, to David and Anne Young, Michele Kunitz, and, of course, Jennifer Nelson for the love, for being there. To Anthony Tuck, for innumerable conversations and friendship, and to his students at the University of Massachusetts for allowing me to try out some of the ideas in this book.

I want to thank Edward Orloff, my agent, who understood the project from the start and helped me to understand it far better than I might have on my own. I am grateful, too, to Karen Rinaldi, who brought the book to Harper Wave and allowed me the scope to write the book I wanted to write; to Sarah Murphy, for her acute editorial eye and steady advocacy; and to Hannah Robinson for all her help. At Aurum Press, Lucy Warburton leant her editorial expertise and provided insightful comments. Thanks also to Jacqueline Marema for extremely helpful photo editing.

It was Leona Christie who suggested the title. Elizabeth Rappaport read large portions of the manuscript and offered astute suggestions.

My gratitude to Jan and Terry Todd at the H.J. Lutcher Stark Center for Physical Culture and Sports at the University of Texas,

Austin, for hosting me and sitting for long interviews. In addition to them, Enid Whittaker, James Fitzgerald, Mark Divine, Dr. Kenneth Cooper, Travis Brewer, Alex Bigge, Nicholas Coolidge, and Ben Smith generously shared their stories, experiences, and time. Without them this book would not have been realized: my heartfelt thanks to them all.

GENERAL NOTES ON SOURCES

Fitness is a topic of oceanic proportions, and no one book can encompass it. Ideals tend to be divorced from methods, and most accounts hew to only a part of the reason for this or that approach. While the idea of fitness as something that results from exercise and training has existed in some form since ancient times, as a scientific fact exercising for fitness remains very new. My research has ranged widely from ancient sources to last week's videos. But it would have been inconceivable without the work done by the preeminent scholars of physical culture, Jan and Terry Todd, and the scholarship they have compiled in the journal *Iron Game History*. Reading Peter Sloterdijk powerfully influenced my thinking on practice culture, enhancement regimes, and despiritualized asceticisms.

In this book, I did not set out to rewrite the history of exercise, the facts of which are freely available, if at times difficult to track down; rather, I aimed to synthesize that history into a series of arguments. I drew from numerous primary and secondary sources, which I detail in the bibliography; the notes here point to those that were particularly useful.

Introduction: Into the New Frontier

Herz (2014) recounts the history of CrossFit well, a story that is told in a more fragmented manner by Greg Glassman himself in numerous speeches available online.

Chapter 1: The Inner Statue

I found Miller (2004) to be my best guide to ancient athletics in general, and his compendium of ancient writing on athletics, Miller (1991), also proved indispensable. Spivey (2012) provides a fine introduction to the Olympics and the Greek competitions. Ben Smith was kind enough to correspond with me about his sense of *areté;* on the ancient Greek concept see Jaeger (1939) as well as Aristotle's *Ethics*. Stewart (1997) provides an insightful discussion of the *Doryphoros*. Although he wrote during the Roman era, Lucian provides a vivid picture of the *gymnasion*. Many of the Greek etymologies and concepts like *philoponia* I gleaned from Sloterdijk.

Chapter 2: But Is It Good for You?

On ancient approaches to physiology and fitness, I relied on Berryman (2003), Chaline (2015), Galen's treatise *De Sanitate Tuenda*, MacAuley (1994), and Tipton (2014). The Socrates quote comes from Xenophon. Foucault (1986) and Cagniart (2000) discuss Roman attitudes to the body and fitness, while Seneca takes up the subject of exercise in general as well as his own regime in his letters. On the Jews and their feelings about Greek body worship, I consulted several versions of the Bible, including the King James and the New English Translation of the Septuagint, electronic edition, as well as Sweet (2012).

The specifics of ancient Chinese, Indian, and Egyptian exercise I pulled from Diem (1938), Headland (1906), Maguire (2013), Mingda (2009), and Stojiljković et al. (2013). It was in Sloterdijk that I first

learned of the relationship of Greek *askesis* to Christian asceticism.

Chapter 3: Feeling, Breathing, Going to War

Vegetius and Galen discuss the training regimens of the Roman army, and one can find details about other military approaches in Chaline (2015) and Berryman (2003), Headland (1906), Maguire (2013), Mingda (2009), Stojiljković et al. (2013), MacAuley (1994), and Willoughby (1970). The history of Indian clubs comes largely from Todd (1995) and Kehoe (1866).

White's (2011) chapter on yoga is an outstanding introduction. Far too little research has been done on the various influences on yoga in the twentieth century, but the history of its reception in America is well covered by Syman (2010).

Chapter 4: Bodyweight Politics

There is much fodder for further research on Hassan Yasin-Bradley and the early history of modern-day calisthenics, and on Bartendaz. I used Cecil (2014), the documentary films *Mind Up* and *Bartendaz*, as well as the BaristiWorkout interview.

Uberhorst (1978) provides a thorough account of Friedrich Ludwig Jahn, the early history of German gymnastics, and how it spread through Europe and America. Important aspects of this history can also be found in Todd (1992, 1995), Giessing (2005), Weber (1971), and Chaline (2015). I relied on Kaimakamis et al. (2010) for the history of the parallel bars and other equipment. On Captain Clias and Catherine Beecher, the best material is found in Todd (1998). Information on and the quote from Tyrs come from Domorazek (2007).

Chapter 5: Hercules and the Athletic Renaissance

Todd (2005) has a detailed account of *Farnese Hercules* and its influence on various individuals. The information on Mercurialis and fitness in the sixteenth, seventeenth, and eighteenth centuries comes from Joseph (1949), Giessing (2005), and Chaline (2015).

Budd (1997) treats the interplay between sculpture, images, and the body in the nineteenth century. On Triat, see Chapman (1995); on barbells and dumbbells, see Todd's (1995) essential essay. Chaline's (2015) account of the history of the gym in the nineteenth century also proved useful.

Muscular Christianity is its own extensive topic. I drew particularly on Ladd (1999) and Whorton (1982), who is also indispensable for health reform more generally in the nineteenth century. Between them Todd (1993) and Paul (1983) provide a thorough history of George Barker Windship and the nineteenth century heavy-lifting boom, while many of my anecdotes come from Windship (1862). Reactions to the boom can be found in Lewis (1862), Whorton (1982), Paul (1983), and Todd (1993). Higginson (1861) gives readers a detailed portrait of a gym in the 1860s.

On Dr. Karpovich, see Todd and Todd (2005). For the contemporary history of strongman competitions and training, a field that lacks a good account, read Bilger (2012) and listen to Pineau (2013).

Chapter 6: Training for the Mirror

On Sargent and his influence, I consulted de la Peña (2003), Bryant (1992), Whorton (1982), Blaikie (1884), as well as Sargent (1927) himself. For workplace efficiency and Taylorism, see de la Peña (2003).

Much has been written about Eugen Sandow, including by Sandow (1897) himself. Chapman (2006) is the best biography. For Bernarr Macfadden, see Taylor's (1950) three-part *New Yorker* profile,

as well as Todd (1991) and Budd (1997). Information on Zander can be found in Tharrett et al. (2011). For the philosophical implications of aesthetic training versus performance-oriented training, I drew on Sloterdijk as well as on my own experience.

The rise of bodybuilding and its differentiation from weightlifting is yet another topic that awaits a thorough scholarly account. Important aspects of it and the rivalry between Bob Hoffman and Joe Weider can be found in McKenzie (2013), Black (2013), and Fair (1997). Thomas (1993) discusses muscle control, while the German weightlifting story is told by Giessing (2005) and Wedemeyer (2000) and (1994).

Vic Tanny was the subject of a publication, Gutterman (1961), celebrating his contributions to fitness, but more historically objective accounts can be found in McKenzie (2013) and Black (2013), while Birmingham (1959) provides a contemporary assessment.

Chapter 7: Acrobats and Beefcake

For the history of the original Muscle Beach, I've relied primarily on Rose (2001) and the very informative Ozyurtcu (2014), with help too from McKenzie (2013), Black (2013), Zinkin (1999), and Terry Todd (2000). For Pudgy Stockton, see also Jan Todd's (1992) excellent biographical essay.

Acroyoga awaits a thorough account, with little available beyond what is found on the websites Acroyoga.org and Acroyoga.com. For the post–World War II history of yoga, I consulted Syman (2010) and White (2011).

The development of Parkour is covered well in Wilkinson (2007), and there are a number of online interviews and documentaries on David Belle, in particular one from TF1 (2001). For the Natural Method, both Hébert (1912) and McDougall (2009) were very helpful.

Chapter 8: The Tyranny of the Wheel

McKenzie (2013) was especially useful on the history of fitness in America after World War II and on Bonnie Prudden, although much of the information about her came from interviews I conducted with Enid Whittaker. Boyle (1955) describes the circumstances surrounding Prudden's meeting with President Eisenhower. I also found valuable insights and details on Prudden and postwar American fitness from Stull (1956), Cook (1959), Havlick (1969), Martin (2011), and Black (2013).

For Thomas Cureton, see Berryman (1996). Kennedy (1960) remains a crucial document of the era.

Chapter 9: From Women's Work to the Women's Movement

Jack LaLanne is a major figure in McKenzie (2013), Black (2013), and Chaline (2015), all of which I also used for the history of fitness in the 1960s, '70s, and '80s, while Horn (1960) provided further details. Many episodes of LaLanne's TV show are available online. On Cureton, I looked primarily to Berryman (1996) and McKenzie (2013).

Gotaas (2009) is a magnificently comprehensive and readable history of running, though I also drew on MacPherson (1968), McKenzie (2013), and Black (2013).

For Kenneth Cooper, see Cooper (1970), McKenzie (2013), Black (2013), and Reinhold (1987).

The credit for fleshing out exactly how the aerobics movement was born and grew must be given to Swanson (1996). I also found Pesta (1983), McKenzie (2013), and Black (2013) most helpful. For aerobics, fitness, and feminism, see Kagan and Morse (1988), Rader (1991), Lloyd (1996), Eskes et al. (1998), and Collins (2002).

On the rise of franchise gyms in the late 1970s and '80s, see Geist

(1983), Gerson (1984), Rader (1991), Stern (2008), and Tharrett et al. (2011), as well as McKenzie (2013), Black (2013), and Chaline (2015). The subject of modern fitness machines is admirably covered in Starr (2015), which I supplemented with Starkman (1981) and Shannon (1982).

On bodybuilding, I was led by Goldberg (1975), Butler's *Pumping Iron* (1977), Fussell (1991), Dutton (1995), Grimek (1999), Lane (2000), McKenzie (2013), Black (2013), and Chaline (2015).

Chapter 10: Practicing at Life

The long quote from Nietzsche is from *The Gay Science*. The material on personal trainers and fitness in the 1990s was informed largely by Bourne et al. (2002), Tharrett et al. (2011), McKenzie (2013), Black (2013), and Chaline (2015).

For CrossFit, see Glassman (2002), Murphy (2012), and Herz (2014).

The evidence for changes to body image in both males and females was so pervasive that it began to seem self-evident. I did find Pope et al. (1999) and Hill (2014) useful, while Todd (2008) is an exceptionally eye-opening look at assumptions about muscularity and steroids. On female strength and muscularity, I benefited from Brace-Govan (2002), Dworkin (2001), Cecil (2012), and Havrilesky (2014).

For the early history of obstacle racing, I consulted Bindley (2012), Keneally (2012), Sifferlin (2012), and Cooper (2014).

BIBLIOGRAPHY

Books

Aldersey-Williams, Hugh. *Anatomies: A Cultural History of the Human Body*. New York: Norton, 2013.

Aristotle. *Ethics*. Trans. J. A. K. Thomson. Harmondsworth: Penguin Books, 1955.

Black, Jonathan. *Making the American Body*. Lincoln: University of Nebraska Press, 2013.

Blaikie, William. *How to Get Strong and How to Stay So*. New York: Harper Brothers, 1884.

Budd, Michael Anton. *The Sculpture Machine: Physical Culture and Body Politics in the Age of Empire*. New York: New York University Press, 1997.

Chaline, Eric. *The Temple of Perfection: A History of the Gym*. London: Reaktion Books, 2015.

Chapman, David L. *Sandow the Magnificent*. Urbana: University of Illinois Press, 2006.

Cooper, Kenneth H., M.D., M.P.H. *The New Aerobics*. Toronto: Bantam Books, 1970.

de la Peña, Carolyn Thomas. *The Body Electric: How Strange Machines Built the Modern American*. New York: New York University Press, 2003.

Domorazek, Karel. *Dr. Miroslav Tyrs: The Founder of the Sokol Union.* Prague: Czecho-Slovakian Foreigners' Office, 2007. https://archive.org/stream/drmiroslavtyrsfo00domorich/drmiroslavtyrsfo00domorich_djvu.txt.

Dutton, Kenneth R. *The Perfectible Body: The Western Ideal of Male Physical Development.* New York: Continuum, 1995.

Epstein, David. *The Sports Gene.* New York: Current, 2013.

Foucault, Michel. *The Care of the Self: The History of Sexuality.* Vol. 3. Trans. Robert Hurley. New York: Vintage, 1986.

Fussell, Samuel Wilson. *Muscle: Confessions of an Unlikely Bodybuilder.* New York: Avon Books, 1991.

Galen. *On the Natural Faculties.* Trans. Arthur John Brock. London: William Heinemann, 1916.

Gotaas, Thor. *Running: A Global History.* London: Reaktion Books, 2009.

Gutterman, Leon, ed. *Wisdom: Physical Fitness Edition.* Beverly Hills, CA: Wisdom Society, 1961.

Hébert, Georges. *Practical Guide of Physical Education.* 1912 ed. http://parkour.gr/books/physed-guide-hebert-nov09.pdf.

Herz, J. C. *Learning to Breathe Fire.* New York: Crown, 2014.

Jaeger, Werner. *Paideia: The Ideals of Greek Culture.* New York: Oxford University Press, 1939.

Kehoe, Simon. *The Indian Club Exercise: Explanatory Figures and Positions.* New York: Peck & Snyder, 1866.

Kolata, Gina. *Ultimate Fitness: The Quest for Truth About Exercise and Health.* New York: Farrar, Straus & Giroux, 2003.

Ladd, Tony, and James A. Mathisen. *Muscular Christianity: Evangelical Protestants and the Development of American Sport.* Grand Rapids, MI: BridgePoint Books, 1999.

Lindqvist, Sven. *Bench Press.* London: Granta, 2003.

McDougall, Christopher. *Born to Run*. New York: Vintage, 2009.

McKenzie, Shelly. *Getting Physical: The Rise of Fitness Culture in America*. Lawrence: University Press of Kansas, 2013.

Miller, Stephen G. *Ancient Greek Athletics*. New Haven: Yale University Press, 2004.

————. *Arete: Greek Sports from Ancient Sources*. Berkeley: University of California Press, 1991.

Mishima, Yukio. *Sun and Steel*. Trans. John Bester. New York: Grove Press, 1970.

Murphy, T. J. *Inside the Box*. Boulder, CO: Velo Press, 2012.

Nietzsche, Friedrich. *The Gay Science*. Trans. Walter Kaufmann. New York: Vintage, 1974.

Plato. *The Republic: The Complete and Unabridged Jowett Translation*. New York: Vintage Classics, 1991.

Rose, Marla Matzer. *Muscle Beach*. Los Angeles: LA Weekly Books, 2001.

Sandow, Eugen. *Strength and How to Obtain It*. 1897; reprint, O'Faolain Patriot, 2012.

Sargent, Dudley Allen. *An Autobiography*. Philadelphia: Lea & Febiger, 1927.

Seneca. *Letters from a Stoic*. Trans. Robin Campbell. Harmondsworth: Penguin Books, 1969.

Sloterdijk, Peter. *You Must Change Your Life*. Trans. Wieland Hoban. Cambridge: Polity, 2013.

Spivey, Nigel. *The Ancient Olympics*. Oxford: Oxford University Press, 2012.

Stewart, Andrew. *Art, Desire, and the Body in Ancient Greece*. Cambridge: Cambridge University Press, 1997.

Syman, Stefanie. *The Subtle Body: The Story of Yoga in America*. New York: Farrar, Straus & Giroux, 2010.

Tharrett, Stephen, Frank O'Rourke, and James A. Peterson. *Legends of Fitness: The Forces, Influences, and Innovations That Helped Shape the Fitness Industry.* Monterey, CA: Healthy Learning, 2011.

Todd, Jan. *Physical Culture and the Body Beautiful: Purposive Exercise in the Lives of American Women 1800–1870.* Macon, GA: Mercer University Press, 1998.

Uberhorst, Horst. *Friedrich Ludwig Jahn and His Time: 1778–1852.* Trans. Timothy Nevill. Munich: Heinz Moos Verlag, 1978.

Vegetius, Flavius. *The Military Institutions of the Romans (De Re Militari).* Trans. Lieutenant John Clarke, 1767. http://www.digitalattic .org/home/war/vegetius/.

Whorton, James C. *Crusaders for Fitness: The History of American Health Reformers.* Princeton, NJ: Princeton University Press, 1982.

Willoughby, David P. *The Super-Athletes.* New York: A. S. Barnes, 1970.

Xenophon. *The Memorabilia: Recollections of Socrates.* Trans. H. G. Dakyns. London: Macmillan, 1897.

Zinkin, Harold. *Remembering Muscle Beach: Where Hard Bodies Began—Photographs and Memories.* Los Angeles: Angel City Press, 1999.

Articles

"About Us." AcroYoga Montreal. Retrieved January 18, 2016. http:// acroyoga.com/about-us.

Barland, Bjorn. "The Gym: Place of Bodily Regimes—Training, Diet, and Doping." *Iron Game History* 8, no. 4 (2005): 23–29.

Berryman, Jack W. "Ancient and Early Influences." In *Exercise Physiology: People and Ideas.* Ed. Charles M. Tipton. New York: Oxford University Press, 2003.

———. "Thomas K. Cureton, Jr.: Pioneer Researcher, Proselytizer, and Proponent for Physical Fitness." *Research Quarterly for Exercise and Sport* 67 (1996): 1–12.

Bilger, Burkhard. "The Strongest Man in the World." *New Yorker*, July 23, 2012.

Bindley, Katherine. "Tough Mudder: Spartan Races See Increase in Women Participants Pushing to Build Strength, Test Limits." *Huffington Post*, November 10, 2012. http://www.huffingtonpost.com/2012/12/10/tough-mudder-women-spartan-race_n_2257878.html.

Birmingham, Stephen. "Far Out Beyond Fitness." *Sports Illustrated*, July 27, 1959.

Blow, Steve. "Dr. Kenneth Cooper Says Physical Fitness Helps Even in Death." *Dallas Morning News*, April 21, 2012.

Boncheff, Peter. "Bonnie Prudden: The First Lady of Fitness Fashion." *Desert Leaf*, April 2008.

Bourdieu, Pierre. "Program for a Sociology of Sport." Trans. John MacAloon and Alan D. Savage, *Sociology of Sport Journal* 5 (1988): 153–61.

Bourne, Nicholas, Jan Todd, and Terry Todd. "The Cold War's Impact on the Evolution of Training Theory in Boxing." *Iron Game History* 7, nos. 2 and 3 (2002): 22–30.

Boyle, Robert H. "The Report That Shocked the President." *Sports Illustrated*, August 15, 1955.

Brace-Govan, Jan. "Looking at Bodywork: Women and Three Physical Activities." *Journal of Sport & Social Issues* 26, no. 4 (2002): 403–20.

Bryant, Doug. "William Blaikie and Physical Fitness in Late Nineteenth Century America." *Iron Game History* 2 (1992): 3–6.

Cagniart, Pierre. "Seneca's Attitude Towards Sport and Athletics." *Ancient History Bulletin* 14, no. 4 (2000): 162–70.

Canby, Vincent. "'Perfect,' Gym and Journalism." *New York Times*, June 7, 1985.

Cassidy, John. "Still Pumped Up." *New Yorker*, November 16, 2013.

Cecil, Andrea Maria. "Olympic Weightlifting Renaissance." *CrossFit Journal*, November 2012.

———. "Tending Bar." *CrossFit Journal*, January 2014.

Chapman, David. "Hippolyte Triat." *Iron Game History* 4, no. 1 (1995): 3–10.

Collins, Leslea Haravon. "Working Out the Contradictions: Feminism and Aerobics." *Journal of Sport & Social Issues* 26 (2002): 85–109.

Cook, Joan. "Physical Fitness of Youth Has Expert Fit to Be Tied." *New York Times*, May 7, 1959.

Cooper, Chris. "Mud in Your Eye." *CrossFit Journal*, August 2014.

"The Cult of the Gym: The New Puritans." *Economist*, December 19, 2002.

Danna, Sam. "The 97-Pound Weakling Who Became 'The World's Most Perfectly Developed Man.'" *Iron Game History* 4, no. 4 (1996): 3–16.

de la Peña, Carolyn. "Dudley Allen Sargent: Health Machines and the Energized Male Body." *Iron Game History* 8, no. 2 (2003): 3–19.

Diem, Carl. "Physical Culture in Ancient Egypt." *Olympic Review*, 1938.

Dworkin, Shari L. "'Holding Back': Negotiating a Glass Ceiling on Women's Muscular Strength." *Sociological Perspectives* 44, no. 3 (2001): 333–51.

Eskes, Tina B., Margaret Carlisle Duncan, and Eleanor M. Miller. "The Discourse of Empowerment." *Journal of Sport & Social Issues* 22, no. 3 (1998): 317–44.

Fair, John D. "Bob Hoffman, the York Barbell Company, and the Golden Age of American Weightlifting, 1945–1960." *Journal of*

Sport History 14, no. 2 (1987): 164–88.

———. "George Jowett, Ottley Coulter, David Willoughby and the Organization of American Weightlifting, 1911–1924." *Iron Game History* 2, no. 6 (1993): 3–15.

Geist, William E. "The Mating Game and Other Exercises at the Vertical Club." *New York Times*, May 19, 1984.

Gerson, Richard F. "Health Clubs of the Eighties: What Better Place to Meet a Fit Man?" *Shape*, September 1983.

Giessing, Jurgen, and Jan Todd. "The Origins of German Bodybuilding: 1790–1970." *Iron Game History* 9, no. 2 (2005): 8–20.

Glassman, Greg. "What Is Fitness?" *CrossFit Journal*, October 1, 2002.

Goldberg, Vicki. "Body Building." *New York Times*, November 30, 1975.

Greif, Mark. "Against Exercise." *N+1* 1 (2004): 63–72.

Grimek, John. "How Steve Reeves Trained." *Iron Game History* 5, no. 4 (1999): 48–49.

Hall, Daniel T., and John D. Fair. "The Pioneers of Protein." *Iron Game History* 8, no. 3 (2004): 23–34.

Havrilesky, Heather. "Why Are Americans So Fascinated with Extreme Fitness?" *New York Times Magazine*, October 14, 2014.

Havlick, James D. "Challenge, Change, Rhythm: The Bonnie Prudden Story." *Journal of Physical Education* (November–December 1969): 36–37.

Headland, Isaac Taylor. "Chinese Children's Games." *Journal of the North China Branch of the Royal Asiatic Society* 37 (1906): 144–45.

Helliker, Kevin. "Fears Mount Over Dangers of Hoisting Heavy Weights." *Wall Street Journal*, March 13, 2003.

Higginson, Thomas Wentworth. "Gymnastics." *Atlantic Monthly*, March 1861.

———. "Saints, and Their Bodies." *Atlantic Monthly*, March 1858.

Hill, Logan. "Building a Bigger Action Hero." *Men's Journal*, May 2014.

Horn, Huston. "Lalanne: A Treat and a Treatment." *Sports Illustrated*, December 19, 1960.

James, William. "The Energies of Men." In *Selected Papers on Philosophy*. London: J. M. Dent, 1917.

Joseph, L. H. "Medical Gymnastics in the Sixteenth and Seventeenth Centuries." *Ciba Symposia* 10 (March–April 1949).

Kagan, Elizabeth, and Margaret Morse. "The Body Electronic: Aerobic Exercise on Video: Women's Search for Empowerment and Self-Transformation." *TDR* (1988) 32, no. 4 (Winter 1988): 164–80.

Kaimakamis, Vasilios, Panagiotis Papadopoulos, Dimitrios Kaimakamis, and Stella Duka. "Invention and Evolution of the Parallel Bars in the First Half of the 19th Century." *Studies in Physical Culture and Tourism* 17, no. 2 (2010): 167–72.

Keneally, Scott. "Playing Dirty." *Outside*, October 22, 2012.

Kenfield, John Fawcett, III. "The Sculptural Significance of Early Greek Armor." *Opuscula Romana* 9 (1973): 149–56.

Kennedy, John F. "The Soft American." *Sports Illustrated*, December 26, 1960.

Kuntzleman, Charles T. "Dance for Your Life!" *Shape*, September 1981.

Lane, John Francis. "Steve Reeves: Putting Muscle and Myth in the Movies." *Guardian*, May 5, 2000.

Laskow, Sarah. "The Man Who Made Jogging a Thing." *Atlantic*, October 1, 2014. http://www.theatlantic.com/health/archive/2014/09/the-man-who-made-us-jog/380847/.

Lewis, Dio. "The New Gymnastics." *Atlantic Monthly*, August 1862.

Lloyd, Moya. "Feminism, Aerobics and the Politics of the Body." *Body & Society* 2 (June 1996).

Lucian. "Anacharsis, A Discussion of Physical Training." In *The Works of Lucian of Samosata*. Trans. H. W. Fowler and F. G. Fowler. Oxford: Clarendon Press, 1905.

MacAuley, Dominic. "A History of Physical Activity, Health and Medicine." *Journal of the Royal Society of Medicine* 87 (January 1994).

MacPherson, Myra. "Train (Pant, Pant) Don't Strain (Pant, Pant)." *New York Times*, February 13, 1968.

Maguire, Richard. "India's Physical Culture and Hidden Contributions." http://www.theleanberets.com/wp-content/uploads/2013/05/IndiaPhysicalCulture.pdf.

Martin, Douglas. "Bonnie Prudden, 97, Dies; Promoted Fitness for TV Generation." *New York Times*, December 18, 2011.

———. "Lucille Roberts, 59, Founder of Fitness Chain for Women." *New York Times*, July 18, 2013.

McCracken, Elizabeth. "The Bell of the Barbell." *New York Times Magazine*, December 31, 2006.

McDougall, Christopher. "A Wild Workout for the Real World." *Men's Health*, March 2009.

McDowell, Edwin. "Publishing: 'Aerobics' Scores Again." *New York Times*, December 3, 1982.

Mingda, Ma. "Reconstructing China's Indigenous Physical Culture." *Journal of Chinese Martial Studies* 1 (Summer 2009).

Nemer, Jason. "About." jasonnemer.com. Retrieved January 18, 2016. http://www.jasonnemer.com/about/.

Norwood, David. "The Legend of Louis Cyr." *Iron Game History* 1, no. 2 (1990): 4–5.

Ozyurtcu, Tolga. "Flex Marks the Spot: Histories of Muscle Beach." PhD diss., University of Texas, Austin, 2014.

Papakonstaninou, Zinon. "The Athletic Body in Classical Athens: Literary and Historical Perspectives." *International Journal of the History of Sport* 29, no. 12 (2012): 1657–68.

Parker-Pope, Tara. "Why Women Can't Do Pull-ups." *New York Times*, October 5, 2012.

Paul, John. "The Health Reformers: George Barker Windship and Boston's Strength Seekers." *Journal of Sport History* 10, no. 3 (Winter 1983).

Pesta, Ben. "Jacki Sorensen: The First Lady of Aerobics." *Shape*, September 1983.

"Physical Training." *Harper's Weekly*, September 1860.

Pieggi, Sarah. "The Pleasure of Being the World's Strongest Woman." *Sports Illustrated*, November 14, 1977.

Pope, Harrison G., Jr., Roberto Olivardia, Amanda Gruber, and John Borowiecki. "Evolving Ideals of Male Body Image as Seen Through Action Toys." *International Journal of Eating Disorders* 1 (1999): 65–72.

Rader, Benjamin. "The Quest for Self-Sufficiency and the New Strenuosity: Reflections on the Strenuous Life in the 1970s and 1980s." *Journal of Sport History* 18 (Summer 1991): 255–67.

Reinhold, Robert. "Has the Aerobics Movement Peaked? An Interview with Kenneth Cooper." *New York Times*, March 29, 1987.

Rubin, Courtney. "Fitness Playgrounds Grow as Machines Go." *New York Times*, April 21, 2013.

Sayre, Joel. "The Body Worshipers of Muscle Beach." *Saturday Evening Post*, May 25, 1957.

Shannon, Daniel. "The Man from Nautilus." *New York Times*, July 22, 1982.

Sifferlin, Alexandra. "We Tried This: Strong vs. Skinny." *Time*, November 5, 2012.

Starkman, Eric. "Converting to the Cult of High-Tech Fitness." *Maclean's* 94 (October 26, 1981): 54.

Starr, Bill. "Rise of the Machines." *CrossFit Journal*, January 9, 2015.

Steiner, Deborah. "Moving Images: Fifth-Century Victory Monuments and the Athlete's Allure." *Classical Antiquity* 17, no.1 (1998): 123–50.

Stern, Marc. "The Fitness Movement and the Fitness Center Industry, 1960–2000." *Business and Economic History On-Line* 6 (2008). http://www.thebhc.org/sites/default/files/stern_0.pdf.

Stojiljković, Nenad, Aleksandar Ignjatović, Zvezdan Savić, Živorad Marković, and Sandra Milanović. "History of Resistance Training." *Activities in Physical Education and Sport,* Federation of the Sports Pedagogues of the Republic of Macedonia 3, no.1 (2013): 135–38.

Storey, Samantha. "Parkour, a Pastime Born in the Streets, Moves Indoors and Uptown." *New York Times,* August 9, 2013.

Stull, Dorothy. "Be Happy, Go Healthy with Bonnie." *Sports Illustrated,* July 16, 1956.

Swanson, Beth S. "A History of the Rise of Aerobic Dance in the United States Through 1980." M.A. thesis, San Jose State University, 1996.

Sweet, Desirae. "'Noble Sweat': *Paideia* in the Gymnasium and Torture Chamber of 4 Maccabees." *Glossolalia* 4, no. 2 (May 2012): 11–23.

Taylor, Robert Lewis. "Physical Culture." *New Yorker*: October 14, 21, and 28, 1950.

Thomas, Al. "Joe Assirati: Reminiscences of Britain's Renaissance of Strength." *Iron Game History* 2, no. 5 (1993): 16–19.

Tipton, Charles M. "The History of 'Exercise Is Medicine' in Ancient Civilizations." *Advances in Physiology Education* 38 (2014): 109–17.

Todd, Jan. "Bernarr Macfadden: Reformer of Feminine Form." *Iron Game History* 1, nos. 4 and 5 (1991): 3–8.

———. "The Classical Ideal and Its Impact on the Search for Suitable Exercise: 1774–1830." *Iron Game History* 2, no. 4 (1992).

———. "From Milo to Milo: A History of Barbells, Dumbells, and Indian Clubs." *Iron Game History* 3, no. 6 (1995).

———. "The History of Cardinal Farnese's 'Weary Hercules.'" *Iron Game History* 9, no. 1 (2005): 29–34.

———. "The Legacy of Pudgy Stockton." *Iron Game History* 2, no. 1 (1992): 5–7.

———. "The Origins of Weight Training for Female Athletes in North America." *Iron Game History* 2, no. 2 (1992): 4–14.

———. "Size Matters: Reflections on Muscle, Drugs, and Sport." *Iron Game History* 10, no. 3 (2008): 3–22.

———. "Strength Is Health: George Barker Windship and the First American Weight Training Boom." *Iron Game History* 3, no. 1 (1993): 3–14.

Todd, Jan, and Desiree Harguess. "Doris Barrilleaux and the Beginnings of Modern Women's Bodybuilding." *Iron Game History* 11, no. 4 (2012): 7–21.

Todd, Jan, and Terry Todd. "The Conversion of Dr. Peter Karpovich." *Iron Game History* 8, no. 9 (2005).

Todd, Terry. "Steve Reeves: The Last Interview." *Iron Game History* 6, no. 4 (2000): 1–14.

Todd, Terry, and Spencer Maxcy. "Muscles, Memory, and George Hackenschmidt." *Iron Game History* 2, no. 3 (1992): 10–15.

Van Doorn, John. "An Intimidating New Class: The Physical Elite." *New York*, May 29, 1978.

van Hilvoorde, Ivo. "Fitness: The Early (Dutch) Roots of a Modern Industry." *International Journal of the History of Sport* 25, no. 10 (2008).

Weber, Eugen. "Gymnastics and Sports in *Fin-de-Siècle* France: Opium of the Classes?" *American Historical Review* 76, no. 1 (1971).

Wedemeyer, Bernd. "Bodybuilding in Germany in the Late Nineteenth and Early Twentieth Centuries." Trans. Anthony Haywood. *Iron Game History* 3, no. 4 (1994): 4–7.

———. "Theodor Siebert: A Biography." Trans. David Chapman. *Iron Game History* 6, no. 3 (2000).

Weiss, Harold. "Sherlock Holmes, Arthur Conan Doyle and the 'Iron Pills.'" *Iron Game History* 1, nos. 4 and 5 (1991): 21.

White, David Gordon. "Yoga, Brief History of an Idea." In *Yoga in Practice*. Ed. David Gordon White. Princeton, NJ: Princeton University Press, 2011.

Wilkinson, Alec. "No Obstacles." *New Yorker*, April 16, 2007.

Windship, George Barker. "Autobiographical Sketches of a Strength Seeker." *Atlantic Monthly*, January 1862.

Zarnowski, Frank. "The Amazing Donald Dinnie: The Nineteenth Century's Greatest Athlete." *Iron Game History* 5, no. 1 (1998): 3–11.

Videos and Podcasts

Bartendaz. Documentary video accessed on YouTube. https://www. youtube.com/watch?v=Ann0QkiLT-g.

"Illinois Innovators: Thomas Cureton Jr., the Father of Physical Fitness." Posted on YouTube, July 17, 2012. https://www.youtube. com/watch?v=9gdAHC7qq70.

Interview with Julian Pineau on the Wodcast podcast #66, June 12 2013. http://wodcast.libsyn.com/episode-66-it-started-when-i-saw-terminator-with-julien-pineau.

Mind Up. Documentary video by Mike Koslap. CrossFit Journal, January 9, 2014. http://journal.crossfit.com/2014/01/bartendaz-mind-up.tpl.

Stormfreerun interview with David Belle. https://www.youtube.com/ watch?v=ZXVvjtG2H8c.

TF1 Documentary on David Belle. 2001. https://www.youtube.com/ watch?v=PvZJtdxGKI8.

Video interview with Hassan Yasin-Bradley by BaristiWorkout.

Posted on YouTube April 28, 2013. https://www.youtube.com/watch?v=DR0mj0FmjyM.

Video interview with Missett by Elizabeth Malloy for the *San Diego Daily Transcript*, February 11, 2010. http://www.sddt.com/files/media/view.cfm?_t=Interview+with+Judi+Sheppard+Missett&-media=LLAL7JW4#.UgUMwWR4blc.

INDEX

ABOUT THE AUTHOR

DANIEL KUNITZ has served as editor in chief of *Modern Painters*, as well as an editor at the *Paris Review* and *Details*, and has been a contributor to *Vanity Fair, Harper's Magazine*, and *New York*. He is also an avid CrossFitter and weightlifter. He lives in New York City.